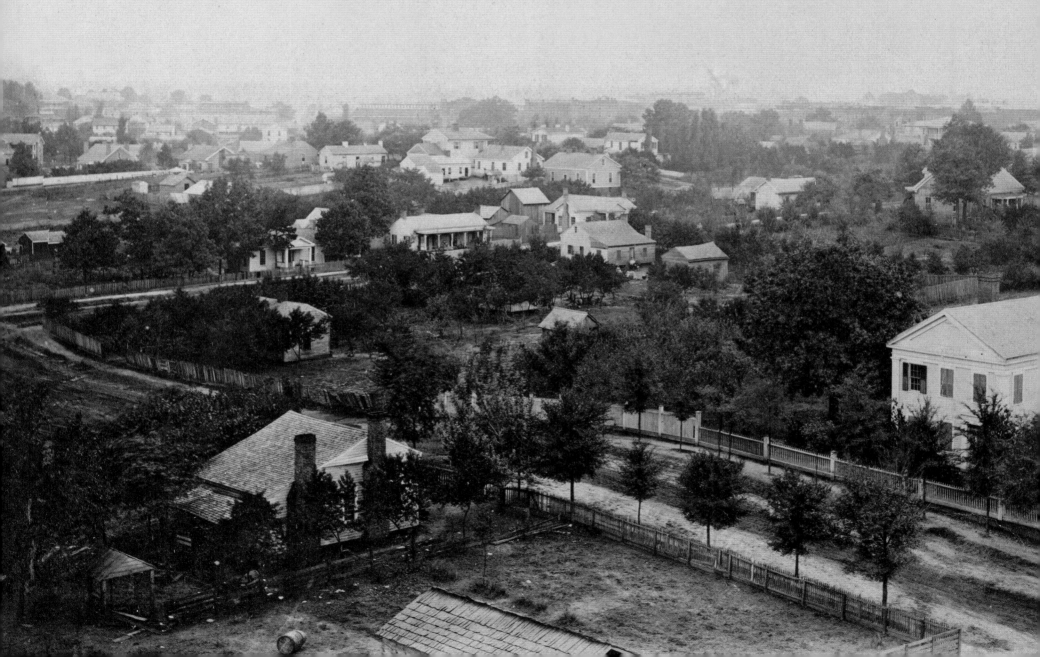

LOST ATLANTA

Acknowledgments

This book would not be possible without the dedication and work of the staff of the Kenan Research Center at the Atlanta History Center—particularly Josh Hogan, Carla Ledgerwood, and Sue VerHoef. Their contributions in writing, research, and photograph selection made this publication possible.

Picture credits

All photographs courtesy of the Atlanta History Center, except where marked. In addition;
Page 50 courtesy of Karl Mondon/Atlanta Braves Museum and Hall of Fame
Page 51 courtesy of Auburn Avenue Research Library
Page 73 courtesy of the Coca-Cola Company

Endpapers

Front: 'Before being burnt by order of General Sherman'. Panoramic photo taken from the Cupola of the Female Seminary by George N. Barnard, 1864.
Back: Birds Eye View of the Cotton States and International Exposition, Atlanta, Georgia. W. L. Stoddart, Werner Company, 1895.

First published in the United Kingdom in 2015 by
PAVILION BOOKS
an imprint of Pavilion Books Company Ltd.
1 Gower Street, London WC1E 6HD, UK

© Pavilion Books Group, 2015

ISBN: 978-1-90981-564-3

A CIP catalogue record for this book is available from the British Library.

10 9 8 7 6 5 4 3 2 1

Repro by COLOURDEPTH, UK
Printed by 1010 Printing International Ltd, China

LOST ATLANTA

Michael Rose, Paul Crater and Don Rooney

in association with

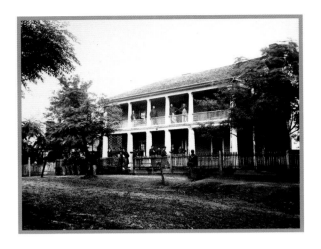
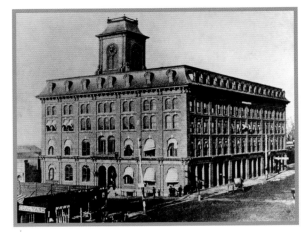
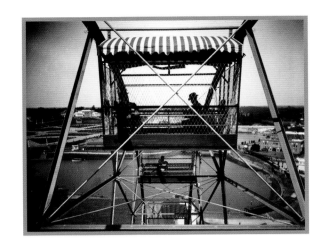

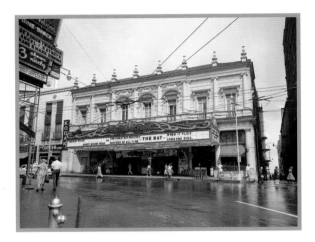
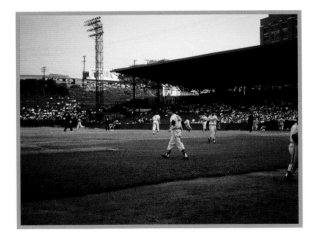
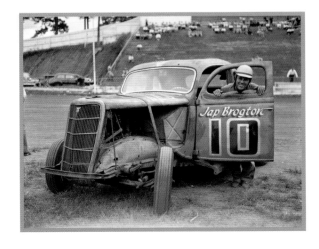
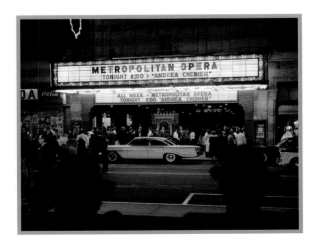
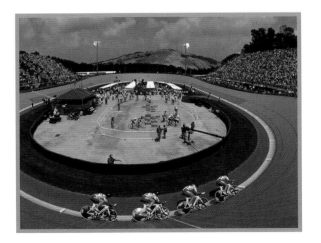

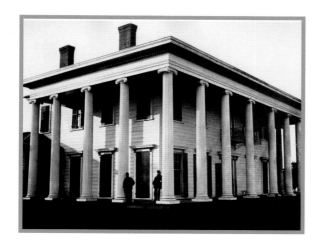

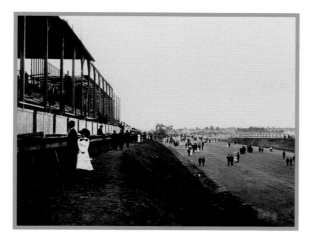

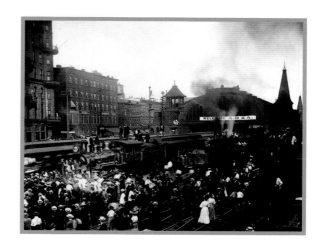

LOST IN THE...

INTRODUCTION

Atlanta is situated in the Georgia Piedmont, a region composed of low, rolling hills bounding the edge of the North Georgia Mountains of the southern Appalachian range. Piedmont soil is commonly rich in iron and red in color, for which Atlanta and Georgia have become famous through fiction and film. Strategically, Atlanta sits along the crest of the Eastern Continental Divide.

The divide separates two distinct watersheds, the Gulf of Mexico and the Atlantic Seaboard. Depending on where you stand in Atlanta, rainwater from the divide flows either to the gulf or to the ocean. In downtown Atlanta, it is defined along DeKalb Avenue, not Peachtree, as popularly assumed. By British proclamation in 1763, the divide represented the boundary between British and French colonial possessions in North America. Another borderline, the Chattahoochee River, which runs along the Brevard Fault Zone, served as a boundary between the Creek and Cherokee peoples.

This land and its attributes thus brought us here. Atlanta, or, rather, the place that would become Atlanta—was Creek Indian territory. It is here that the land and water meet. The Native American trails provided routes for hunting, trading, and war. These routes followed the ridge lines between stream valleys and, in turn, led to our own roads and streets.

When white men came, they sought the prime location to cross the river—for constructing a bridge for a railroad. The Creek were gone by that time—removed in 1821—but the ridge lines were perfect for constructing rail lines atop them, and thus brought transportation and commerce to this place that is now Atlanta.

In 1837, the site that became Atlanta was—quite literally—a stake driven into the ground in the Georgia wilderness. Here, engineers for the Western & Atlantic Railroad, selected the location as the point at which a rail line would terminate—a goal finally accomplished thirteen years later. Yet the place had no name, only scattered settlers, and seemingly limited potential: "A good location for one tavern, a blacksmith shop, a grocery store, and nothing else," stated Stephen Long, engineer for the W&A.

Atlanta became much more than that. A bustling frontier rail town, all business and progress, pushing itself forward until the Union Army knocked it down.

But it rose from its ashes with drive again—the Gate City, Empire City of the South, New South Capital, the City Too Busy to Hate, Forward Atlanta, Hotlanta, the World's Next Great City, The ATL, and more are all names that symbolize Atlanta's robust, positive spirit, business acumen, and notorious boosterism.

Its distinction is founded in transportation, railroads to airlines to highways to information; its business leadership and financial performance—the Atlanta Spirit—and its historic role as a home to diversity and the promise of opportunity—economic, social, political, and cultural.

In this setting, Atlanta "raised a brave and beautiful city" as the journalist and promoter Henry Grady said. Sadly, much of it is gone. The antebellum city—no land of cavaliers and cotton fields, though it was of master and slave—is lost. What Sherman and the Union Army left, we have ourselves destroyed. As the city grew out and grew up—with skyscrapers and high-rise hotels—it tore down what had come before. We have razed a brave and beautiful city.

Some of the losses found here in *Lost Atlanta* have raised awareness and galvanized efforts to salvage what is deemed important and worthy to pass along to future generations. There are also the hidden Losts—the landscape, the native people, and the natural environment. These are difficult to portray, but are, nevertheless, elements of our greatest losses.

What we can show here in *Lost Atlanta* are those parts of the built environment that either no longer exist, or whose original purpose has changed. We can record the annual events, the grand stations, the old stadiums, the cinemas, the businesses and the storied restaurants that were once part of the fabric of life in Atlanta which time, fashion, or governance has swept aside.

RIGHT *Marietta Street from Five Points at the beginning of the twentieth century.*

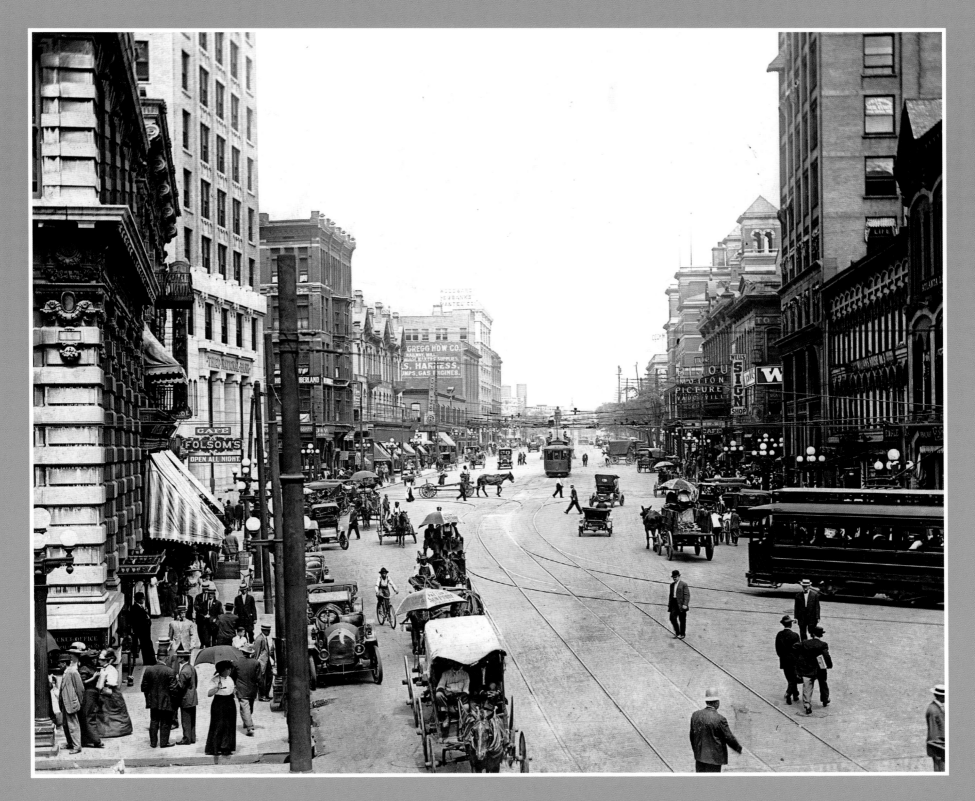

Antebellum Atlanta DESTROYED 1864 AND AFTER

Antebellum Atlanta—the stuff of fiction, film, and old wartime photographs—is gone.

Founded as a railroad terminal, Atlanta was defined by its rail lines. Centered on the train depots, the city's streets were aligned with the tracks, which were themselves defined by the topography of the land—and Atlanta is a city among the hills. At the close of the 1850s, there were four major lines serving the city and linking the Southeast: the Western & Atlantic, the Georgia Railroad, the Macon & Western, and the Atlanta & West Point, with Atlanta as the Gate City of the South.

Even before the Civil War, Atlanta was the thruway for resources, products, and markets between the Georgia coast, inland markets, and ultimately the Tennessee, Ohio, and Mississippi Rivers. This strategic location established Atlanta as a railroad hub connecting the Atlantic Ocean with the great Mississippi. During the Civil War, this meant that all men, supplies, or ordnance moving from the Western Theater of war to the Eastern front in Virginia passed through Atlanta.

It was the city's growth as a transportation, military, and industrial base that made it the target

of General William Tecumseh Sherman's army—and resulted in the destruction of all of the city's fighting capabilities when he departed on the March to the Sea.

In 1862, following the Union capture of Nashville, New Orleans, and Memphis, Confederate war industries relocated to Georgia and especially Atlanta because it was considered safe from invasion. By 1864, four Confederate government arsenals were in Georgia, including Atlanta, producing cannon, ammunition, guns, and equipment of all types. Atlanta was also an important hospital center and over 100,000 soldiers were cared for in the city's hospitals.

There were at least ninety private manufacturers of military equipment in Georgia as well as thirty-eight textile mills supplying 130,000 uniforms per year to the Confederate Army. All of this military-related production was linked by Atlanta's railroad network. Capturing Atlanta, therefore, meant cutting the Confederacy's most important supply lines and neutralizing the South's war industries.

In the spring of 1864, Sherman was placed in charge of the Military Division of the Mississippi

comprised of a total of about 100,000 men. Sherman's superior numbers faced Joseph E. Johnston's Army of Tennessee, a force of 65,000. By 1864, the population of Atlanta had doubled to about 20,000, many of whom were war workers and refugees. Responding to a July 10 Confederate military order for civilians to evacuate the city, and fearing the Union approach, all but approximately 2,500 people left Atlanta by the time it first came under fire on July 20.

Atlanta was also a political target. In the North, Abraham Lincoln's 1864 reelection campaign was a referendum on the president's conduct of the war for the Union and against slavery. Many believed that if Confederate forces could hold Atlanta, the Northern states might elect Lincoln's opponent, General George B. McClellan, who favored a negotiated peace with the Confederacy. When Union armies captured Atlanta on September 2, 1864, they assured Lincoln's reelection and, ultimately, Union victory in the Civil War.

Tales of Sherman's destruction, however, give him too much credit. His destruction, as significant as it was, leveled Atlanta's military-industrial complex: its transportation, industrial, commercial, and military infrastructure. But it did not lay waste to the city. That transpired over the following decades as wartime survivors—some presented here in *Lost Atlanta*—met a later fate, as buildings and sites forfeited their lives for commercial development, parking lots, and freeways.

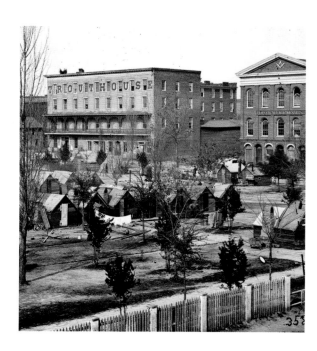

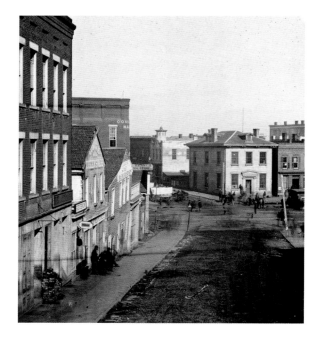

OPPOSITE PAGE *Union troops pose on the grounds of an unidentified house located on what was known as "Upper" Peachtree Street, the section between Ellis and Baker Streets. Union Major General George H. Thomas' own headquarters was located in the Herring-Leyden House near the intersection of Ellis and Peachtree Streets.*

FAR LEFT *Atlanta's first public park adjoining the General Passenger Depot is filled with temporary living quarters built by the Union Army during the occupation, September to November 1864.*

LEFT *Whitehall Street ends and Peachtree Street begins on the other side of the railroad tracks. The rail line essentially bisected Atlanta throughout the nineteenth century.*

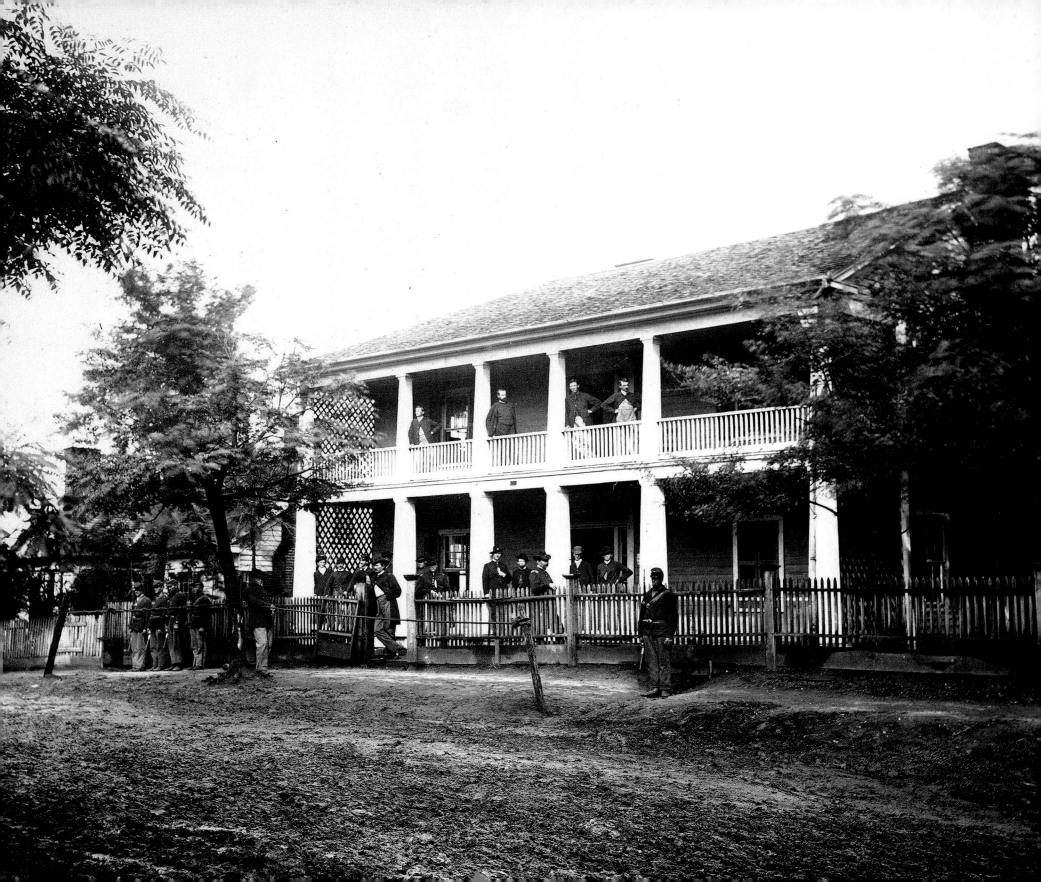

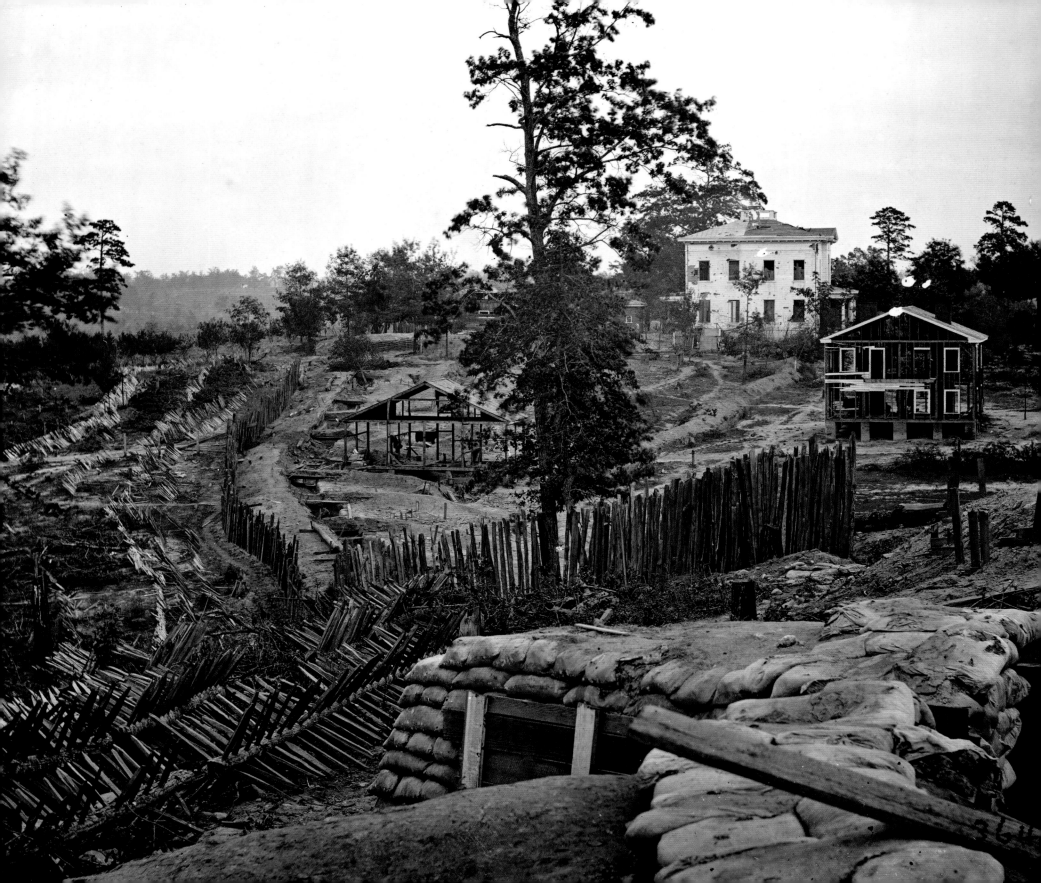

Fort Hood and the Ponder House DESTROYED 1864

In mid-1863, Colonel Lemuel P. Grant, chief engineer of the Confederate military department of Georgia, undertook construction of defensive fortifications designed to safeguard the city of Atlanta. From August 1863 through April 1864, Grant supervised the construction of a ten-mile-long ring of earthworks encircling Atlanta. Much of the work was performed by enslaved labor requisitioned from their owners at $25 per month – payable to the slaveholder – and daily rations for the thousands of slaves needed to complete the work – work intended to ensure their continued enslavement.

Grant developed a perimeter defense line considered far enough from the city to protect it from artillery bombardment and consisting of seventeen redoubts connected by a sequence of rifle trenches. Fort Hood, named for Confederate General John Bell Hood, was the northern-most redoubt in an extended Siege Line constructed in late July in response to Sherman's field guns, located only a short distance away.

Located east from Fort Hood, the fort's cannon embrasure overlooked the property of planter and slave trader Ephraim G. Ponder. Moving to Atlanta in 1857, Ponder built a grand home on a high knoll north of the city. Constructed of white-plastered stone and surrounded by terraced gardens, boxwood, and fruit trees, the house was topped by an observation deck, providing a splendid view from its hill-top prominence.

Ironically, the vantage point that influenced Ponder to build his house on this site also motivated the Confederate army to construct substantial defensive works along the approach to the house, which provided a strong fortified position. The house itself served as a perfect sharpshooter's position for Southern forces and subsequently a perfect target for Federal artillery in the woods near present-day Eighth Street.

An integral part of Atlanta's defense was to clear the area before the earthworks of timber for a distance of up to 1,000 yards. Observing landscapes such as this, Orlando M. Poe, Sherman's chief engineer, noted that the city's defenses were "too strong to assault and too extensive to invest." Instead, Sherman chose to lay siege to the city, bombarding Atlanta throughout the month of August.

In addition to the war's impact on Atlanta's residents, houses, and the city's transportation and military facilities, the environmental impact was heavy. Thousands of trees were leveled as the surrounding woods became a clear cut, opening up the land to have a clear view of the approaching Union Army. As the land was denuded, the lumber from the trees was used to construct fortifications as well as to create additional means of war—wooden spikes or spears, rows of logs sharpened to points, or merely laid as obstacles.

In his plans for the city defenses, L. P. Grant documented land lot numbers, possibly for identifying and compensating landowners affected by the construction, which damaged or destroyed $250,000 worth of pastures, fields, and buildings.

Grant's defense line, however, was never far enough away to prevent bombardment of the city or damage and injury to building, property, and residents. In fact, parts of the northeast and northwest corners of the line were located within the city limits. In the summer of 1864, Confederate armies extended the fortifications outward in those areas, adding an additional two miles to the lines.

Following the war, the Ponder House, which contained nearly a ton of shells that had been shot into it, was pulled down. Its site along Marietta Street is near the current Ivan Allen College of Liberal Arts on the edge of the Georgia Tech campus. Over the years, the vast ring of defenses that delayed Atlanta's destruction, but did not save the city, were overrun by progress. The only remnant is the embankment of Fort Walker, a salient that still exists in the southeast corner of Grant Park.

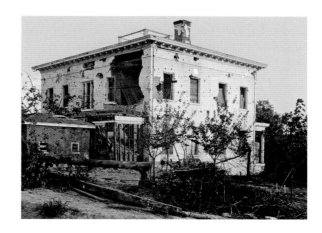

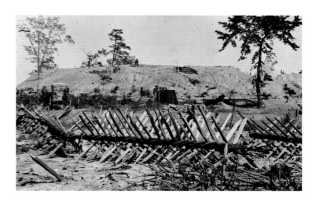

TOP *The Ponder House, Fort Hood and other Confederate fortifications, as well as the rail yard and streets of the city were photographed by George N. Barnard, Sherman's photographer, following the surrender of the city. Sherman laid siege to Atlanta, bombarding throughout the month of August 1864. Mayor James M. Calhoun surrendered the city on September 2, 1864, not far from Fort Hood and the Ponder House.*

OPPOSITE PAGE *The Ponder House stands just beyond the ramparts of Fort Hood, named for Confederate General John Bell Hood. Hood was appointed commander of the defense of the city in July 1864 when General William T. Sherman and the Union Army were already not far from the Ponder House and the city. In a matter of a few days, Hood's aggressiveness resulted in substantial losses and he was forced to withdraw within Atlanta's fortifications.*

ABOVE *The portable darkroom of photographer George N. Barnard stands outside Fort Hood on the Marietta Road. In Fulton County, the road led from the site of the Creek village of Standing Peachtree on the Chattahoochee River to the intersection in downtown Atlanta now known as Five Points. That intersection was itself originally the juncture of two Creek routes, the Peachtree Trail and the Sandtown Trail.*

General Passenger Depot DESTROYED 1864

Built by the Western & Atlantic Railroad and completed by 1854, Atlanta's General Passenger Depot, commonly known as the Car Shed, was 300 feet long and 100 feet wide - large enough to include the tracks of all four rail lines serving Atlanta. As the railroad hub connecting the western and eastern halves of the Confederacy, anything that moved between them had to move through Atlanta – the heart of the Confederacy. The depot was the core of that heart.

From weapons—guns, swords, and bullets—to the seemingly commonplace beltplates, much of the means of war was manufactured in Atlanta. Therefore, when William T. Sherman departed Atlanta on the March to the Sea, Atlanta's reason for being, its rail lines and transportation structures—depots, freight houses, roundhouses, storage, and supplies—were targeted for destruction.

In a letter to Ulysses S. Grant, Sherman wrote, "I … prefer to make a wreck of … Atlanta." As he planned his departure, soldiers unfit for the march were sent north, along with hundreds of African Americans—former slaves headed to freedom.

Before leaving the city, the Union Army methodically destroyed railroads, factories, and Atlanta's business district. While some buildings were pulled down with ropes, others were knocked down with battering rams made from railroad tracks. The iron tracks themselves were heated and twisted into "Sherman's Neckties," which became a hated symbol of the intentional destruction by the

Union army in Atlanta and on the March to the Sea.

Sherman himself supplied directions for burning the wooden rail cross ties and then coiling—not merely bending—the metal rails: "Officers should be instructed that bars simply bent may be used again, but if when red hot they are twisted out of line they cannot be used again. Pile the ties into Shape for a bond fire, put the rails across and when red hot in the Middle, let a man at Each End twist the bar so that its surface is Spiral."

Under the direction of Captain Orlando M. Poe, Sherman's chief military engineer, soldiers destroyed the General Passenger Depot on November 14 using a specially-constructed battering ram to knock out the depot's brick support pillars.

On the night of November 15, Sherman's engineers then set fire to the rubble, including the ruins of the depot, and to the remaining commercial buildings—anything that might be of service to the Confederacy. Since Sherman left no Union troops in Atlanta, he needed to destroy Atlanta's infrastructure so that it could not be used again.

In addition, some soldiers also set fire to

houses. Sherman, watching from his headquarters in the Neal-Lyon House, made no attempt to stop them. "We have been utterly destroying everything in the city of any use to the armies of the South," an Indiana soldier wrote. In all, forty percent of Atlanta was destroyed.

The Union Army marched out as clouds of dense black smoke rose from Atlanta. An Ohio captain wrote: "Heaven and earth … agree in decreeing a terrible punishment to those perfidious wretches who concocted this terrible war."

OPPOSITE PAGE *The brick depot dominates the heart of Atlanta, not only by its sheer size, but with the sounds and smells it created.*

BELOW LEFT *Atlanta's reason for being—the rail lines and the great Car Shed—lie in ruins as Sherman and the Union Army finish their days of destruction to the city's resources to support the Confederate cause.*

BELOW *Union soldiers demonstrate how they pulled up rails from the cross ties before heating and twisting them out of shape. The remains of the destroyed Passenger Depot appear to the right of the troops.*

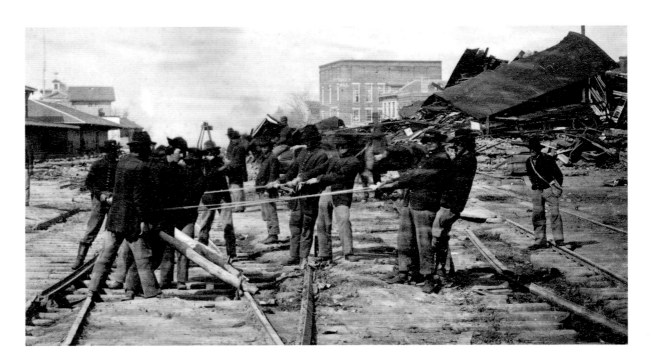

Kimball's Opera House / Atlanta's First State Capitol BURNED 1894

For many years, citizens of Atlanta and state legislators wanted to move the capital of Georgia from small-town Milledgeville to the more-convenient and ever-growing city of Atlanta. In 1868, Atlanta was chosen to become a temporary post-Civil War capital. One year earlier, the Atlanta Opera House and Building Association began constructing a five-story opera house at the corner of Marietta and Forsyth Street.

But in just one year, the company was out of money and the building sold to Edwin Kimball. He bought the property for $31,750 and finished it with the very idea that it could become the state capitol. He intended to lease most of the building to the state for five years, after which he would turn over the rented portion to them—the annual rent was $6,000.

In 1870, however, as legislators prepared to move in, Governor Rufus Bullock realized there were no lights, carpets, heat, or furniture in the building. Nevertheless, perhaps in an attempt to facilitate the move—or perhaps because they were friends—Bullock funneled $54,500 in state funds to Kimball from the state treasury, without the knowledge of the state treasurer. Bullock, once perceived as the very essence of a Northern carpetbagger, was later tried and acquitted for corruption and mismanagement.

Scandal plagued the Kimball Opera House as Edwin Kimball, who bought the building with the intention of selling it to the state, sold it to his brother, Hannibal, for $60,000 just before the state's lease went into effect. The state, however, decided not to rent, but purchase the opera house, and in 1870 paid Hannibal Kimball $250,000 in state bonds. Kimball failed, though, to mention the $60,000 mortgage. When the state legislature discovered the debt, they threatened to return the capitol to Milledgeville. Seeking to keep the capital, Atlanta city officials bought the mortgage, plus interest, and several years later, cancelled the debt from the books.

Despite the political intrigues, financial scandals, and collusions of Reconstruction Georgia, the Kimball Opera House and State Capitol was considered a beautiful building topped by a solid mansard roof and a tall clock tower above the Forsyth Street entrance. The second floor contained the two large halls for the Senate and House of Representatives with high ceilings, a series of galleries on three sides, and frescoed walls and ceilings.

The Senate Chamber contained a full length portrait of George Washington while the Supreme Court library held paintings of Benjamin Franklin and the Marquis de Lafayette, which had all been brought to Atlanta from the capitol in Milledgeville.

The 1826 paintings by C.R. Parker now hang in the present state capitol. The only criticism of the building and its décor was for the rented sleeping rooms on the top floor, said to be in poor taste.

Despite its overall size, the state became in desperate need of a larger facility, though the state legislature continued to meet in the building until the current Georgia State Capitol was completed. The legislature met for the last time in the old Kimball Opera house on July 4, 1889. For a short time, the structure was renamed the Venable Building for the Venable family who bought it in 1890. One of the Venable brothers, Samuel Hoyt Venable, owned Stone Mountain near Atlanta and was involved in the Ku Klux Klan and the mountain's Confederate Memorial. The opera house building was razed in 1894 after two-thirds burned and the remaining structure had been condemned.

OPPOSITE PAGE *The Kimball Opera House was an impressive and beautiful Italianate building towering over nearby buildings when it was built in 1868.*

LEFT *The Kimball Opera House sits adjacent to Concordia Hall on the corner of Marietta Street and Forsyth Street in downtown Atlanta in 1880.*

RIGHT *This 1870 handbill for the Kimball Opera House shows that it housed the Georgia State Capitol building and Post Office. In 1878, the post office moved into the city's first federal building, the U.S. Customs House and Post Office.*

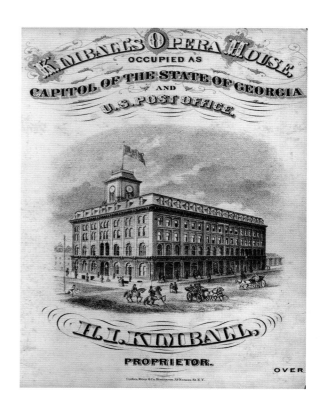

KIMBALL'S OPERA HOUSE

OCCUPIED AS

CAPITOL OF THE STATE OF GEORGIA

AND

U.S. POST OFFICE.

H. I. KIMBALL,

PROPRIETOR.

OVER

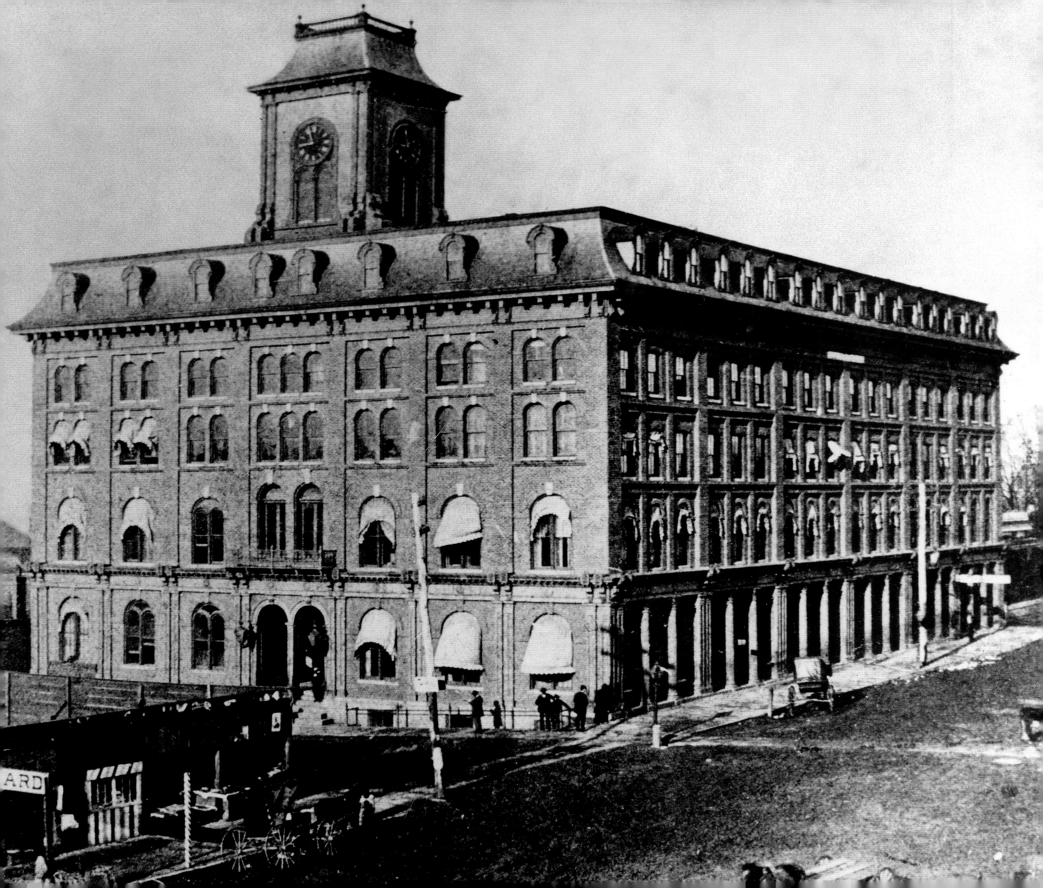

Mule- and Horse-drawn Streetcars ENDED 1894

Soon after the destruction of the Civil War, a corporate charter was granted to establish the privately held Atlanta Street Railroad Company in February 1866. Atlanta was the Gate City of the South with trains systematically arriving and departing the city, but getting around the ever-growing city was becoming more difficult, lengthy, and tedious.

The mayor and city council endorsed the enterprise and promoted the construction of rail lines amid the heart of downtown commerce: Peachtree, Whitehall, Broad, Marietta, and Decatur Streets "for the convenience of the public." But despite municipal advocacy, considerable requirements—such as the cost of paving the unpaved dirt streets of Atlanta—and a tax on each streetcar halted development for five years.

In 1871, Atlanta entrepreneurs Richard Peters, president of the company, and George Washington Adair, secretary-treasurer, laid the first cast iron track along Whitehall Street, just south of the railroad line. The West End Line ran a little over a mile to its end on Peters Street near present-day Spelman College. Perhaps not coincidentally, it went past the residences of both Peters and Adair. The first horse-drawn street car pulled the line on September 8, 1871.

In 1872, however, public subscriptions faltered, and Peters and Adair were forced to continue construction using personal funds. Three additional street lines opened that year and in the following two years lines were extended as far as Ponce de Leon Springs. Along the way, horses, trolleys, and passengers crossed the 270-foot trestle high above the Clear Creek ravine between Myrtle Street and Argonne Avenue in present-day midtown.

Another of five independent street railway companies, the Metropolitan Street Railroad was established in 1882 and operated two routes beginning downtown and both terminating at Grant Park. In addition to mule-powered cars, the company introduced "dummy" or steam-powered engines that were capable of speeds reaching thirty-five miles-per-hour—the residents along the route complained of the noise and smoke.

In 1886, Joel Hurt chartered the Atlanta & Edgewood Street Railroad Company. The corporation constructed the city's first electric transit line connecting downtown with Hurt's

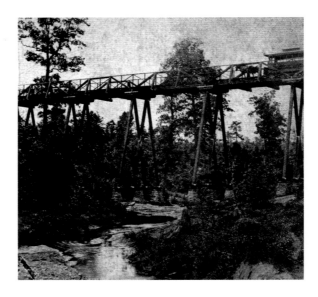

suburban neighborhood of Inman Park, two miles to the east. Double tracks were laid on newly constructed Edgewood Avenue and the first electric streetcar completed its first fifteen-minute journey in 1889. In 1890, almost twelve miles of electrified track were in operation among the city's forty-five miles of street railroads.

Technology and growth altered all aspects of life in Atlanta as the twentieth century approached. Horse-car tracks, particularly in the city, were converted to accommodate electric trolleys. In September 1894, the *Atlanta Constitution* reported the end of Atlanta's horse-drawn railroad era with announcement of the "The Wheat Street Hayburner —A Relic of a Bygone Era."

Prior to its retirement, twice a day, one of the workers in the Edgewood Avenue car shed, (site of the current Hurt Building) hitched a "patient-looking" mule to the Wheat Street streetcar. It was led over the electric streetcar line past the African American Y.M.C.A. building and onto Wheat Street (now Auburn Avenue). Swift electric streetcars ran to the north and south, on Houston Street and Edgewood Avenue respectively. The days of horse-drawn public transit in Atlanta were over.

OPPOSITE PAGE *Horse-drawn streetcars ply the Alabama Street route in 1882.*

ABOVE LEFT *High above the Clear Creek ravine in 1874, a streetcar full of passengers is bound for Ponce de Leon Springs.*

BELOW *Among a rush of activity, a horse-drawn streetcar heads south on Whitehall Street at Alabama Street in 1882.*

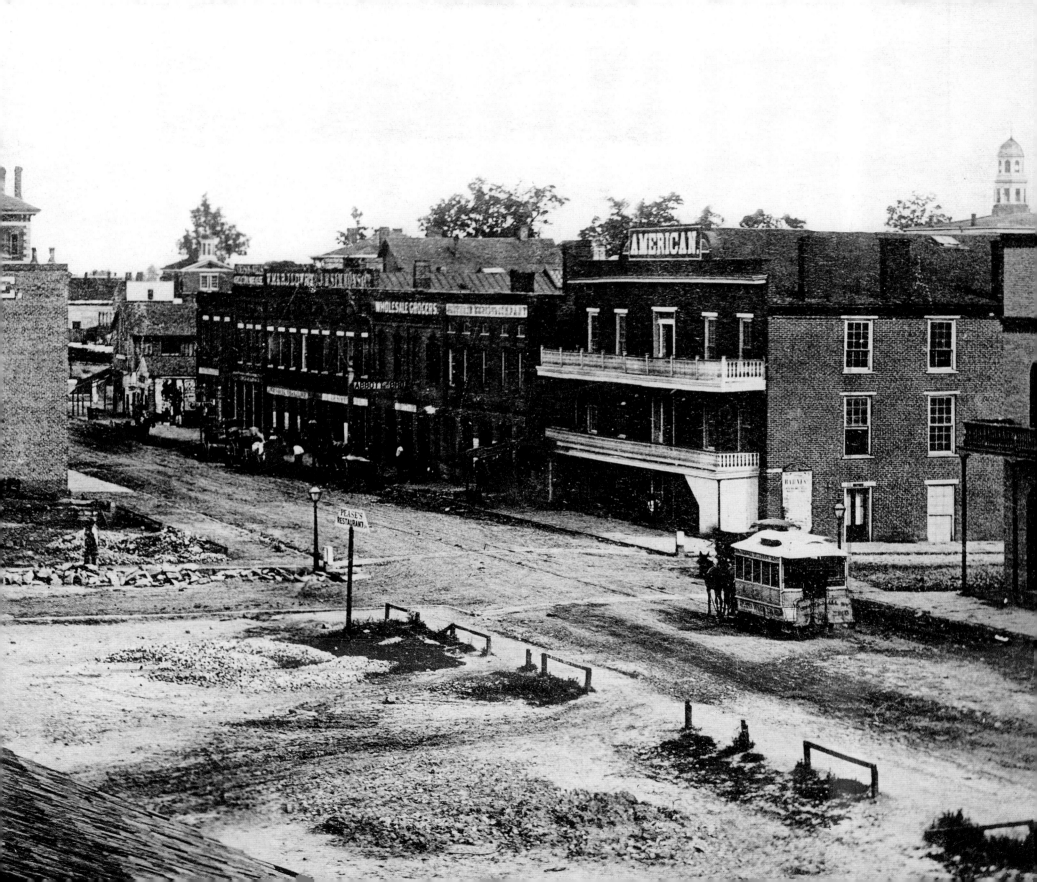

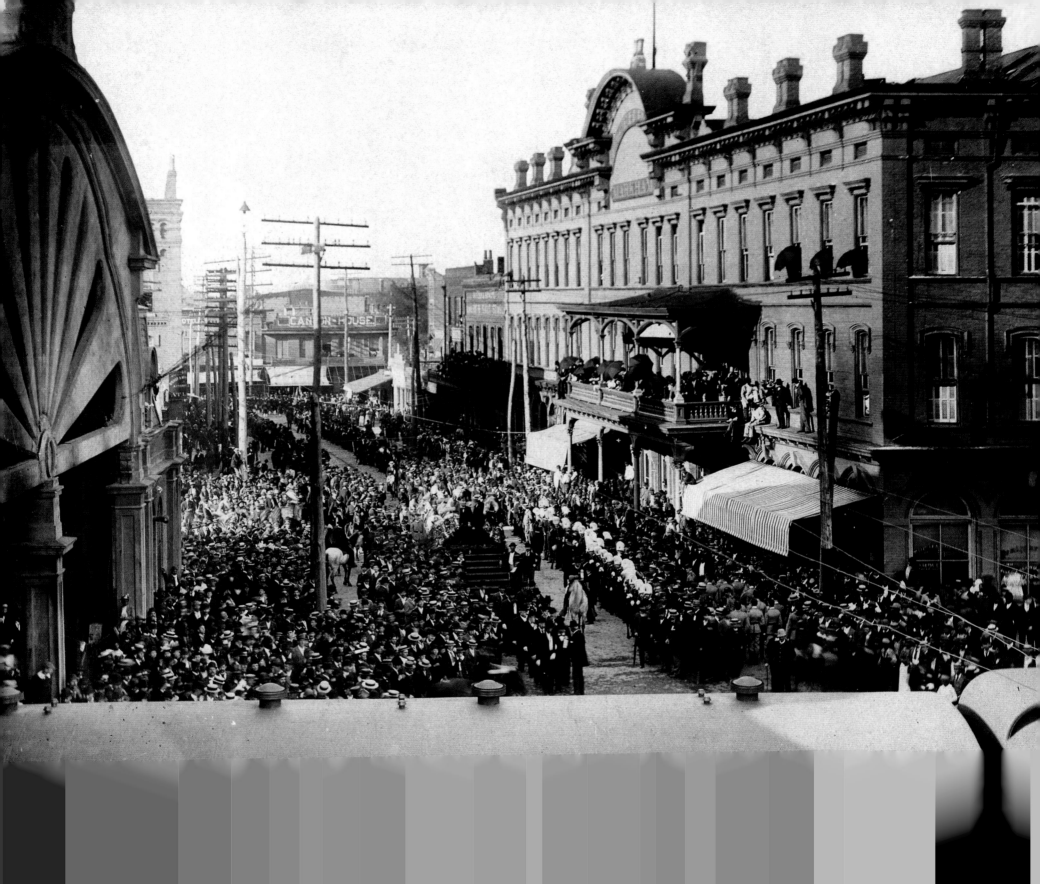

Markham House BURNED 1896

By 1875, following a decade of recovery from Sherman and the Civil War, the railroad lines were bringing substantial goods and people to town for business and pleasure—and the city outgrew its capacity for overnight visitors.

Built on the site of the town's first hotel—the 1845 eight-room Washington Hall—the Markham House dazzled visitors and locals alike. In 1870, the Kimball House Hotel had opened as the city's largest with over 300 rooms. Five years later, William Markham opened what came to be called the "Parlor Hotel of the South" two blocks from the Kimball. Situated adjoining the train depot, the massive three-story hotel took up the entire block. When the city finally numbered the streets, it was 20-26 Loyd Street.

The amenities included 107 sleeping rooms as well as a reading room furnished with the country's leading journals of the day, flower garden, hydraulic elevator, spacious arcade, and steam heat. The hotel also boasted a "Magnetic Annunciator" that indicated the room from which the service bell was rung. The hotel also had centralized water plugs allowing access to city water pipes from all halls in the hotel and ensuring safety for its guests in the event of a fire. On completion, the hotel was deemed virtually fire proof.

The hotel claimed to have the best sewage system in the city. Water was supplied by both a well (thirty-five feet deep and twelve feet in diameter) and the city waterworks. Ready to meet all the needs of its guests, the cooking range was ten and a half feet long. The hotel also contained two dark rooms to accommodate railroad men and night clerks who needed sleep in the daytime. Rates for the hotel ranged from $2 to $3 per day, depending on room location. Rooms with attached bath were charged an extra fifty cents per day.

Located at the 1871 Union Depot, the hotel was a favorite among businessmen and dignitaries who used the front balcony as a platform for speeches. President Grover Cleveland spoke at Markham House in 1887. The hotel was such a symbol of Atlanta, its advertisement graced the cover of the Atlanta City Directories for several years in the 1880s.

But on Sunday night, May 17, 1896, the Markham House was completely destroyed by a fire that started in a nearby restaurant and spread to the entire block. All hotel guests escaped the fire, yet the building was a total loss and the *Atlanta Constitution* (possibly forgetting Sherman) called the fire the most disastrous in the history of the city.

The Markham was the most expensive property lost as buildings nearby—many related to the railroads—were described as shanties by local residents. Many residents rejoiced over the destruction of those eyesores, alleging "no block was a better aim for the ravages of the flames," than Loyd Street.

African American Atlanta businessman and entrepreneur Alonzo Herndon owned and operated a barber shop inside Markham House at 20 Loyd Street. Four days after the fire, Herndon reopened his business across the street in the Gridiron Restaurant building. The Markham never reopened. The following year, in 1897, plans were made to build six stores on the block formerly occupied by Markham House.

MARKHAM HOUSE
ATLANTA, GA.

JAS. E. OWENS, - - - - Proprietor.

The above new and elegant Hotel will be opened on the 10th of December. It has been pronounced the most comfortably arranged house in the South. Every modern improvement. Nothing lacking to render entire satisfaction. I respectfully ask a call.

JAS. E. OWENS.

OPPOSITE PAGE *Hundreds of people wait outside the Union Depot and Markham House on Loyd Street for President Grover Cleveland to exit his railroad coach and give a speech from the balcony of the Markham House on October 18, 1887. The president was in Atlanta for the Piedmont Exposition, the city's second great commercial fair and the first held at what became present-day Piedmont Park.*

FAR LEFT *The Markham House hotel was three stories tall and featured a baggage room, drug store, billiard saloon, bar room, water closets, a barber shop, and a 60 x 100 foot ballroom.*

LEFT *The Markham House Hotel was conveniently located at the corner of Union Station train depot on Loyd Street. Horse-drawn buggies and wagons sit outside the depot waiting on passengers.*

Cotton States and International Exposition

DEMOLISHED 1896

In the late nineteenth century, Atlanta staged a series of expositions or agricultural and business trade fairs founded in the concept of the New South. The first was held in the city's Oglethorpe Park while the latter two were held in what is now Piedmont Park. In an effort to show the world—and Northern capitalists—how far the agrarian South had advanced since the Civil War, the city presented the International Cotton Exposition (1881), Piedmont Exposition (1887), and Cotton States and International Exposition (1895).

Freed from dependence on a slave-based plantation system, promoters maintained the Southern economy was now ready to open itself to technology, manufacturing, and diversified agriculture with the hope that business and industrialization would bring prosperity to the region.

But the New South used to describe the region—as opposed to the antebellum Old South—was not simply centered on the promise of economic growth for Atlanta and the Southern region; it was also founded in supremacy of the white race. Henry Grady, perhaps the most well-known proponent of the New South model, spoke firmly of the social and economic domination over African Americans, "because the white race is the superior race."

At the opening of the exposition, September 18, 1895, educator and orator Booker T. Washington made his historic declaration, the Atlanta Compromise as it came to be called, agreeing in essence with the spirit of the New South. Delivered to 3,000 predominantly white attendees in the exposition auditorium, he counseled African Americans to seek economic security before political or social equality—and avoid confrontation over segregation—with whites.

Even so, Atlanta's growth throughout the late nineteenth century included a significant emergent African American community. Between the close of the Civil War and the turn of the century, the city became home to several of the nation's most important black colleges and universities, including Atlanta University, Clark University, Morehouse College, Morris Brown College, and Spelman College. By 1900, Atlanta's population included 35,000 African Americans, constituting forty percent of the city's residents.

Opening in September 1895, the Cotton States and International Exposition ran through December 31, containing 6,000 exhibits and buildings for a number of states, the U.S. government, and a variety of Central and South American nations. The fair was financed primarily by the joint efforts of local businesses, the city of Atlanta, and Fulton County, which completed $150,000 worth of improvements to the Piedmont Exposition grounds. The Piedmont Park site—which was privately owned at the time—was selected by the exposition committee over the city's first choice, the Lakewood waterworks property, already owned by the city. Ultimately, event planning grew beyond all anticipation and cost nearly $3,000,000.

To publicize the Southern economy, the exposition included displays of agriculture and industry, as well as cultural attractions. Recreation included a Midway with Ferris wheel, a Wild West show, and one of the fair's most popular rides, the "Shoot the Chutes." The Midway was located on the Terrace along Bleckley Avenue (present-day Tenth Street) and included an animal arena, ostrich farm, monkey paradise, deep-sea diving, and a beauty show. The site of the Midway is now Oak Hill, overlooking Piedmont Park—the Chutes shot riders into the waters of the lake, Clara Meer.

Exhibition halls endorsing production and commodities included individual buildings for agricultural produce, manufacturing, electricity, machinery, and minerals and forestry. In addition, buildings were dedicated to displays of fine arts

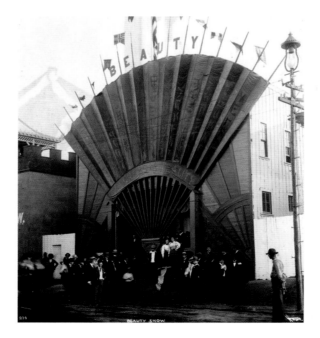

ABOVE *Public entertainment included the nation's first projected motion picture at a public screening of the Phantascope in the Trocadero Theatre, advertised as "Living Pictures." Audiences protested when the lights were dimmed and many patrons left the theater blinking and rubbing their eyes.*

OPPOSITE PAGE *Atlanta architect W. T. Downing designed the Porch Art Building. Downing began his career by working for Hannibal I. Kimball. In 1897, he published* Domestic Architecture, *which cemented his position as an arbiter of architectural taste in Atlanta.*

LEFT *In addition to industry, culture, and entertainment, exposition planners knew there was much to be learned from prior fairs and recognized the interest in provocative and titillating amusement. But the real purpose was to make money for the exposition.*

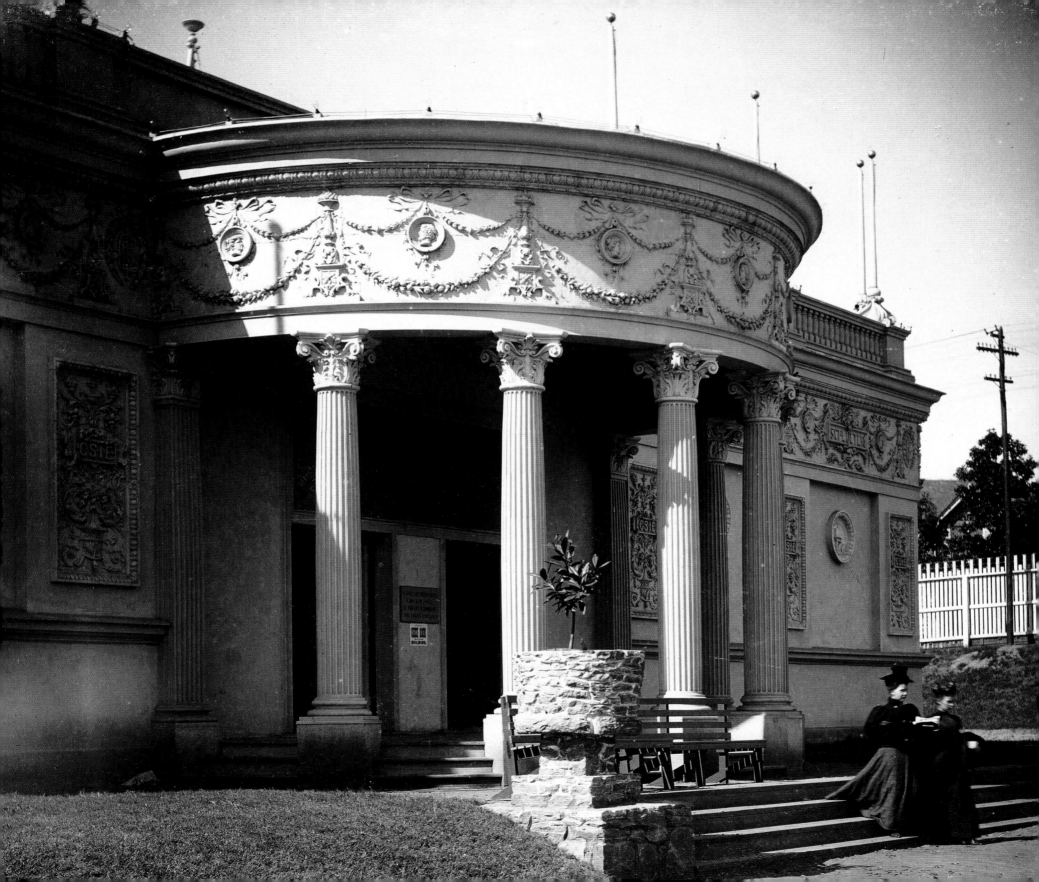

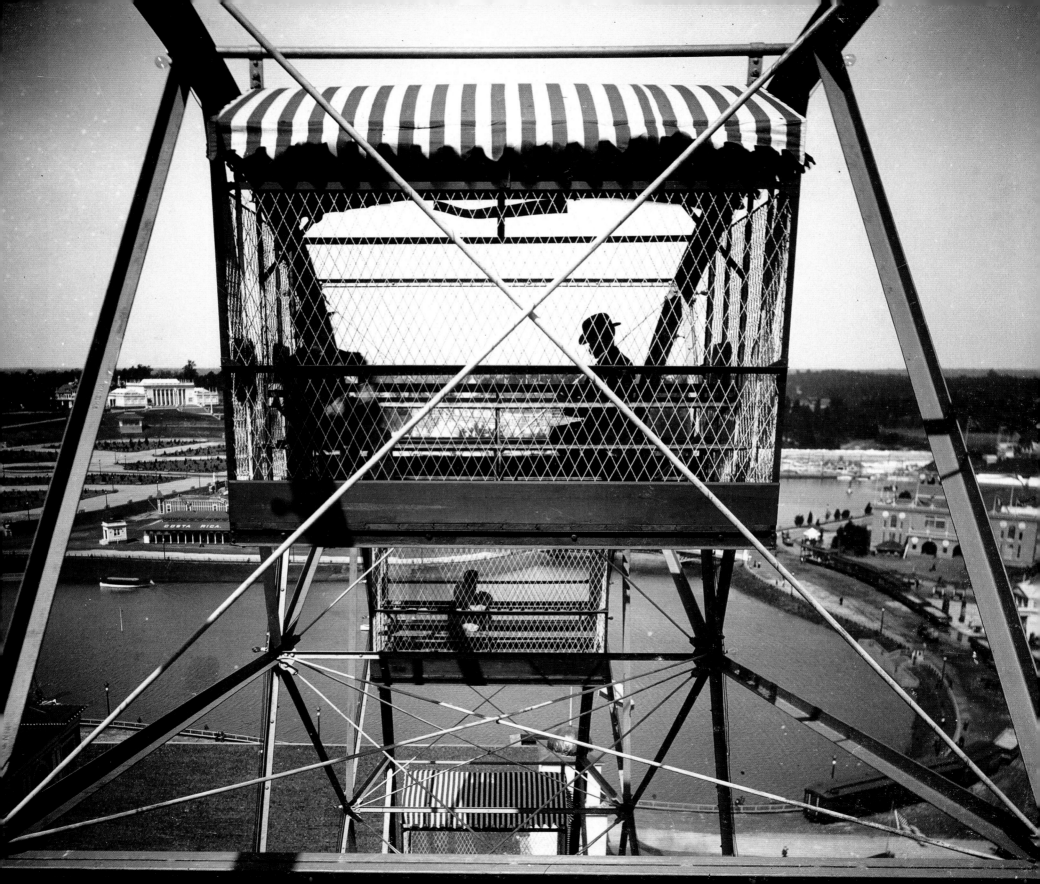

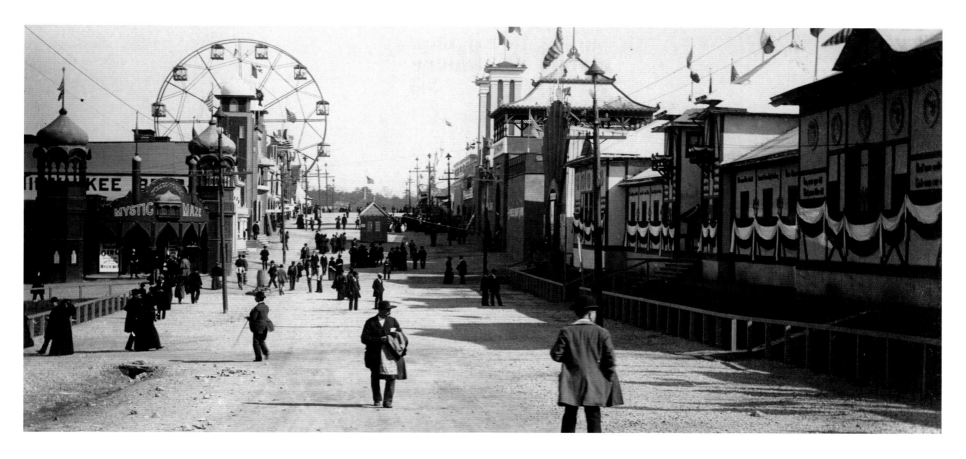

and separate buildings to present the capabilities and achievements of women and for African Americans.

In fact, a key element in the success of obtaining federal financial support for the exposition was the appearance in Washington, D.C., of three prominent African American leaders: Bishops Wesley J. Gaines of Georgia and Abraham S. Grant of Texas, and Booker T. Washington. Their support of the exposition was influential in swaying votes on the U.S. House of Representatives Committee on Appropriations, which funded $200,000 for a government exhibition.

During the course of the ninety days of the exposition nearly a million visited the grounds and buildings of the park. Primarily designed by New York-based Bradford L. Gilbert, all of the exposition buildings were constructed as temporary facilities and removed after the fair. Yet, the 1895 exposition had served an important and lasting purpose—at the close, Atlanta had established itself as the capital of the New South.

ABOVE *The Government Building and Chime Tower stood at the top of a series of steps, portions of which survive in today's Piedmont Park. The Dorothy Chapman Fuqua Conservatory of the Atlanta Botanical Garden now stands on the site.*

RIGHT *To publicize the Southern economy, the exposition included displays of agriculture, industry, and manufacturing, as well as cultural attractions. Recreation included a Midway with Ferris wheel, a Wild West show, and one of the fair's most popular rides, the "Shoot the Chutes." The Midway was located on a terrace along Bleckley Avenue (present-day Tenth Street).*

OPPOSITE PAGE *The Atlanta Exposition was by no means a small affair and its site was a natural park about three miles from the heart of the city. From a ridge that marks the southern outside boundary, the land still slopes down toward a basin in the center, which was utilized for the bed of an artificial lake—the present-day Clara Meer—seen through the Ferris wheel.*

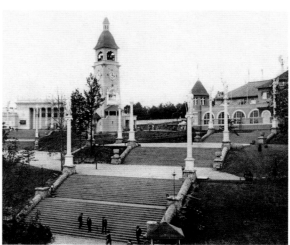

Atlanta Medical College DEMOLISHED 1906

In 1853 a group of enterprising physicians decided that the community of only a few thousand souls needed a medical college. These physicians, led by Dr. John G. Westmoreland, were successful in organizing and obtaining a charter for the college in 1854 and received permission from the city to hold lectures in the newly-constructed Atlanta City Hall. The building, which stood on the site of the present Georgia State Capitol, was considered state of the art and included weighted window sashes, a new technology of the time.

The first session, which included seventy-eight students, began in the spring of 1855 in City Hall while the college made plans to construct a building of its own on the northwest corner of Butler Street (now Jesse Hill Jr. Drive) and Jenkins Street (now Armstrong Street). Dr. Westmoreland had been successful in obtaining $15,000 in funding from the state during his term as a member of the Georgia House of Representatives in exchange for the college accepting one student tuition-free from each county in the state. The City of Atlanta and its citizens also gave money toward the building and furnishings for the building. The cornerstone was laid June 21, 1855, and the building was completed in May 1856.

By the spring of 1861, the college, which had managed to matriculate students every year since its opening, saw a much reduced number of students and difficult financial times due to an economic depression and rumors of coming war. Later that year, the college's activities were suspended for the duration of the Civil War, and the building was used as a hospital for wounded Confederate soldiers.

The building escaped destruction by General Sherman's army due to a subterfuge by one of the doctors, Dr. Noel Pierre P. D'Alvigny. When Union troops came to set the building alight, D'Alvigny claimed they would be burning wounded soldiers. The Union commander denied that any soldiers were left in the building as all patients had already been evacuated. D'Alvigny brought him inside and showed him a room full of men—the hospital's attendants in the beds acting the part of desperately ill patients. The Union commanding officer gave D'Alvigny until morning to remove the men to a safe location, but when daylight came all of the Union troops had already left Atlanta on the March to the Sea.

After the war, the college resumed its courses and in 1866 expanded its offerings to two five-month courses, a preparatory course in the summer and a regular course in the winter. The demand for medical studies in Atlanta increased and in 1878 former faculty member Dr. Thomas S. Powell organized the Southern Medical College. His new, competing institution erected a building on Butler Street next door to the old Atlanta Medical College. After twenty years of rivalry, the two institutions merged in 1898 to form the Atlanta College of Physicians and Surgeons.

The original Atlanta Medical College building continued to be used by the new institution until January 1906 when it was razed to make way for a new building for the college. The cornerstone of the original building was found to contain a time capsule that included, among other things, a bottle of alcohol, a Roman cane, and a pea whistle. The new building was ready for the first day of classes in October 1906.

In the final years of its existence, the Atlanta College of Physicians and Surgeons again took the name Atlanta Medical College when it merged with the Atlanta School of Medicine in 1912. It became a part of the Emory University School of Medicine in 1915.

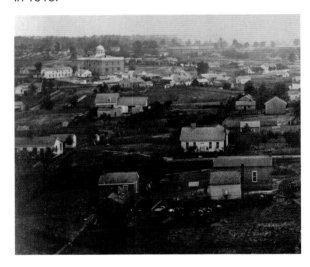

ABOVE *The dome-topped Atlanta Medical College stands at left in a portion of a panorama taken by George N. Barnard during the Union occupation of Atlanta, September to November 1864.*

OPPOSITE PAGE *The Atlanta Medical College stands on the northwest corner of Jenkins Street (now Armstrong Street) and Butler Street (now Jesse Hill Jr. Drive), ca.1900. (Photo: Atlanta Medical College, Emory University Photograph Collection, Manuscript, Archives, and Rare Book Library, Emory University.)*

LEFT *The Atlanta Medical College stands to the left of the Southern Medical College (center) in 1892.*

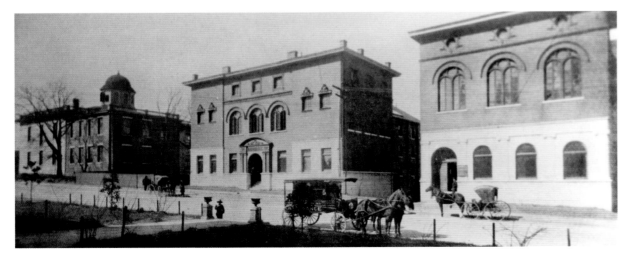

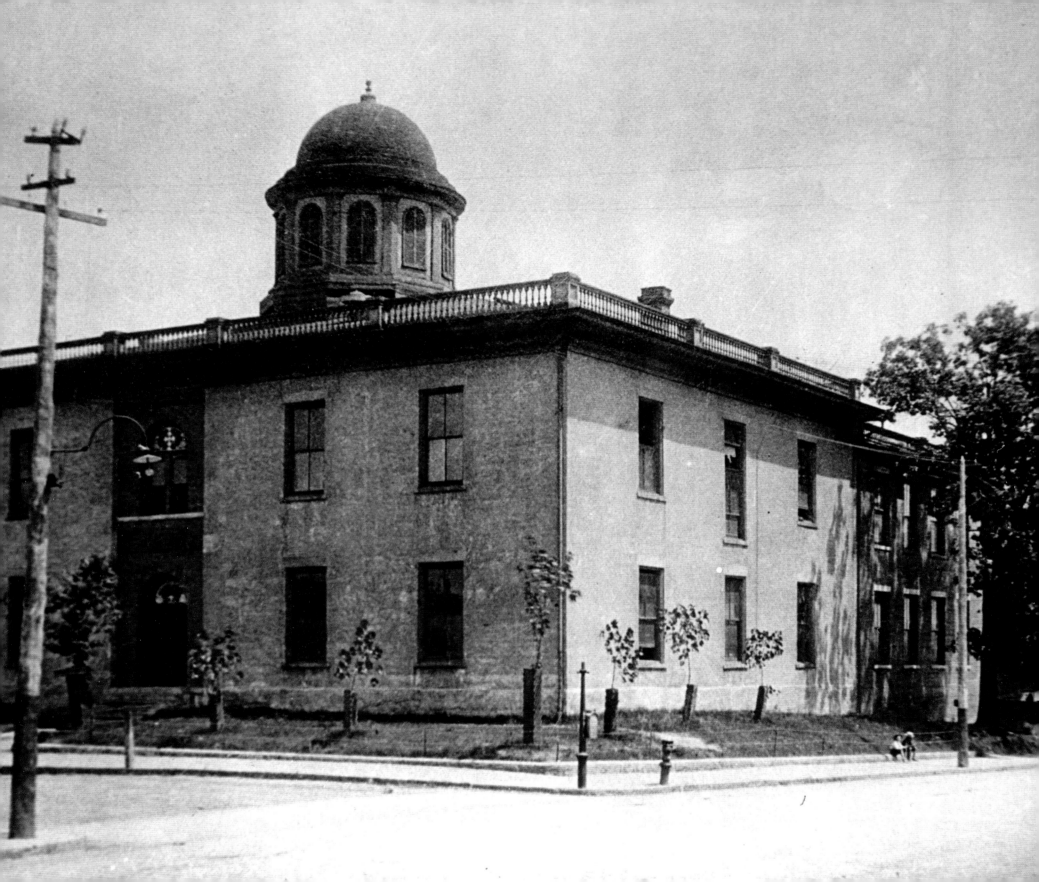

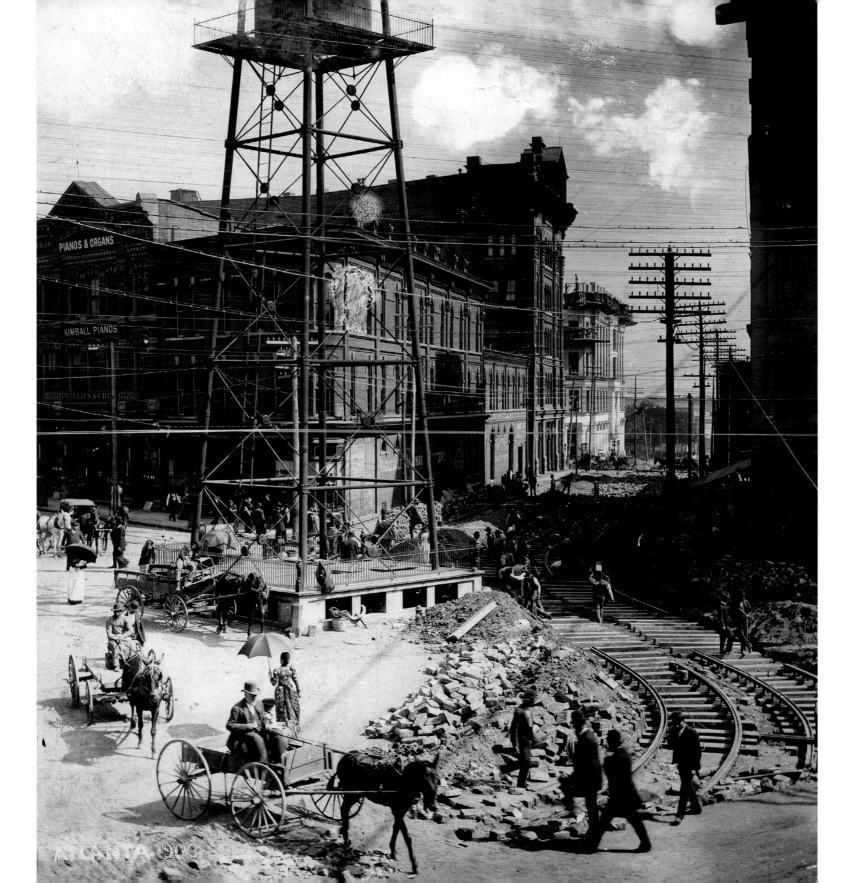

Artesian Well at Five Points

ABANDONED 1893; DEMOLISHED 1910

Unlike many American cities, the presence of water had little to do with the settlement of Atlanta. Atlanta has no harbor, riverfront or water navigation, or large water-power developments. Instead, the city was located at the intersection of several Appalachian Mountain ridges that made excellent railway routes.

Residents drank first from the springs and then from private and public-dug wells. As the city rapidly grew, the water table began to fall beneath the onslaught of so many wells. Attempts to address Atlanta's water needs began as early as 1866, but it was not until 1875 that the fear of illness coupled with the threat of fire resulted in the creation of the first water treatment plant and pumping station at South River, located near present day South Bend Park next to the former Lakewood fairgrounds.

Since the waterworks were intended to serve the agricultural and limited industrial needs of the city, most people relied chiefly on public and private wells for drinking water. The city's Committee on Wells, Pumps, and Cisterns maintained twenty-three public pumps and seven drinking fountains for fire protection and watering livestock, though many wells were badly contaminated. Atlanta's African American residents suffered most since their location within the city mirrored their social status. Generally confined to low-lying areas, such as Buttermilk Bottom, their properties and wells received the runoff from residents on higher, more expensive ground.

As if to underscore the city's need for a more reliable source of water, the 400-room Kimball House, Atlanta's finest hotel, burned to the ground in August of 1883, taking the offices of the city's waterworks with it. Fire insurance rates soared, some increasing by 100%, and one citizen complained that while the South River water was excellent for "drowning puppies, killing crabgrass, and dyeing white goods buff-brown," it was unsuitable for bathing, cooking, and drinking purposes.

To address the problem, the Atlanta City Council authorized drilling an artesian well at what later became known as Five Points, the convergence of Peachtree, Edgewood, Decatur, and Marietta Streets. Drilling began in 1884 and reached a depth of 2,044 feet. The water was conveyed along the principal downtown streets by separate mains and was used exclusively for drinking. Taps, provided with iron cups, were placed at convenient points for public use and the well was incorporated into the municipal waterworks system in 1886.

Though known as the "Artesian Well," the moniker was inaccurate since a steam-powered pump and raised tank were required to extract the 200,000 gallons of water it provided daily. A speaker's platform built around the base of the well became a gathering place for local politicians and entrepreneurs selling patent medicines.

But the success of the well was short-lived. The city chemist found the "so-called Artesian Water" was contaminated by surface drainage and in its 1888 report the Board of Health declared the well unsafe. In 1893, a second waterworks was constructed near present-day Howell Mill Road to filter the water of the Chattahoochee River. In November 1893, the City Council adopted a resolution that a connection be made between the two pipe systems and the Chattahoochee water be supplied to the drinking hydrants. It also called for abandoning the Artesian Well.

The city engineer then plugged and sealed the well. Nevertheless, since the well was abandoned only twenty-eight years after the Civil War siege of Atlanta, residents believed that should the city ever be under siege again, any water was better than none. The tank and tower were finally torn down in 1910.

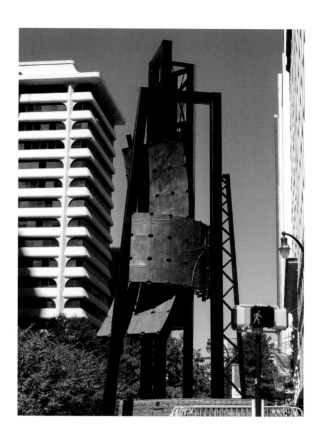

ABOVE *Evocative of the nineteenth-century artesian well, a modern sculpture now stands at Five Points near where the tower once stood. (Photograph by Jacey VerHoef).*

OPPOSITE PAGE *Streetcar lines under construction bypass the Artesian Well, ca.1890. Though long considered the center of Atlanta, the term "Five Points" did not actually appear until the 1910s.*

LEFT *Located at an important crossroads, the Artesian Well stands at what was the juncture of two important Creek Indian routes – the Peachtree Trail and the Sandtown Trail. The Peachtree Trail led from Hog Mountain in Gwinnett County to its termination at the Sandtown Trail, which led from Stone Mountain to Sandtown, a Creek village on the Chattahoochee River.*

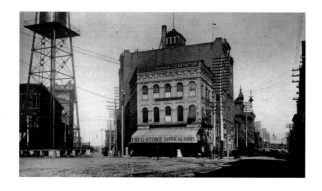

Fulton County Court House DEMOLISHED 1911

Designed to "serve forever the needs of the county" this imposing Second Empire-style building was completed in 1883 at the southeast corner of Pryor and Hunter Streets (now Martin Luther King Jr Drive). Yet, the building did not fulfill the claim made at the time of its opening; it functioned as the seat of county government for less than three decades.

In 1880, Fulton County was in dire want of a dedicated court house for its own needs. Since the county's creation in December 1853, government officials had shared their offices with those of the city of Atlanta in the red-brick Atlanta City Hall. In addition, for a six-month period in 1868 that same building also served as the first State Capitol in Atlanta until a dedicated state house was ready in January 1869.

Fulton County's new court house was one of the few buildings designed during a three-year architectural partnership of William H. Parkins and Alexander C. Bruce. Parkins, a native of New York and a Union sympathizer, had fled north from Columbia, South Carolina, at the outbreak of the Civil War. Nevertheless, he returned to the South

when he moved to Atlanta late in 1864 to establish an architectural practice in the largely-ruined city. In 1879, he joined with Bruce who hailed from Knoxville, Tennessee, and had brought with him to Atlanta a portfolio of his previous courthouse designs. An early advertisement for the firm stated: "We make a specialty of planning Court-Houses, Colleges, Churches, Opera Houses, Libraries, and all public buildings. "

By 1910, Fulton County's 1880 population of 49,000 had more than tripled and plans for a replacement courthouse were underway as early as 1907 to accommodate the county's tremendous population growth. Many citizens lamented the courthouse demolition in 1911—downtown was left without a public clock. Architect A. Ten Eyck Brown, assisted by the firm of Morgan & Dillon, drafted plans for the new, and present, court house, a neo-classical structure, completed in 1914 on the site of the old.

Court House, Atlanta, Ga.

TOP RIGHT *Leo Frank circa 1913.*
ABOVE *Horse-drawn buggies and street railways compete along Hunter Street in 1905.*
OPPOSITE PAGE *The distinctive Second Empire-style tower is among the most prominent landmarks on the skyline in 1903, and the most visible public clock in the city.*

LEFT *A later annex on Hunter Street houses the Fulton County Board of Education and the State and County Tax Collectors' offices.*

THE LEO FRANK TRIAL

Following the 1911 demolition of the Fulton County Court House, the county was without a courthouse for three years. As a result, one of the most notorious trials in the state's history was held in the Atlanta Chamber of Commerce Building. Leo Frank, the young Jewish superintendent of the National Pencil Factory was accused of murdering thirteen-year-old Mary Phagan who had gone to her workplace on April 26, 1913. Her body was found in the cellar by the factory watchman late that evening. Frank was presumed the last person to see Phagan alive, and he was arrested the following day. After a twenty-five day trial, dubious testimony , and sensationalized newspaper reporting, Frank was found guilty.

Frank unsuccessfully appealed his conviction three times to the Georgia Supreme Court. Ultimately, the United States Supreme Court heard an appeal in the case and while denied, two dissenting justices believed the trial was unfairly conducted in a rarified atmosphere driven by anti-Semitism. As Frank's attorneys turned to the Georgia governor for a commutation of the death sentence, the media sensation commenced with vigor.

Governor John M. Slaton reduced the penalty to life imprisonment. With this news, mobs stormed the Governor's Mansion. Slaton called in the National Guard to quiet the unrest. On August 17, 1915, Frank was taken from his jail cell and lynched by a group of citizens from Marietta, Georgia, Mary Phagan's hometown. In 1986, the Georgia State Board of Pardons and Paroles pardoned Leo Frank.

Herring-Leyden House DEMOLISHED 1913

A white-columned mansion almost a model image of moonlight and magnolia in the public's mind of antebellum Atlanta, the Herring-Leyden House stood on Peachtree Street between Ellis and Cain Streets (now Andrew Young International Boulevard). Designed by the city's first architect, John Boutell, it was built between 1858 and 1859 as the home of businessman William Herring. Herring and Austin Leyden were business partners in a dry goods store and as a result Leyden had met and married Herring's daughter, Rhoda Catherine Herring in 1850. The couple later lived in the house for many years.

Leyden, a native of Pennsylvania and a resident of Atlanta since 1848, established Atlanta's first iron foundry and metal fabrication company, A. Leyden & Co., and became quite wealthy. The foundry became the Atlanta Machine Works, which was instrumental in the Confederate cause making weapons and goods for the war effort.

Built in the Greek Revival style so representative of the mid-nineteenth-century Southern plantation, the house boasted twelve ionic columns, eight of which faced Peachtree Street. The interior followed a standard plan of a two-story box shape, two rooms deep, with a central hallway. The house had four rooms downstairs and four rooms upstairs. The upstairs had five windows across mirroring the four windows on the lower story and the central door. The roof held an enclosed glass observatory that overlooked the city. A brick smoke house, stables, and slave quarters for the house slaves were located behind the house.

During the Civil War, Leyden was a major in the Confederate Army and his wife and daughter fled from the city during the siege of Atlanta in the summer of 1864. The house was used as an army hospital as well as the headquarters of General John B. Hood, commander of the Confederate Army defending the city. The glass observatory was used as a lookout for Confederate troops and quickly became a target for the Union. When Atlanta fell, the house was used as the headquarters of U.S. General George H. Thomas, commander of the Army of the Cumberland.

In the early 1880s, a fire destroyed the roof and when the family rebuilt, they added a third story, a mansard roof, and a coat of green paint. Local residents hated the renovations and what they

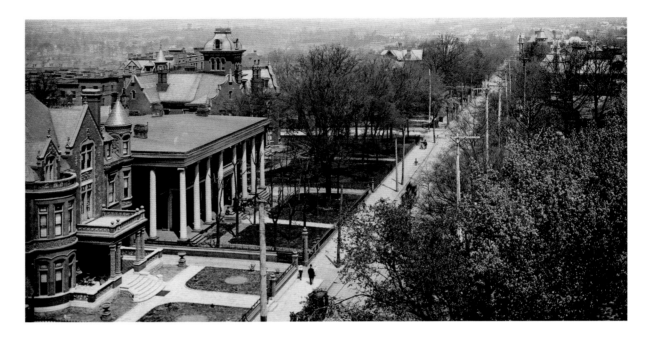

perceived as the destruction of a beautiful and historic house. A few years later, to the dismay of the family and the delight of neighbors, the house suffered another fire that took out the second and third floors. This time, the house was restored to its original height and repainted white, and a second-floor balcony was added across the front of the house.

Although the Leyden house no longer exists, it was immortalized by writer Margaret Mitchell in her blockbuster, *Gone With the Wind.* The Butler mansion was said to tower over the neighboring Leyden House, which Scarlett described as "dignified and stately." In 1893, the house was rented to Emma Bell who operated a boarding house at the residence, called the Bell House, renting exclusively to Atlanta bachelors who were commonly known as Bell House Boys. According to lore, Mrs. Bell enforced three rules: no drinking; residents wore a coat downstairs and on the veranda; and no smoking in the dining room. Mrs. Bell died in 1914, but the Bell House had moved on by then—the house was demolished in 1913 after Coca-Cola magnate Asa Candler acquired the property for commercial purposes.

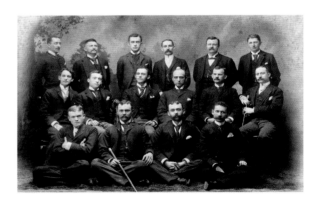

OPPOSITE PAGE *The Leyden House was occupied by Union General George H. Thomas, commander of the Army of the Cumberland during the Civil War.*

TOP *The Leyden House stands on Peachtree Street beside the Victorian mansion of Josephine Richards at left and the Governor's Mansion at right. At one time, the flat roof held a glass enclosed observatory used to look out over the city.*

ABOVE *The Bell House Boys circa 1890. The Bell House was a boarding house for Atlanta's young professional bachelors.*

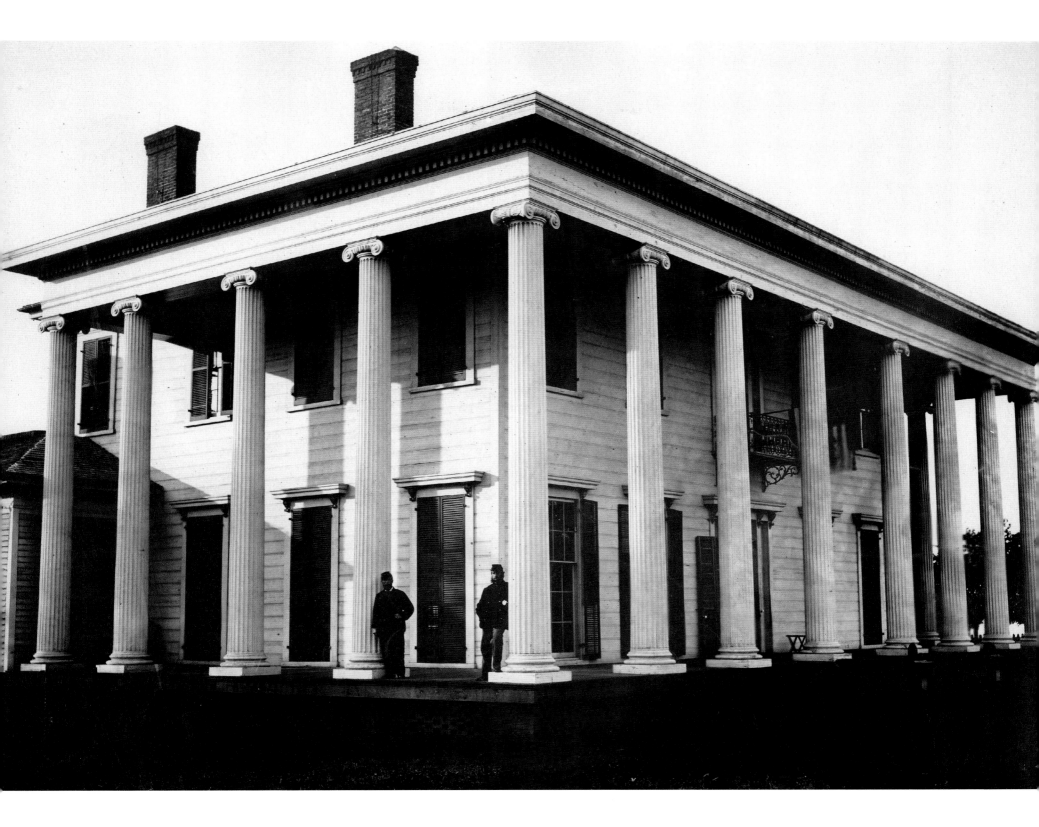

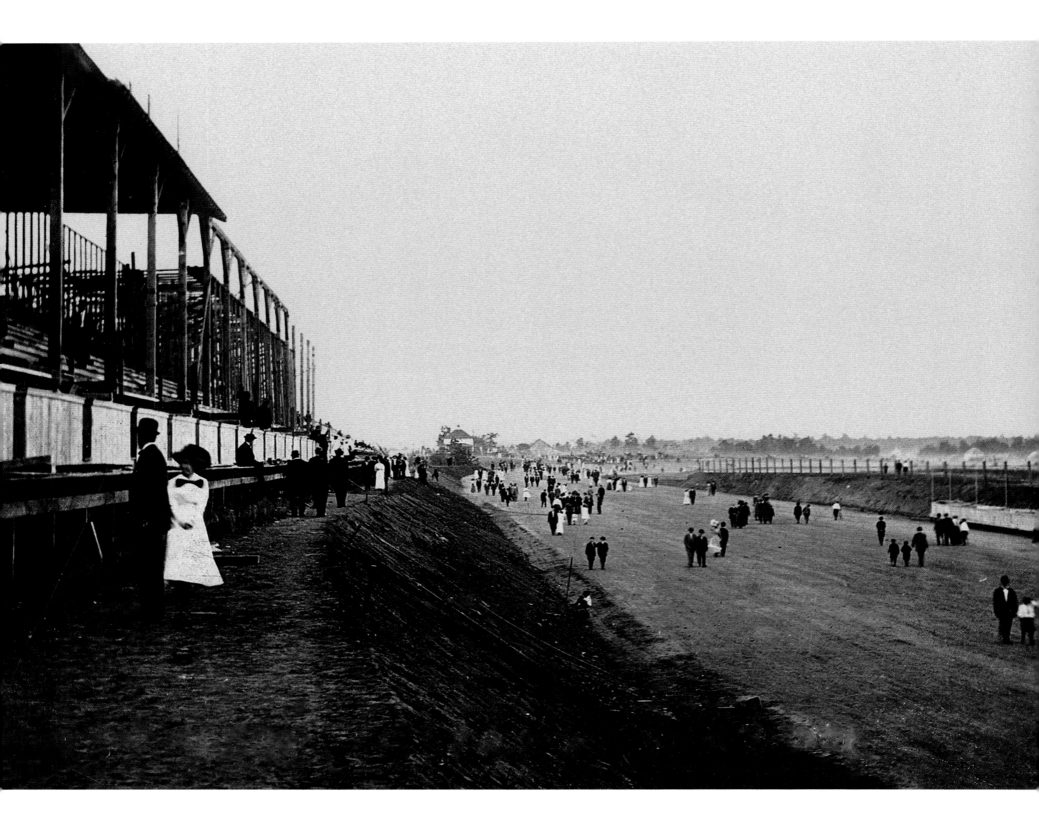

Atlanta Speedway CLOSED 1913

Asa Candler Jr., faithful son and namesake of the former Atlanta mayor and co-founder of the Coca-Cola Company had some very interesting hobbies. He hunted big game and collected mementos of his kills. He was fascinated by magic tricks and kept a room in his mansion filled with equipment used to perform them. He bought a huge $94,000 pipe organ for his music room and kept an array of animals he later gave away to the Atlanta Zoo. But one of his earliest passions was automobile racing, and so when the organization he co-founded, the Atlanta Automobile Association, needed land to build a track they called upon the elder Candler who sold them a piece of property near the city of Hapeville, adjacent to Atlanta.

It was the dawn of the mass production of autos in America and Atlantans were enthusiastic about auto racing. A track two miles in circumference and wide enough for fifty cars to safely race opened in 1909 with great fanfare. The new Atlanta Speedway was considered a prime example of what city leaders referred to as the "Atlanta Spirit"—a feisty mixture of civic pride, business opportunity, and vision that made Atlanta great. The Atlanta Automobile Association sponsored several races in

the inaugural season and attracted some of the country's best drivers, including future Indianapolis 500 champion Ralph DePalma and racing pioneer Barney Oldfield, the first person to drive sixty miles-per-hour on an oval track.

It's too bad the venture turned out a miserable failure. The bumpy, uneven track required costly repairs and the association could not attract the marquee drivers after the first year of operation, though races were held sporadically through 1913. The association eventually gave the property back to the senior Candler who closed down the track and forgave their debts. He demolished the huge grandstands and auto garages and sold the refuse for scrap that same year. Auto racing in Atlanta resurfaced in 1918 at a course at Lakewood Fairgrounds located seven miles northeast of Hapeville. This eventually became one of the premiere stock car tracks in America.

Meanwhile, the land on which the former Atlanta Speedway was built found use for another technological advance: aviation. Flight demonstrations and landings had been occurring on the property almost since the time it was converted from farmland in 1909. In May 1910,

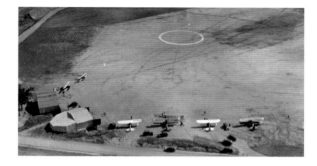

aviation pioneer Charles Keeney Hamilton performed a variety of air maneuvers to the delight of thousands who had come to the speedway for a race. The "crazy man of the air" performed again the next day.

In 1919, the United States Air Force endorsed a plan to develop Candler's property for a landing field for planes with the aspiration that it would be a suitable location for a terminal to facilitate airmail delivery. A proposal was made to name the site Asa G. Candler Field, who agreed to allow the use of his property. In 1925, William B. Hartsfield of the Atlanta City Council led negotiations with Candler to acquire the property for this purpose. The city entered into a five-year lease for the 287-acre site and ultimately purchased it from him. The first flight after the lease was an airmail plane that arrived from Jacksonville, Florida, in September 1926. In 1930, Delta Air Corporation (now Delta Air Lines) began service to Candler Field, which was later renamed Atlanta Municipal Airport in 1946. Today, Hartsfield-Jackson Atlanta International Airport is the world's busiest facility.

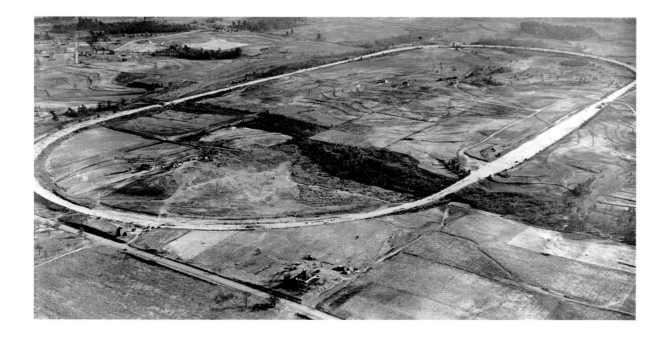

ABOVE *Several airplanes await takeoff from Candler Field. The site hosted air shows for more than a decade before the land was leased to provide airmail service from Atlanta.*

OPPOSITE PAGE *A ground view of the track and grandstands at the Atlanta Speedway reveals the width of the track. The track's promoters billed it as the "fastest automobile race track in the world."*

LEFT *An aerial view showing the track around Atlanta Speedway in Hapeville after the demolition of the grandstands and other amenities.*

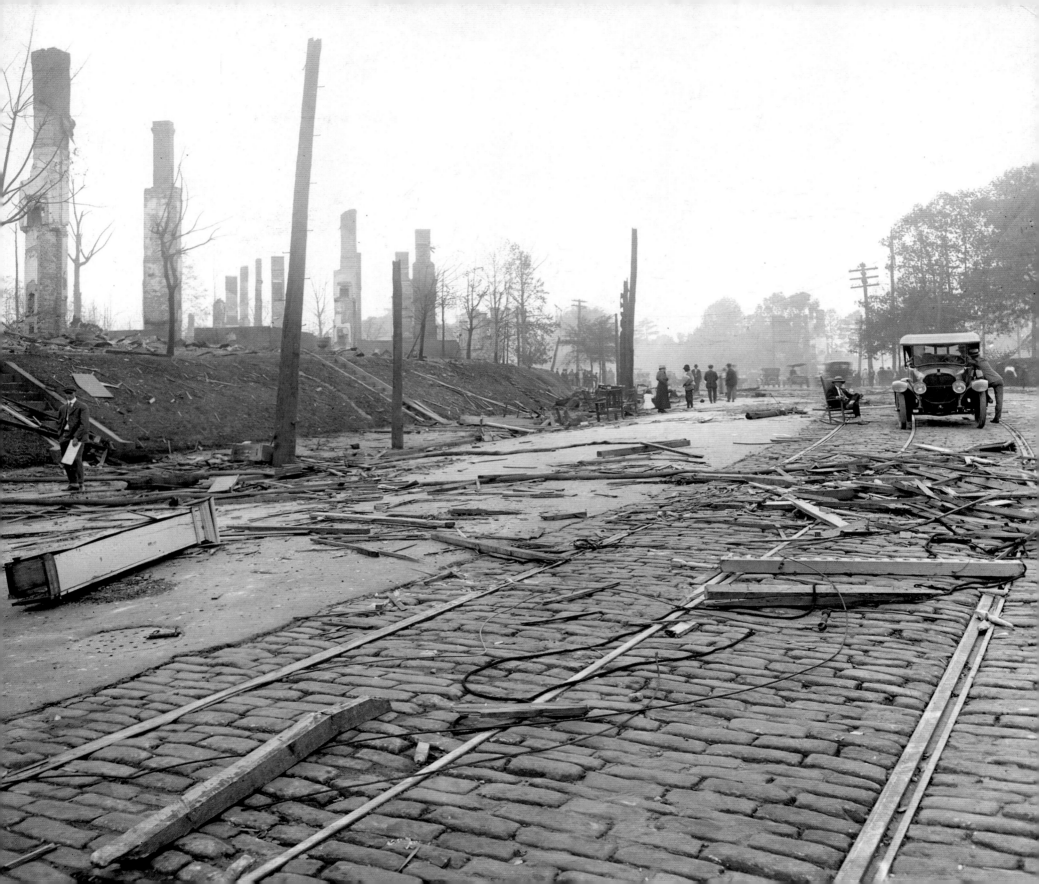

The Great Atlanta Fire 1917

The morning of May 21, 1917, dawned bright and clear as Atlanta residents awakened to their usual morning activities. Weather conditions were ideal, with breezes blowing from the south at about fourteen to seventeen miles-per-hour. No measurable rain had fallen in the city for two weeks, leaving the air—and the wood-shingled roofs throughout the city—very dry. The weather, however, was of little interest to most residents, who were more concerned with the U.S. entry into World War I a few weeks prior. In just under twelve hours, a rash of fires left a significant section of Atlanta in ashes.

The first fire, broke out at a residence on Grant Street at 9:23 a.m. and was quickly brought under control. Two hours later, sparks from a steam shovel ignited a second fire at a warehouse where hundreds of bales of cotton were stored. A third fire flared up minutes later when two boys set alight trash behind a home one mile west of the warehouse fire.

By the time the closest fire equipment reached the scene, three homes were engulfed in flames. Less than thirty minutes later, a fourth fire flared up at a residence two miles to the east. While firefighters attempted to extinguish that rapidly spreading blaze, trolley wires fell into the street, setting fire hoses ablaze. Just over one-half-hour later, the fifth and largest fire began north of Decatur Street when wind-driven sparks ignited mattresses stored on the porch of a Grady Hospital building.

Fire alarm operators were inundated. With fires burning simultaneously across the city, new alarms were ignored by operators who assumed they had been pulled for existing fires. Officials used dynamite to destroy homes in an unsuccessful effort to stop the spread of the fire. With the help of fire departments from throughout Georgia as well as South Carolina, Florida, Kentucky, and Tennessee, the fire was contained at 10:00 p.m. though debris smoldered for a week.

Over 300 acres and 1,938 buildings were consumed, including 1,537 residences and apartments. More than 10,000 people, mostly African American, were left homeless. Property loss totaled $5,500,000 with only about half of the damage covered by insurance. Miraculously, only a few injuries and one death were reported, that of a woman who suffered a heart attack when she learned her home was destroyed.

The fire made it clear that horse-drawn engines could no longer protect the city from a fire of this magnitude. Many animals, forced to run from one location to another, arrived on the scene with bleeding hooves and were removed from service while the department hostler frantically searched for replacements. In May 1918, one day after the first anniversary of the fire, the Atlanta Fire Department was fully motorized at a cost of approximately $130,000.

The fire also brought the city's telephone system into close scrutiny. The city had no trunk lines reserved for the fire department; as a result, calls for help went unanswered; in fact, many operators refused to break into a busy line to make the necessary connections. Finally, an ordinance outlawing wood shingle roofs was passed in June 1917. The wood shingles posed a well-known fire hazard and eighty percent of the homes and buildings destroyed in the fire had wood roofs.

OPPOSITE PAGE *Military troops and residents survey the damage to this neighborhood, probably along Edgewood Avenue. Note the fallen streetcar wires.*

LEFT *A forest of gaunt chimneys is all that remains of Atlanta's Fourth Ward. Downtown Atlanta, including the dome of the Georgia State Capitol, rises in the distance.*

BELOW *Residents rush belongings into the street in an effort to save them from their homes that are in the clear path of the fire, which in the words of one eyewitness, traveled faster than a man could walk.*

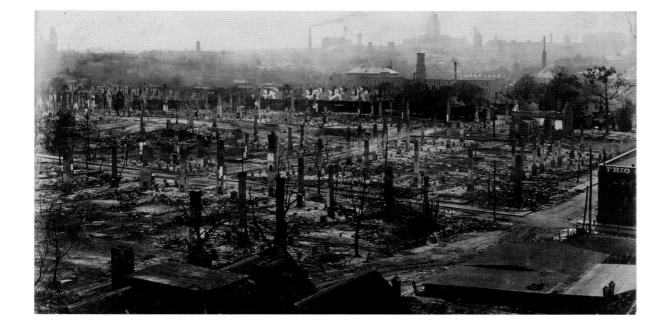

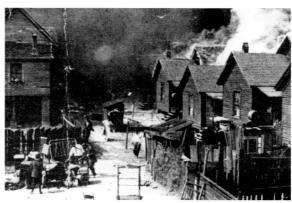

Governors' Mansions

DEMOLISHED 1923 AND 1969

Peachtree Street

In 1868, Atlanta businessman Richard Peters presented a resolution to the Georgia legislature enticing them to move the capital of Georgia from Milledgeville to Atlanta. In addition to furnishing a site for the state capitol, the proposal provided a residence for the governor.

The James House at the corner of Peachtree Street and Cain Street (current Andrew Young International Boulevard) was later purchased by the state to serve as the first official governor's mansion in Atlanta in 1870. Built by prominent Atlanta banker John H. James, the house was considered a palace by contemporaries. James had purchased the lot for $10,000 and hired architect W. H. Parkins to build the Victorian mansion for $53,000 in 1869.

The residence had a sixty-foot-tall tower in the front center, complemented with turrets, gables, and bay windows. The Italianate, Romanesque, and Gothic red brick house served as the residence for seventeen governors and became symbolic of post-bellum progress in Atlanta. Dignitaries and Atlanta social clubs entertained in the house, and President Grover Cleveland visited in 1895. Former Confederate States Vice-President Alexander

Stephens died in the house in March 1883, four months after taking office as governor.

In 1916, Governor Hugh Dorsey became the last to live in the house. He and his wife chose to move from the increasingly dilapidated residence into their own home in 1921 and left the house vacant. After the state agreed to build a new governor's mansion, the house was demolished in 1923 and replaced by the Henry Grady Hotel. The Westin Peachtree Plaza now occupies the site.

Ansley Park

The six-acre estate of businessman Edwin Ansley located at 250 The Prado in the Ansley Park neighborhood was leased and later purchased in 1924 for use as the Governor's Mansion. Ansley Park was determined to be the best site for the new mansion and deemed the "most excellent park in the City of Atlanta." Ansley Park was not too far from the city center and close to the Piedmont Avenue, Peachtree Street, and West Peachtree Street car lines. A report to the general assembly stated the site was also favorable because the house site was one of the highest in the city at 1,200 feet above sea level.

The Ansley mansion, designed by prominent Atlanta architect A. Ten Eyck Brown, was one of the finest in the city, containing seven bedrooms, five bathrooms, reception rooms, and wide verandas capable of entertaining 300 to 400 guests. Built

between 1908 and 1910, the house was constructed of granite from Georgia's Stone Mountain, and in the fall of 1924 Governor Clifford Walker was the first of eleven governors to move into the residence.

Due to its location, the house had one of the best views in the city. From second story windows, visitors could see both Kennesaw Mountain, over twenty miles to the north, and Stone Mountain, nearly thirty miles to the east. Not everyone, however, liked the new Governor's Mansion. It was described by a few of the Georgia legislators as "gray, austere, and medieval." It was so dark inside, lights burned in many rooms in the middle of the day.

Nevertheless, governors who resided in the Ansley Park house made it their home. Ellis Arnall had small children in the house, so he installed playground equipment and a child's rollercoaster that rolled downhill. Governor Eugene Talmadge grazed goats on the lawn, while his son, later Governor Herman Talmadge, preferred cows, which he milked on the outdoor terrace. As with the mansion on Peachtree Street, after nearly fifty years the residence was plagued with persistent maintenance problems and was demolished in 1969. Lester Maddox was the last governor to occupy the house and the first governor to reside in the present Governor's Mansion on West Paces Ferry Road.

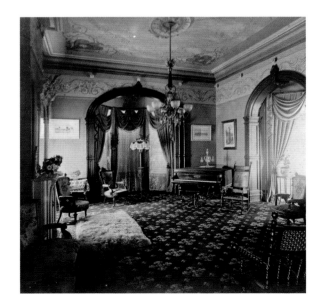

OPPOSITE PAGE *The 1869 James House was purchased by the city to serve as Atlanta's first governor's residence after relocating the capitol of Georgia to Atlanta from Milledgeville.*

LEFT *The parlor of the Governor's mansion on Peachtree was known as the "Red Room." The house was redecorated in 1894 under the direction of Georgia First Lady Annie B. Northen.*

RIGHT *In 1924, Governor Clifford Walker became the first governor to reside in the mansion in Ansley Park. The site was considered the most amenable place for the new Governor's Mansion due to the social prominence of the park and the elevation of the stately home, which sat on one of the highest points in Atlanta.*

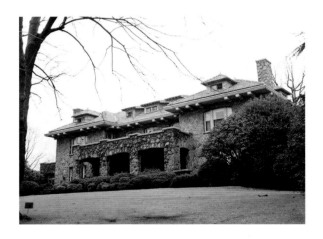

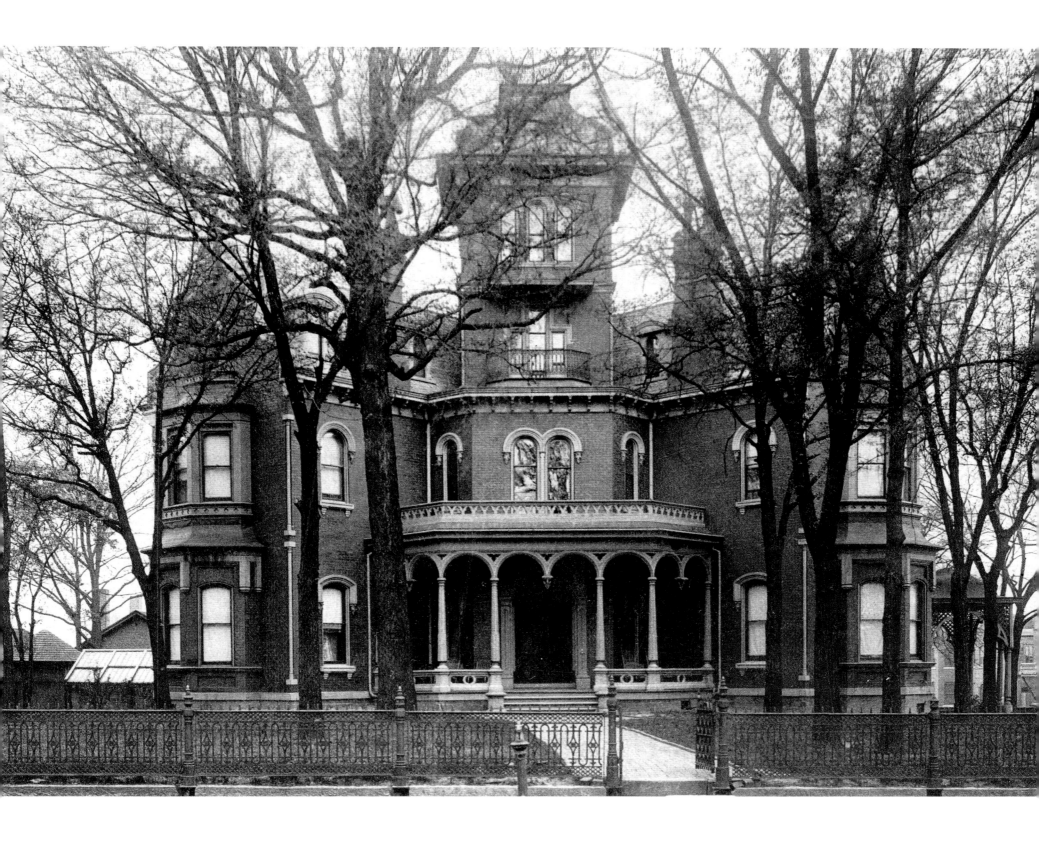

Ponce de Leon Springs DIVERTED 1924

Long before the advent of modern amusement parks featuring adrenaline-releasing thrill rides, Atlanta residents enjoyed life's simpler pleasures embodied in Ponce de Leon Springs. Located two miles from downtown Atlanta and situated along the Atlanta & Richmond Air-Line Railway (later Southern Railway), Ponce de Leon Springs was the city's most popular location to appreciate nature's delights during the late 1800s and early 1900s.

The woodsy retreat received its name from two natural springs that ran side by side in a shallow basin. In 1870, Atlanta physician Dr. Henry Wilson began drinking the water and credited it with restoring his health. He advised people about the springs and others began making the trip outside the city in search of them. Wilson suggested the springs be named after Juan Ponce de Leon to draw a parallel with the Fountain of Youth the Spanish voyager allegedly sought during his sixteenth-century explorations of the Americas.

Soon, a roadway was developed to allow vehicles to reach the springs and the area slowly grew in popularity. By 1872, carriage operators were bringing well-heeled passengers from posh locales in downtown Atlanta to picnic and sample the cool spring water and fresh country air. Visitors carried the spring water away in jugs and bottles, and daily wagon deliveries brought water from the springs to dozens of homes in Atlanta.

In 1874, the Atlanta Street Railway brought visitors from Peachtree Street to sample the site's growing number of attractions, including a dance hall, bath house, and fruit and ice cream vendors. By the 1880s the site was known as Ponce de Leon Park. An artificial lake was added across the street from the springs in 1890 to allow for boating and bathing; the lake was later drained to build a baseball field that was also part of Ponce de Leon Park and retained that name after the demise of the amusement park.

Nearly fifty acres surrounding the streams were purchased in 1903 by what came to be known as the Ponce de Leon Amusement Company. Subsequently, in the early 1900s, the company developed a full-fledged amusement park featuring a theater showing motion pictures and vaudeville acts, a fifty-foot-high circle swing, toboggan slides, a merry-go-round, and a dance hall and pavilion featuring outdoor concerts. German opera singer Ernestine Schumann-Heink once performed in a huge skating rink on the grounds and Georgia populist Thomas E. Watson delivered his speech accepting the candidacy for president of the United States in the same building in 1908.

The grounds of Ponce de Leon Springs slowly waned in popularity in the 1910s as the area surrounding it was commercially developed. The Ford Motor Company built its headquarters for southeastern operations next to the springs in 1914 and in 1924 Sears, Roebuck & Company purchased the land containing the springs to build a $3 million mail-order plant and retail store.

The springs that had flowed naturally for so long were capped and diverted into a sewer under the east wing of the building built along Ponce de Leon Avenue.

In 1990, Sears sold its two-million-square-foot building to the City of Atlanta, which then resold it to investors in 2011 to use the original building as a mixed-development complex known as Ponce City Market. The long-abandoned Southern Railway line running adjacent to the area has been converted to a component of the Atlanta Beltline, a multi-use trail connecting the surrounding neighborhoods with newly developed parks.

OPPOSITE PAGE *The artificial lake created along Ponce de Leon Avenue in 1890. The lake was drained to construct Ponce de Leon Park baseball field that stood until 1966.*

BELOW *Looking north with Ponce de Leon Avenue in the background, the Casino entertainment house in Ponce de Leon Park that featured burlesque comedies and vaudeville acts throughout in the first part of the twentieth century.*

BOTTOM *The revolving air ship, one of the attractions at Ponce de Leon Park amusement park at Ponce de Leon Springs.*

LEFT *The rocky stream bed along one of the two natural springs that originated in the Ponce de Leon Springs.*

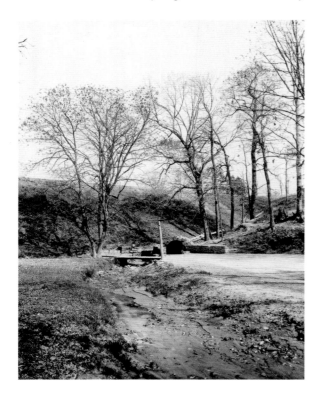

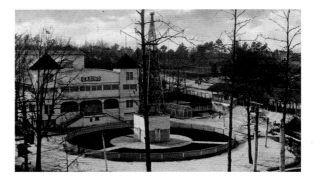

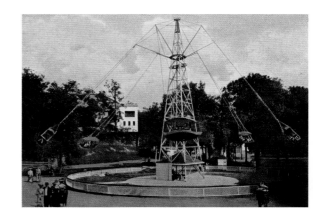

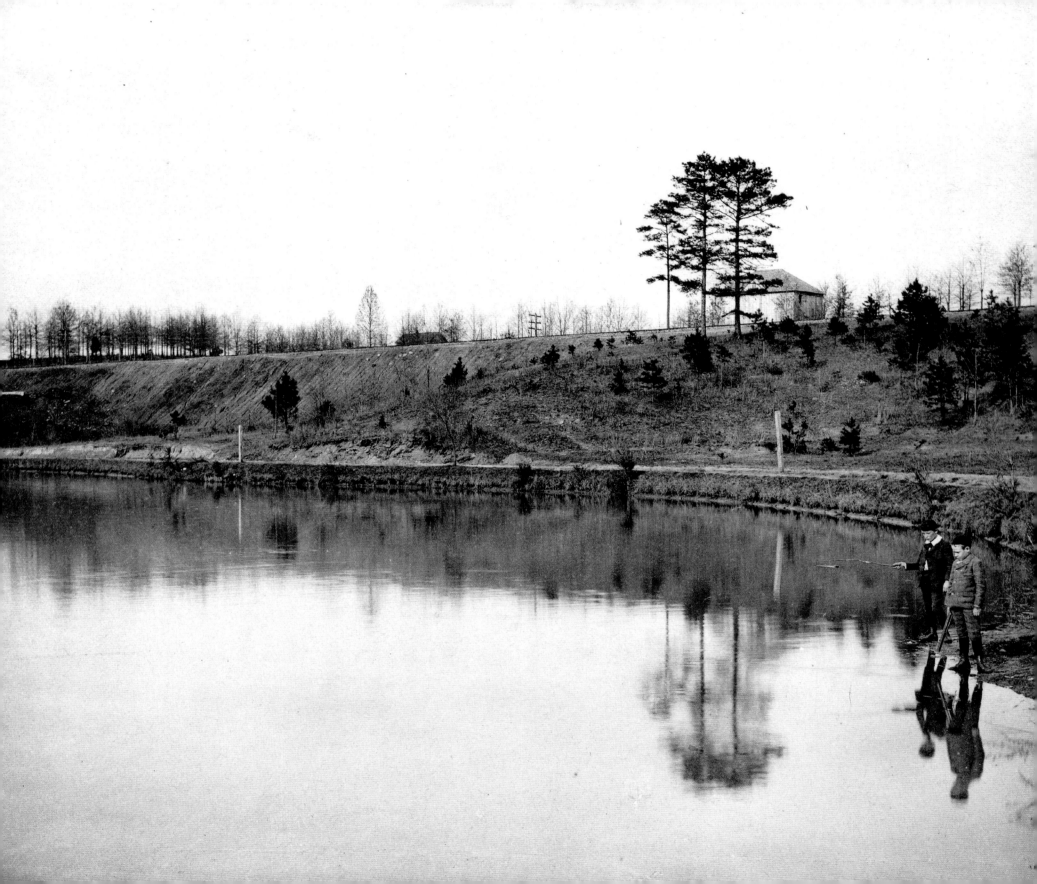

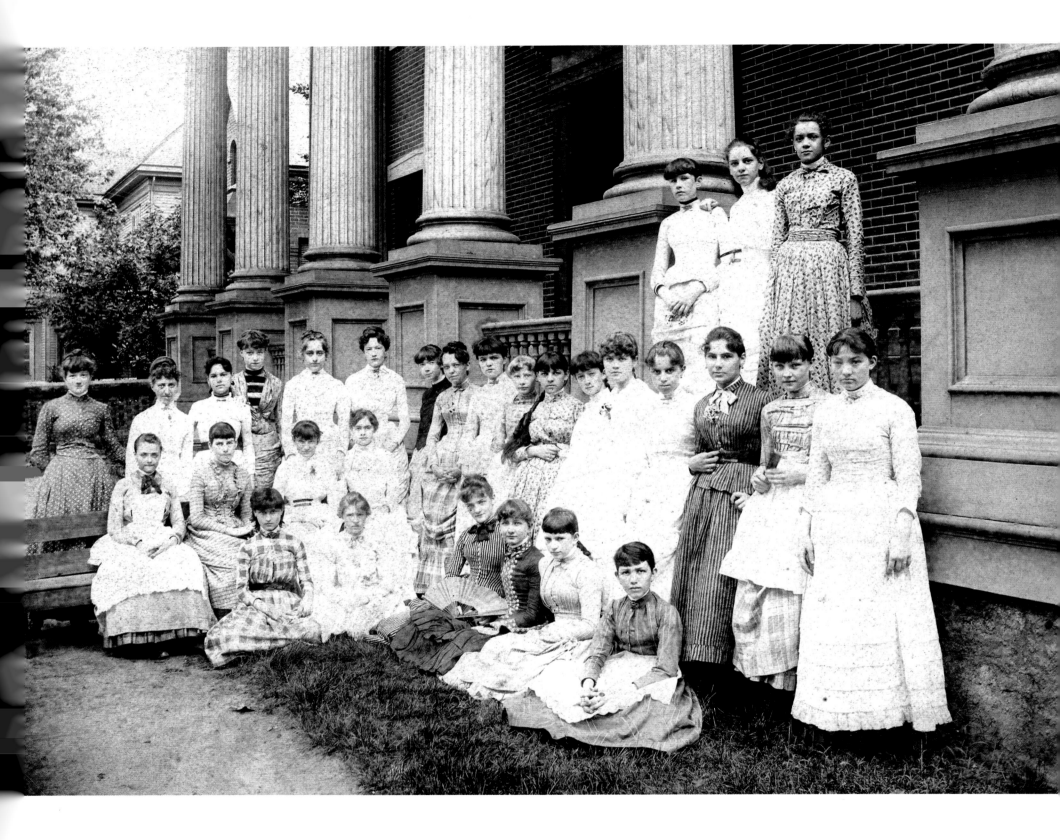

Neal-Lyon House 1928

John Neal, born in 1796 in Warren County, Georgia, first moved to Atlanta in 1858. He had made a career as a prosperous planter and merchant in Zebulon, Pike County, Georgia and was the business partner of Atlanta pioneer Samuel Mitchell. Neal selected a lot on the southwest corner of Washington Street and Mitchell Street to build one of the finest homes in the young city. The two-and-a-half story house, built at a cost of $25,000, was topped by a stained-glass cupola and presented a row of "handsome" Corinthian columns to Washington Street.

When the Civil War broke out in 1861, Neal and his family stayed in their residence, but returned to Zebulon in 1864 when General William T. Sherman's forces started their push toward Atlanta. Neal agreed to sell his house to Judge Richard F. Lyon, who was an associate justice of the Georgia Supreme Court, for $12,500—half of the original construction cost. At the time of his departure, Neal convinced Professor J.R. Mayson, principal of the Atlanta Female Institute, to move the college from its location at the intersection of Ellis and Collins (now Courtland) Streets into the house, believing that its use as an educational institution would make it less likely to be destroyed.

When Union troops occupied the city in September 1864, the female college disbanded and Mayson left the property. Subsequently, General Sherman selected Neal's home for his headquarters during the Union occupation,

September 2-November 15. By all accounts, Sherman left the property in "excellent condition," not even damaging the furniture the Neal family had left behind.

After the conclusion of the war, Judge Lyon was unable financially to honor his promise to buy the home and John Neal eventually regained possession. Nevertheless, the property was never again a family residence. Shortly after the war, the house served as a hotel and in 1870 it again became an educational institution when Oglethorpe College took up residence. Although the college, by then known as Oglethorpe University, purchased the house for $20,000 in 1872, financial difficulties ultimately forced it to close its doors in 1873.

Following the closure of Oglethorpe, the house became Girls' High School and served in that capacity until 1926. During that time, the building was remodeled several times and expanded, losing its Corinthian columns along the way. After Girls' High moved, the Neal-Lyon house remained standing until 1928. It was demolished to make room for Atlanta's current City Hall, completed in 1930.

GIRLS' HIGH SCHOOL

Girls' High School was organized in 1872 as one of the original seven schools of the Atlanta Public School System. The school was housed in four rooms on the second floor of the DeSaul Building at the corner of Whitehall and Hunter Streets. These accommodations proved insufficiently large and the school moved in 1873 to the Neal-Lyon House. Initially, they shared the house with Boys' High—the boys were educated in the basement. Later, the boys were moved to another building on the property and separated from the girls by a high wooden fence.

By 1888, the Neal-Lyon House had grown too small and the building was expanded by adding a three-story, red-brick building, known as the Mitchell Street Building, to the back of the original house. The school continued to grow, and by the 1920s was again too large for the building. The school moved into a new building on Rosalia Street near Grant Park in 1926. It remained a girls-only high school until 1947 when it became co-educational and was renamed Roosevelt High School.

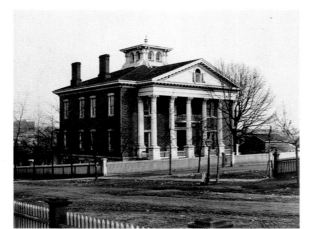

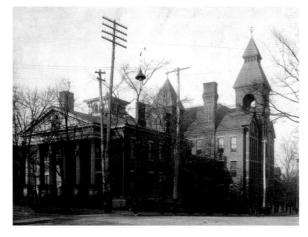

OPPOSITE PAGE *The 1884 graduating class of Girls' High School in front of the Corinthian columns of the Neal-Lyon House. The school's faculty stands at the left rear of the group.*

FAR LEFT *The Neal-Lyon House stands on the southwest corner of Washington and Mitchell Streets in the autumn of 1864. The house's location on a high point of the city's terrain suited the political and social prominence of the Neal family – and of General William T. Sherman.*

LEFT *The Mitchell Street building addition of Girls' High School rises behind the Neal-Lyon House, circa 1900.*

U.S. Post Office and Customs House

DEMOLISHED 1930

In 1874, the mayor and city council of Atlanta bought a lot at the northwest corner of Marietta and Forsyth Streets for $50,000 with the purpose of securing a U.S. Post Office and Customs House in Atlanta. The lot was deeded to the United States government at no cost and the federal government erected a large brick and stone building on the site.

Architect William Appleton Potter was commissioned to design the post office in 1878. Potter was supervising architect of the U.S. Treasury and oversaw architectural designs for many government buildings, including customhouses, courthouses, and post offices. His style of choice for government buildings was High Victorian Gothic and the U.S. Post Office and Customs House was Atlanta's earliest example of the style.

High Victorian Gothic architecture was an urban building type used mainly for public buildings and sometimes used for residential mansions. The style was executed in brick, stone, or terracotta and incorporated multi-colored bands of decorative masonry. Windows and doors were often accented in contrasting colors and arches could be rounded or pointed Gothic style. The Customs House, which occupied the block bounded by Fairlie, Marietta, and Forsyth Streets, was completed in 1878 under the supervision of Atlanta real estate developer Thomas G. Healey. The building functioned as the city's post office until 1911.

All federal employees, including the Internal Revenue Service, Weather Bureau, U.S. Marshall Service, Secret Service, postal inspectors, federal courts, judge's chambers, and all supporting personnel were located in the federal building. In 1897, after the retirement of the building custodian, Internal Revenue Collector Henry Rucker was appointed Custodian of the U.S. Post Office and Customs House. The custodian of federal buildings was always a current federal employee and received no extra pay for the job.

In 1888, plans were made to enlarge the Customs House by adding a story and converting the attic to office space with a passenger elevator. The Atlanta architectural firm of Bruce & Morgan was appointed to superintend the work. In 1898, the stairs began to sink and had to be reinforced and the elevator needed replacement. By 1903, the federal government had outgrown the building. Atlanta mail had grown exponentially in twenty-five years and the volume was so high that mail was stacked to the ceilings and in sacks on the floor.

In 1910, the building was purchased from the federal government for $70,000 by Atlanta Mayor Robert F. Maddox. It served as Atlanta City Hall until 1930 when it was deemed insufficient to meet the needs of the city government. Deterioration, cost to renovate, and poor layout made it undesirable as a civic building and it was subsequently demolished.

In 1930, as the building was demolished, a new city hall was built at 68 Mitchell Street on the site of the Neal-Lyon House that had been used by General William T. Sherman as his headquarters during the occupation of Atlanta prior to the March to the Sea.

OPPOSITE PAGE *A statue of Henry Grady was erected in 1891 at the corner of Marietta and Forsyth Streets in front of the Customs House. Though the building is gone, the monument remains.*

BELOW FAR LEFT *In 1910, the Customs House was personally purchased from the federal government for $70,000 by Atlanta Mayor Robert F. Maddox to be used as the new Atlanta City Hall. He was later reimbursed by the city, which used the building until 1930.*

BELOW LEFT *Facing Marietta Street, the Customs House exterior was so solid, one demolition company went bankrupt during the razing and it took five months to dismantle the massive building in 1930.*

BELOW *Henry A. Rucker was born a slave in 1852, Georgia. After the Civil War he was appointed as a clerk in the internal revenue collector's Atlanta office by President Grover Cleveland. He was later appointed Collector of Internal Revenue by President William McKinley in 1896. He was the only African American to receive such an appointment. He was also named Custodian of the Atlanta federal building. He maintained his office on the second floor of the Customs House.*

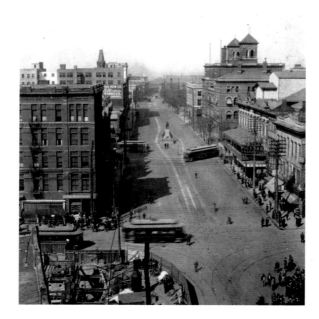

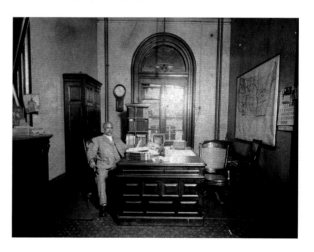

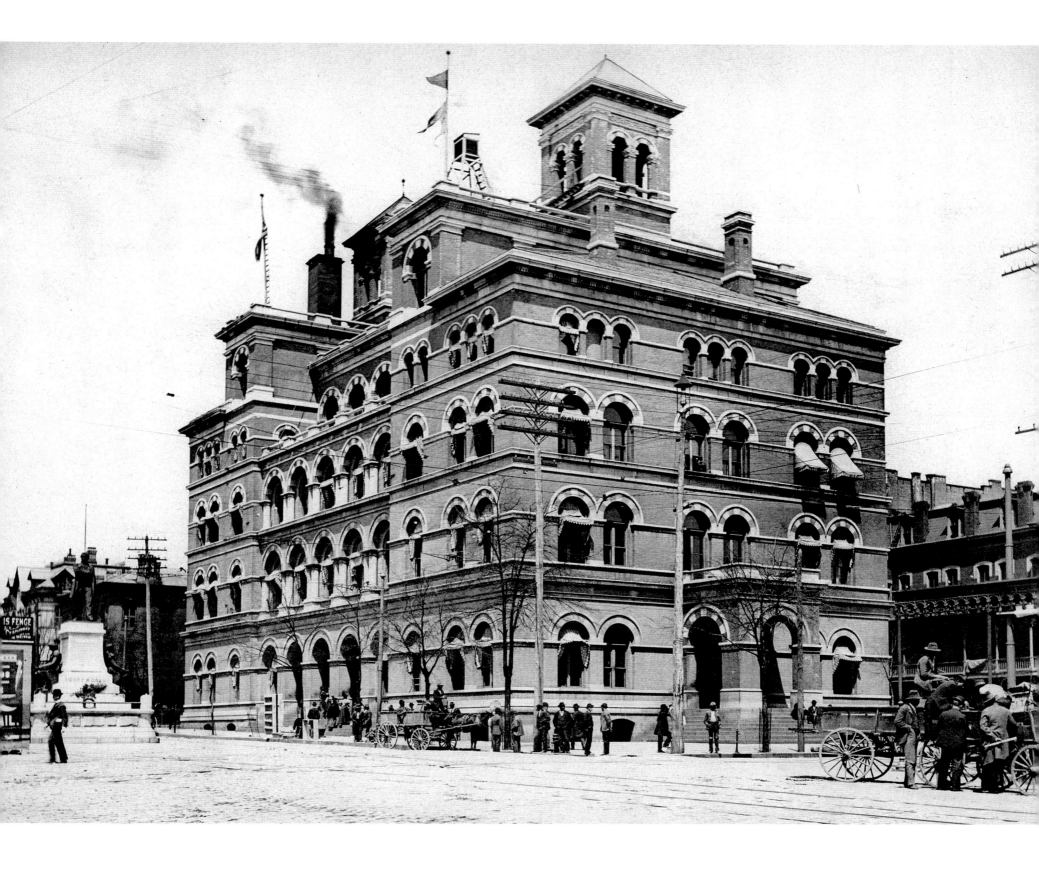

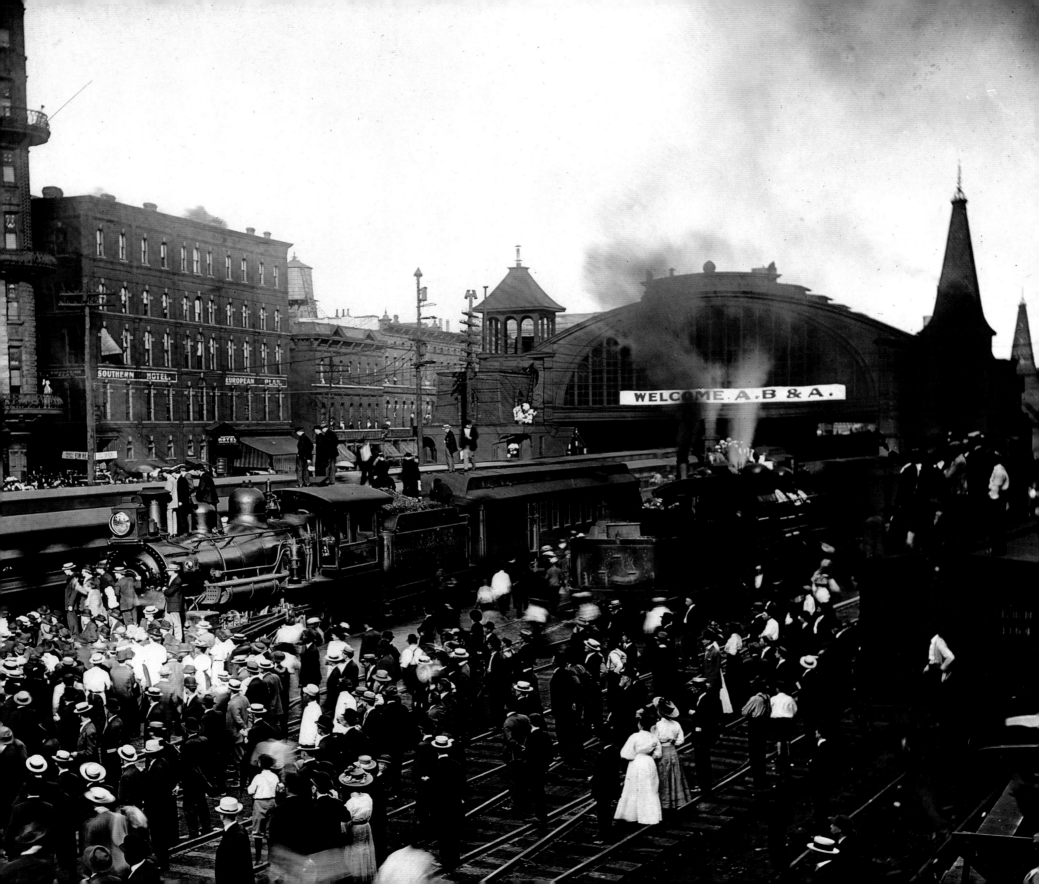

Union Station DEMOLISHED 1930

After the war-time destruction of Edward Vincent's Union Passenger Depot in 1864, Atlanta constructed a small wooden structure on the site to temporarily serve passenger needs as the rail lines leading through the city were rebuilt. By the early 1870s, Atlanta was sufficiently recovered to construct a new iron car shed on the site of the old.

Maxwell Van Den Corput, a Belgian immigrant to Georgia and a Civil War veteran was selected for the job. He had been a third lieutenant and later a captain in the Confederate Army, serving from Floyd County in the Atlanta Campaign. After the war, he moved from Cave Spring, Georgia, to Atlanta and worked in partnership with prominent Georgia architect Calvin Fay.

The "magnificent iron depot" opened in 1871, providing waiting rooms, a barber shop, luncheonette, and telegraph and telephone services. The shed was constructed by the J. P. Stidham Company, later known as the Philadelphia Architectural Iron Company. Corput was also architect of the Georgia Railroad Freight Depot (1869) and DeGive's Opera House (1871) – both located very close to the new Union Station – and the Clayton County Courthouse (1869).

The depot boasted steep Mansard roofs at the corner towers shingled with colored slate laid in patterns, and fan-shaped openings in the end arches. The Second Empire style was uncommon in Atlanta. Sometimes called the "General Grant Style" due to the popularity for civic architecture during President Ulysses S. Grant's eight years in office, 1869-1877, the depot shared architectural features found on the Georgia State Capitol at the time, the first Kimball House hotel, and the Fulton County Court House.

Union Station was considered outmoded as early as 1885. That year, a commission was established to investigate plans to construct a new downtown depot on the Western & Atlantic Railroad property, owned by the State of Georgia. Efforts to remodel or restore the old depot, however, were met with resistance by the state legislature, which refused to authorize funds. In October 1901, the railroads themselves allocated $25,000 to repair and renovate the structure. A new floor was laid, modern comfort stations installed, and waiting rooms enlarged and improved.

The volume of passengers, however, continued to tax the capacity of the thirty-year-old depot. *The Atlanta Constitution* reported in October 1901: "The passage way is one seething mass of disgusted humanity. A lady, with three small children, has five minutes to reach a train on an outer track and she is frantic with excitement and fear."

Although Terminal Station west of downtown now served as a significant transportation center for the city, the old Union Station remained a necessity for Atlanta. In fact, it continued to serve three of the principal railroads into Atlanta. Two more decades passed before construction began on a replacement for Corput's downtown train station and a new Union Station opened in April 1930. The demolition of the vast "magnificent iron depot" began shortly thereafter.

OPPOSITE PAGE *A large crowd gathers on the tracks on the north end of Union Station to welcome the arrival of rail service for the Atlanta, Birmingham & Atlantic Railway, circa 1914.*

BELOW *Automobiles and buggies share the street at the railroad crossing on the north end of the depot.*

BOTTOM *A single locomotive emerges from the station in a stereo view from the 1870s. Surprisingly, the usually bustling, noisy, and smoky area is almost void of pedestrians and vehicles.*

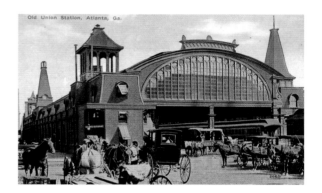

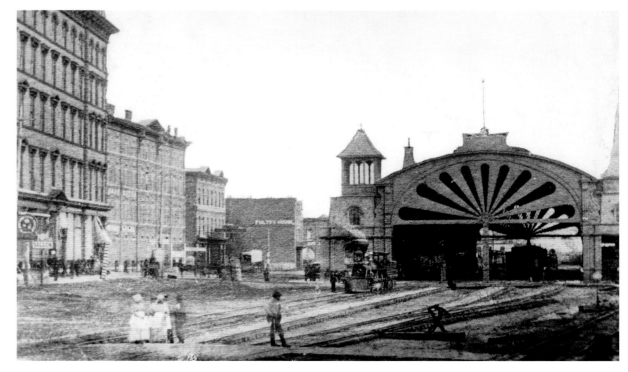

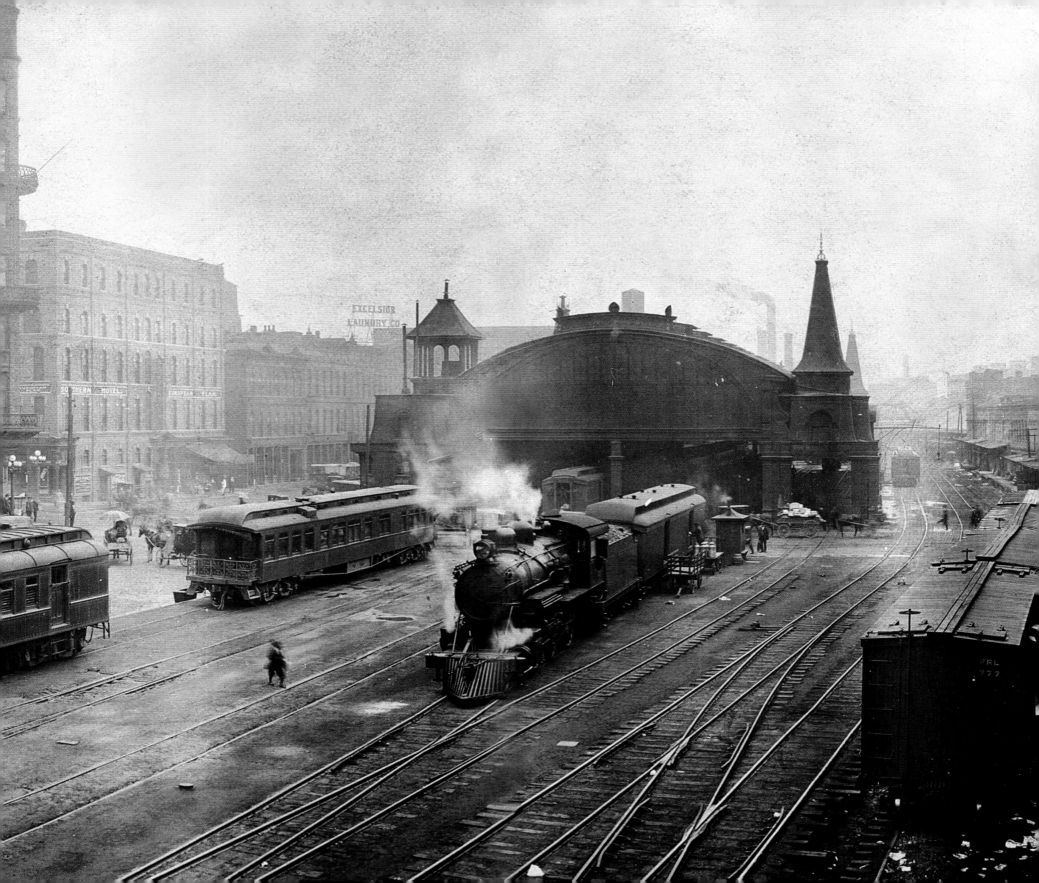

Atlanta Black Crackers CEASED OPERATION 1949

Professional baseball was segregated until 1947 when Jackie Robinson became the first African American player to make a major league roster. Robinson's achievement in breaking the color barrier conversely produced the slow demise of baseball's Negro Leagues since the best black players were not excluded from the majors.

Atlanta's African American team was initially called the Atlanta Cubs, though many people began referring to the team as the Black Crackers, adapted from the Atlanta Crackers who represented the city in the all-white Southern Association from 1902 to 1961. In fact, in many Southern cities professional African American teams were frequently referred to by the official nickname of the Southern Association team. The Black Crackers often included the best players taken from Atlanta's historically black colleges and universities, including Morehouse College, Morris Brown College, and Clark College, as well as from numerous neighborhood baseball teams.

The Atlanta Cubs had played locally for years, but received their major boost in 1919 when Frank Reynolds, general manager of the Atlanta Crackers, agreed to lease Ponce de Leon Park to the Cubs to play teams when the white Crackers were on road trips. Both black and white fans attended the games. African Americans, who were confined to the left field bleachers during Southern Association games, could sit in the grandstands, though never in the same section as whites.

After the season, there was momentum to start a professional baseball league in the South for all black teams and to sell stock in the Atlanta team to the leading African American businessmen in the city. In all, $10,000 was raised and in 1920 the team played a full season of scheduled games with seven other teams in what became the Negro Southern League.

But financial stability was difficult to achieve with the Black Crackers and other teams in the league, especially during the 1920s and 1930s when seasons were sometimes cancelled early because of lack of attendance. White minor league players did not receive much of a salary and black players were paid even less. To supplement their income, the Black Crackers went on the road and played teams in Georgia, the Southeast, and occasionally outside the region.

In 1937, Atlanta businessman John Harden and his wife, Billy, bought the team and the franchise became more financially stable. The following year, the Black Crackers entered the Negro American League and competed against better established teams, such as the Homestead Grays, the Memphis Red Sox, and the Kansas City Monarchs. Yet, this was the only year in which the Black Crackers competed in this advanced league, after which they returned to the Negro Southern League. After Jackie Robinson joined the Brooklyn Dodgers in 1947, interest in the major leagues was at an all-time high among African Americans. As a result, John Harden discontinued his ownership and the Black Crackers ceased operation.

OPPOSITE PAGE *A signed shirt from star first baseman James 'Red' Moore who played for the Atlanta Black Crackers in 1934-35, 1938 and 1946-48.*

LEFT *Several unidentified members of the Atlanta Black Crackers talk with what appears to be an umpire in right field at Ponce de Leon Park. These images are from a reel of 8mm film—the only known moving images of the Atlanta Black Crackers at Ponce de Leon Park. The film is in the collection of the Kenan Research Center at the Atlanta History Center.*

Coca-Cola

GREETS THE BASEBALL SEASON With Refreshments --- AND WISHES THE BEST FOR THE

BLACK CRACKERS

IN THEIR CURRENT SEASON

OPENING TONIGHT

ATLANTA COCA-COLA BOTTLING CO.

560 EDGEWOOD AVENUE

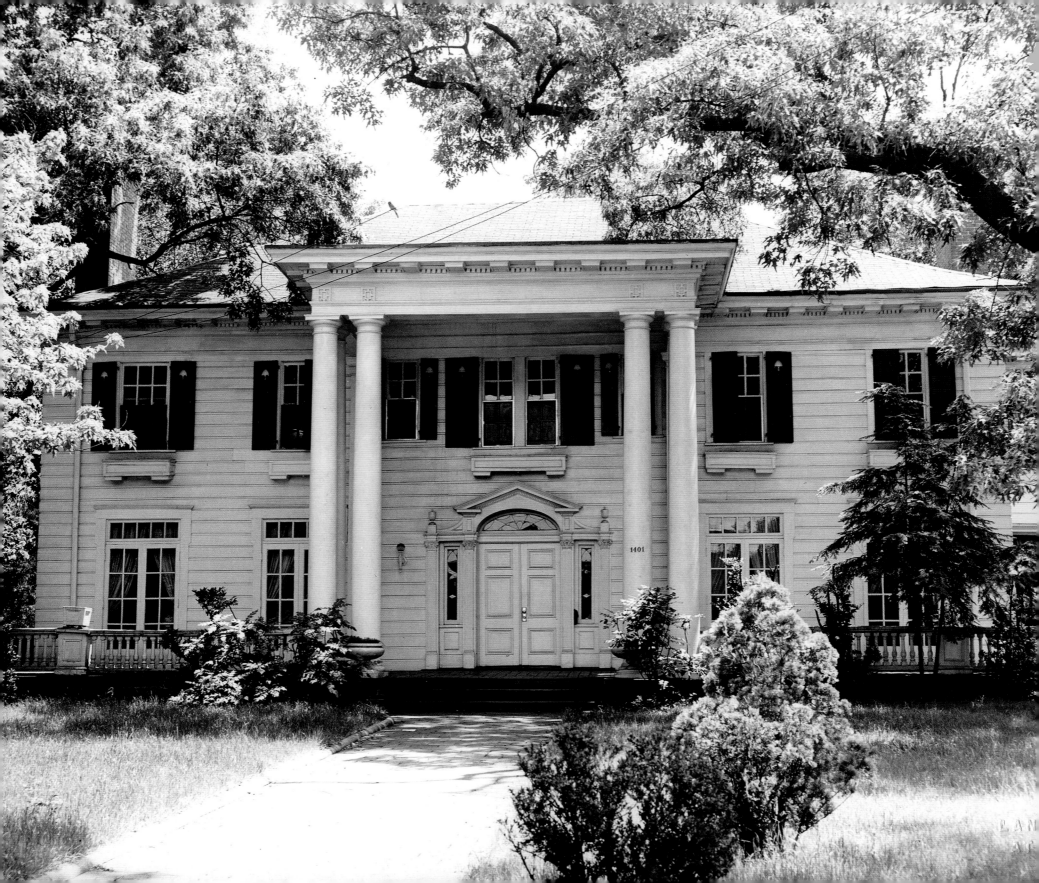

Margaret Mitchell Girlhood Home

DEMOLISHED 1952

When she was eleven years old, Margaret Mitchell, later the Pulitzer Prize-winning author of *Gone With the Wind,* and her family moved to this home in 1912. She had spent her early childhood in a large Victorian home on Jackson Street, but her father, Eugene Mitchell, felt the Jackson Street neighborhood was in decline and built a new, large, columned house on fashionable Peachtree Street. The house, built in Classical Revival style, was one of only two homes on the block when the family moved in.

Situated close to the street, the house lacked the stable, gardens, and treehouse of the Jackson Street property, but Margaret adjusted to her new surroundings by regaling her new neighborhood friends with ghost stories in the basement and impromptu dramatic performances in the large central hallway.

She left to attend Smith College in Massachusetts in 1918, but completed only one year before returning to look after the house, her father, and her older brother, Stephens, following her mother's death in 1919. Margaret and her first husband, Berrien "Red" Upshaw, lived in the house during their brief, tumultuous marriage.

It wasn't until 1925 and her second marriage, to John Marsh, that she moved out of her girlhood home when the couple moved into the Crescent Street Apartments where she wrote much of her world-famous novel. In 1952, three years after her death, Margaret Mitchell's brother, Stephens, sold the house to Atlanta realtor Ben Massell for $60,000. Written in the sale contract was the stipulation requiring the home's demolition because, as Stephens said, "we didn't want anyone else to live in it…and we didn't want it to deteriorate to a third-rate boarding house. I'm not sentimental about the old house," he said, "I think when you are through with things, you are through."

OPPOSITE PAGE *Mitchell dreaded managing the big house on Peachtree Street following her mother's death in 1919. Though she had a small staff of domestic servants to assist her, Mitchell wrote, "I wouldn't call housekeeping a bed of roses."*

ABOVE RIGHT *Prior to release of her novel,* Gone With the Wind, *Margaret Mitchell and her father, Eugene Muse Mitchell, pose for a 1936 publicity photograph in front of the house. Since the novel had not yet been distributed, the volume she holds is not her book.*

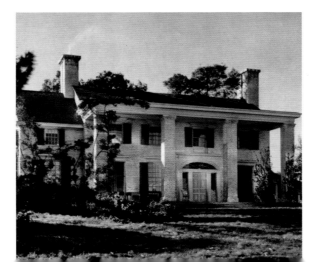

TARA

Few homes in literature have fascinated readers as much as Margaret Mitchell's "Tara," the fictional home of *Gone With the Wind* heroine Scarlett O'Hara and her family. As soon as the book was published, tourists began making their way to Atlanta and Clayton County, Georgia, anxious to see Tara for themselves. Their numbers increased following the 1939 release of David O. Selznick's motion picture version of the best-selling novel.

Mitchell freely admitted that many of her ideas came from listening to stories told by elderly relatives and from Sunday afternoon drives through the countryside in Clayton County. But she insisted that the characters in her book—including Tara—originated in her imagination and were not based on any single individual or house.

In letters to friends and associates, she bemoaned the Hollywood version of Tara, insisting the "ugly, sprawling, column-less" Tara of her book ended up looking like "a combination of Grand Central Station [and] the old Capitol at Milledgeville." Both Clayton County and Atlanta were only too happy to capitalize on the popularity of the novel and film by offering *Gone With the Wind* tours. In a 1939 letter to Franklin M. Garrett, then Vice President of the Atlanta Historical Society, she sharply reprimanded him for including "nonexistent houses in a historical tour" planned by the Atlanta Chamber of Commerce, telling him "should [anyone] ask you about where my characters lived, please say they lived only in my mind."

LEFT *In January 1939, Mitchell wrote, "I grieve to hear that Tara has columns," when she heard of the motion picture version of her fictional Tara. Yet Hollywood's version of Tara is the iconic image that the general public has in mind, one that reinforces Atlanta's romanticized role in pop culture.*

Chattahoochee River Ferries DISCONTINUED 1958

Though not a deep channel stream, the Chattahoochee River's waters have been an obstacle to travel and trade from the time the first white settlers arrived in North Georgia. As a result, to move people, livestock, crops, and merchandise across the river, a network of ferries developed with franchises granted by the State Legislature.

Georgia State law required the ferryman to post a bond and pledge "faithful performance." Ferries became vital links between pioneer settlements and, for some, lucrative business. The earliest recorded franchise in the present-day Atlanta area was awarded to William Blake in 1823 for a ferry located near the mouth of Sandy Creek north of what is now Fulton County Airport-Brown Field. Over time, at least thirteen ferries plied the waters at landings located all along the river between what is now Alpharetta to the north and Palmetto to the south.

The ferries began as wooden flats operated by a rope stretched high across the river from landing on one side of the river to the landing on the opposite bank. The flat ferry boat, through a system of pulleys, central wheel, and small lines at either end, allowed the ferryman to set the boat at an angle to the current—the moving water then pushed the boat across the river. A bell placed at each landing allowed passengers to summon the ferryman, who often lived in a home near the landing.

For travelers who needed to cross the Chattahoochee River at Pace's Ferry, established by Hardy Pace in the 1850s, the fare was 62 cents for a loaded wagon—only 50 cents if it was empty; 12 cents for a man and a single horse; and 4 cents per head of cattle.

Ferry crossings were hotly contested during the Civil War, as retreating Confederate forces and advancing Union forces moved troops across hastily constructed pontoon bridges at landings during the Atlanta Campaign. As many as 1,800 slaves were impressed to construct fortifications along the Chattahoochee River Line to prevent Union crossings. Nevertheless, Union troops made their way to Atlanta through pontoon bridges constructed at both Pace's Ferry and Power's Ferry (established by plantation owner James Power in 1835).

The Mayson-Turner Ferry, established in 1850 by James Mayson and Daniel Turner, was located north of the present-day bridge for the Veterans Memorial Parkway. On September 2, 1864, Atlanta Mayor James Calhoun surrendered the city to Union forces just outside the city on Mayson-Turner Ferry Road.

As the years passed, ferry operators replaced wood flats with steel-bottom boats and rope lines with steel cables. Salvaged automobile or truck engines were added to turn the wheel. The old landing bells were replaced by highway signs instructing motorists to honk their horns when they wished to cross.

One by one, ferry crossings disappeared as bridges were constructed to accommodate the growth of the state highway system and the need to move Atlanta's rapidly increasing traffic more quickly. The Campbellton Ferry, near present-day Fairburn, ceased operations in 1958. This was the last remaining ferry on the river and had been in the Brock family for fifty-seven years. Henry Brock remembered ferrying everything from mules to moonshine before the state highway department took over in 1935, eliminated the toll, and placed him on a salary.

The very first ferry to cross the Chattahoochee—Vann's Ferry—began in 1804 and was named for the Cherokee leader James Vann. It crossed the river between what became Hall and Forsyth Counties. Ironically, it is now beneath the waters of Lake Lanier. No ferries remain today, but their legacy lives on in the names of the many roads that once led to the landings.

ABOVE *Honk for Service—the standard means of attracting the ferry if it is on the wrong side of the river. While automobiles proved less problematic than mule-drawn vehicles to carry, the occasional inattentive driver or brake failure could push a car into the river.*

OPPOSITE PAGE *In addition to wagons, buggies, and automobiles, ferry crossings allowed itinerant entrepreneurs to transport their business. A pioneer family business of Atlanta, the Kuhns photography gallery used a traveling gallery to photograph country residents who rarely made it to the big city. The Kuhns wagon crosses the Oconee River in 1901 just as the portable studio would have used many ferries along the Chattahoochee River.*

LEFT *The Mayson-Turner Ferry crossing the Chattahoochee in 1903. Calhoun "Uncle Coat" Turner, ferryman, holds the pole used to push off from the riverbank.*

The New Kimball House DEMOLISHED 1959

The first Kimball House hotel opened in October 1870, though the majestic Second Empire building was destroyed by an early-morning fire in August 1883. Hannibal I. Kimball promptly began to rebuild on the same footprint of his earlier hotel. When architect Lorenzo B. Wheeler arrived from New York in January 1884, he brought a completed set of building plans and construction of the massive New Kimball House hotel moved quickly. On August 12, 1884, privileged guests attended a formal tea on the rooftop and the hotel opened to the general public on April 30, 1885.

Occupying nearly an entire city block south of Decatur Street between Peachtree and Pryor Streets, the seven-story, red brick, stone, and terracotta exterior was accentuated with decorative iron railings and embossed sheet-metal ornamentation. While the stepped and scalloped Flemish gables suggest design elements borrowed from the Dutch Renaissance, Wheeler designed a building far more architecturally eclectic and complicated. The interior spaces included a ground-floor lobby, surrounded by seven stories of

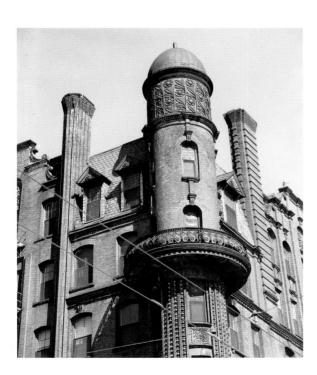

galleries providing an open atrium extending to a skylight above. Stained-glass windows, polished oak wainscoting, glazed floor tiles and fireplace surrounds, carved and turned woodwork, polished filigree screens, and marble stairs all added to the hotel's sumptuous features.

The success of the Kimball House came not only from its decorative and comfortable furnishings, but also from its location in the heart of the city adjacent to the passenger depot. In addition to the thirty-one stores and general offices in the building, the hotel provided 357 guest rooms and twenty-two public rooms and meeting spaces.

President Grover Cleveland lodged at the Kimball House while visiting the Cotton States & International Exposition in 1895 and in December 1898 President William McKinley attended the Atlanta Peace Jubilee celebrating the end of the Spanish-American War. In October 1905, the *Atlanta Journal* reported that the hotel "was the official mecca to which every legislative axe was carried for grinding ... governorships have been awarded within its walls; senatorial togas have been won and lost in its rooms ... in short, everything of the slightest interest to the capital city has had at least one angle leading to the Kimball."

Atlanta businessman Hugh T. Inman eventually acquired from over two-hundred investors all 30,000 shares of stock in the hotel, except for two shares held by the widow of Hannibal Kimball and another two shares held by the Savannah Orphans Home. He gave the hotel to his daughter, Annie, and her husband, John W. Grant, as a wedding gift in 1905.

Early-twentieth-century developments brought significant change to Atlanta's downtown. In the 1920s, viaducts were constructed over many of the at-grade railroad crossings around the Kimball House, altering the downtown streetscape. The prevalence of the automobile and the convenience of mass transit dispersed the public beyond the downtown core. The opening of Atlanta Terminal Station in 1905 also shifted lodging needs away from the Kimball House location to newly-constructed buildings called Hotel Row nearer the new train station.

Though the Kimball House undertook renovations in the 1920s, as the decades passed, the grand hotel slipped into a steady decline. Remarking on the pending loss of the Kimball House, the *Atlanta Constitution* reported in March 1959, "Atlanta's historic Kimball House closed her doors to the passing world at the lonesome stroke of midnight Wednesday and awaited the arrival of a destructive modern-day devil named progress."

OPPOSITE PAGE *The Kimball House, 1949.*

LEFT *The southeast corner of the Kimball House with its prominent turret, inset terracotta, patterned brickwork, fish-scale shingles, and iron railings all contribute to the rich texture of materials and construction techniques found on Atlanta's "grand old lady."*

BELOW *Horace Bradley's drawing of the hotel dates from soon after its completion. Bradley, a native of Dublin, Georgia, grew up in Atlanta and became one of the most prominent illustrators for such national newspapers as* Frank Leslie's Illustrated Weekly *and* Harper's Weekly.

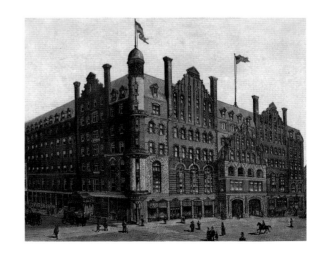

Howard / Paramount Theatre DEMOLISHED 1960

Atlanta cotton merchant George Troup Howard financed construction of Atlanta's first opulent movie palace, which opened in December 1920 at the prominent intersection of Peachtree and Forsyth Streets. It was completed just six years after New York City's famed Strand Theatre, considered the nation's first movie palace. Unlike Atlanta's atmospheric Moorish-themed Fox Theatre that opened nine years later, the Howard was Italianate in design. Atlanta architect Philip Trammell Shutze turned to his Italian sketchbooks as he drew plans for the theater. He had just returned from Italy having won the famed *Prix de Rome* in 1915. The sixteenth-century Palazzo Chiericati in Vicenza, Italy, designed by Andrea Palladio, provided Shutze with inspiration.

The entrance façade was faced with buff Indiana limestone and no movie marquee obscured the Renaissance-style façade in the theater's early years. Instead, mounted on the red-clay, mission-tiled rooftop, a sign depicting two pots of gold and a rainbow lit Atlanta's night sky. Constructed by the Buhler Company in Columbus, Georgia, it was the largest electric sign in Atlanta at the time.

Flooring in the open loggia was laid with gray marble. On entering the vaulted, two-and-one-half-story lobby, a grand staircase led to the promenade and balcony-level seating. An unusual feature in the original loge included seventy-eight Windsor-style armchairs providing ample comfort. W. E. Browne Decorating of Atlanta provided the furnishings and decorative features. George Troup Howard told the architect he wanted the best that money could buy—and the 1,000-seat

theater was constructed at a cost of $1,000,000.

Concert cellist and orchestra conductor Enrico Leide was hired as the theater's first conductor. He came from the Capitol Theatre in New York City and remained in Atlanta for his lifetime. Leide also served as the first conductor of the Atlanta Symphony Orchestra, performing Sunday afternoon concerts beginning in 1924. The early ensemble was composed of sixty musicians from the pit orchestras of the Howard and the Metropolitan Theatres.

When Paramount studios acquired the Howard Theatre in September 1929, they constructed a spectacular sixty-nine-foot-tall vertical marquee and a fully-illuminated horizontal marquee. Paramount's marquee was hailed as the brightest spot in Atlanta for many years, and a landmark on Peachtree Street. The effects of the Great Depression were felt by all Atlanta theaters and in March 1931 the Paramount closed for one year.

When the regional theater operators Arthur Lucas and William Jenkins took control of the Paramount in early 1934, they reduced live stage performances at all of their Atlanta venues except at the Capital Theatre. A notable exception was June 22-24, 1956, when Elvis Presley gave ten performances in three days on Paramount's stage.

Shortly after, the Paramount's opulence and attraction began to fade and in June 1960 the theater screened its last film, *The Lost World,* a fantasy-adventure based on the novel by Arthur Conan Doyle. The theater's furnishings were sold and the building was demolished later that year. Fortunately, the grandeur of the original Howard Theatre is not entirely lost.

During demolition, the stone facing was purchased for $5,000, loaded onto twelve flatbed trucks, and a portion of the façade was reconstructed—two hundred miles away—as a residence in Moultrie, Georgia.

OPPOSITE PAGE *Although partially obstructed by the addition of a traditional marquee, the ornate façade of the Howard continues to grace Peachtree Street in 1959. Theater goers prepare to watch mystery unfold on the silver screen in* The Bat, *starring Vincent Price and Agnes Moorhead.*

RIGHT *The promenade at the mezzanine floor level is an elliptical room fifty-two feet in length on its major axis. An open well at the center is surrounded by a balustrade of artificial brèche violette marble. The ceiling is painted yellow and rubbed with silver.*

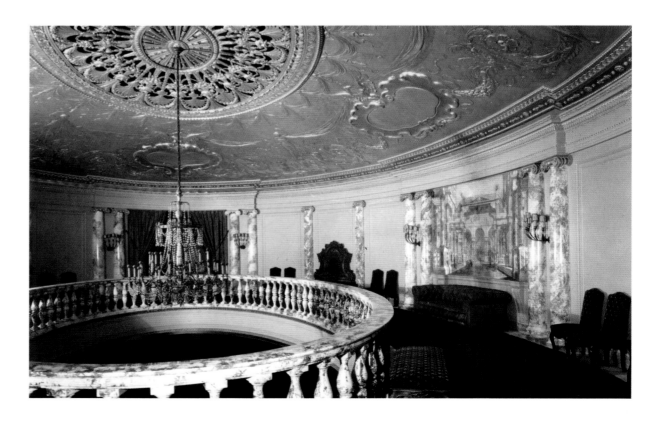

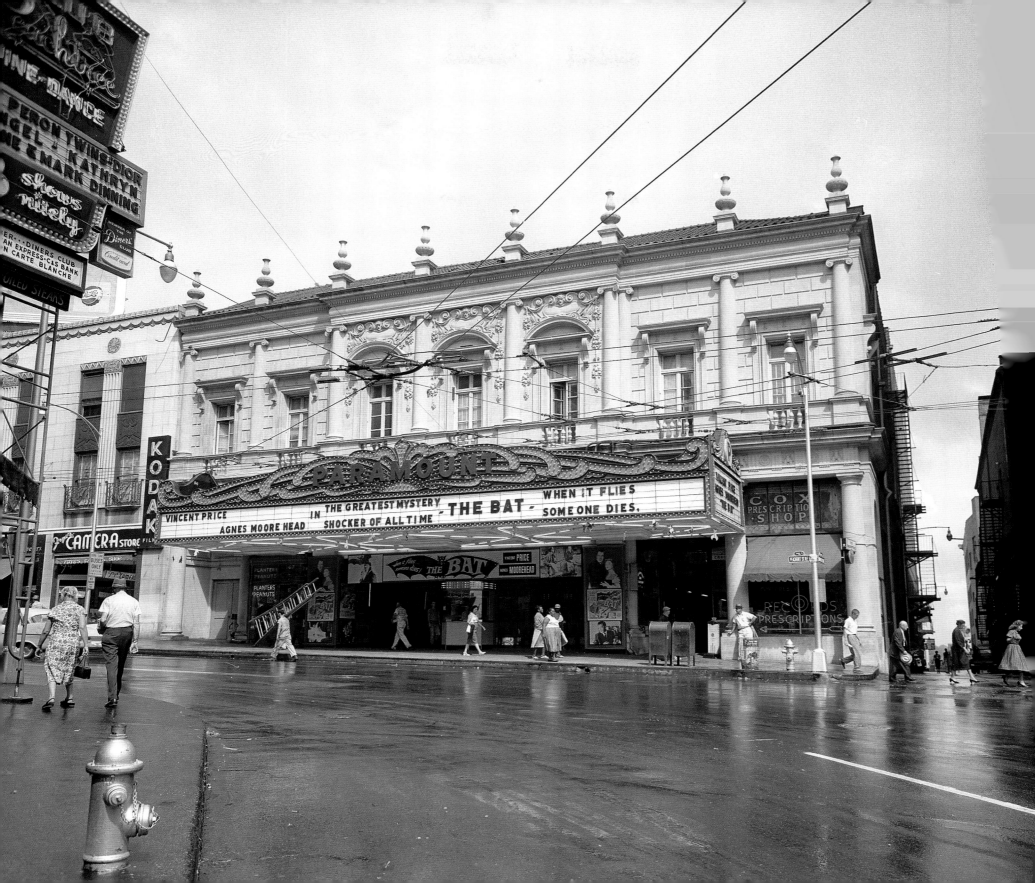

Lake Abana FILLED 1963

Several springs of mineral-rich waters emanated from approximately one hundred acres of land that Lemuel P. Grant presented to Atlanta for a park in May 1883. Later that year, Mayor John B. Goodwin appointed merchant Sydney Root as Atlanta's first park's commissioner and a topographical survey was drawn. The newly established Metropolitan Street Railway Company provided the first streetcar service to the area. Early recreational opportunities at Grant Park included walking paths and carriage roads as well as the natural features of the forested landscape. The carriage roads were named for prominent cities in Georgia, including Savannah, Americus, Augusta, Macon, Brunswick, Columbus, Rome, and Milledgeville.

In 1886, the city park commission provided funds to further improve the land in Grant Park and constructed a small lake within the natural ravine where Willow Brook flowed. The lake was named Abana for the Biblical river flowing into Damascus as referenced in the Book of Kings. Greek lore called Abana "the golden stream."

Constitution Springs offered the site for a pavilion adjoining the lake and Bethesda Springs provided another source of mineral water. At the north end of the lake, a boathouse was constructed and row boats were rented for ten cents in 1887. Lake Abana was first enlarged that year and in 1888 the volume of Willow Brook's water flow proved excessive for the lake. As a result, a second, smaller lake was constructed to the south, named Lake Loomis. The two lakes were merged in 1901, and postcards dated 1906 name Swan Island as one of two islands in the lake.

In 1904, the eminent landscape architectural firm of the Olmsted Brothers drew preliminary master plans for Grant Park. The firm's vision led to the majority of the park being left in a pastoral state intersected by undulating roads and paths. At the southeast corner of the park were earthwork remnants of Fort Walker, a portion of Atlanta's Civil War defensive fortifications placed on the highest elevation in the park. Lemuel P. Grant was the engineer of the extensive fortifications erected around Atlanta, which kept General William T. Sherman from a direct attack against the city.

The donation of a spotted fawn in 1886 was the first instance of a zoological display at Grant Park. In 1889, Atlanta businessman and lumber magnate

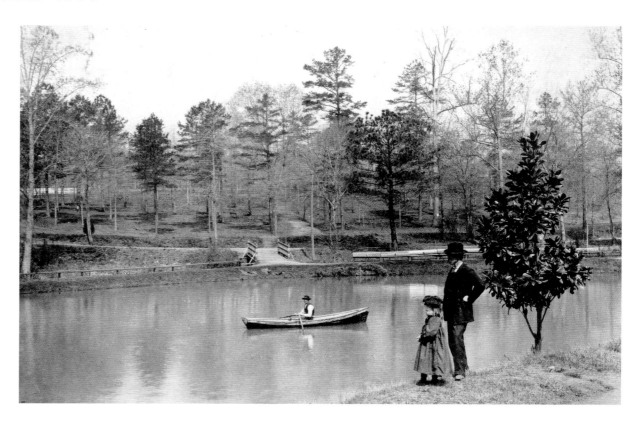

George V. Gress purchased animals from the bankrupt "five-car" Hall & Bingley Circus on the steps of the Fulton County Court House and established the Gress Zoological Collection at the park. He provided the lumber for the first menagerie building and pledged $500 per year for the upkeep of the animals. Shortly thereafter, Architect Gottfried Norrman donated plans for a building to be constructed between Lake Abana and the Metropolitan Street Railway adjacent to Boulevard Avenue to replace earlier makeshift pens and cages. The growth of the zoo would eventually seal the fate of Lake Abana.

The park's swimming pool, which opened in 1917, was constructed from a portion of Lake Abana. The pool, measuring 200 x 500 feet, was reportedly the largest swimming pool in the southeast. In August 1961, two new sites for the zoo, a bear den and a sea lion pool, were constructed at the southwest corner of the park

and the pool was filled in to provide for the new infrastructure. In 1963, landscape architect W. C. Pauley drew plans for a Children's Zoo to provide a barnyard area where children could pet farm animals. For a small admission, children and their parents could ride around the perimeter of the Children's Zoo in a miniature train. When the plans were adopted, the remainder of Lake Abana was filled in 1963 to provide for construction.

OPPOSITE PAGE *Well-worn paths lead to the early boat house and nearby pavilion in 1895.*

ABOVE *The quietude of the lake, for boaters and strollers alike, is a welcome respite from the nearby city.*

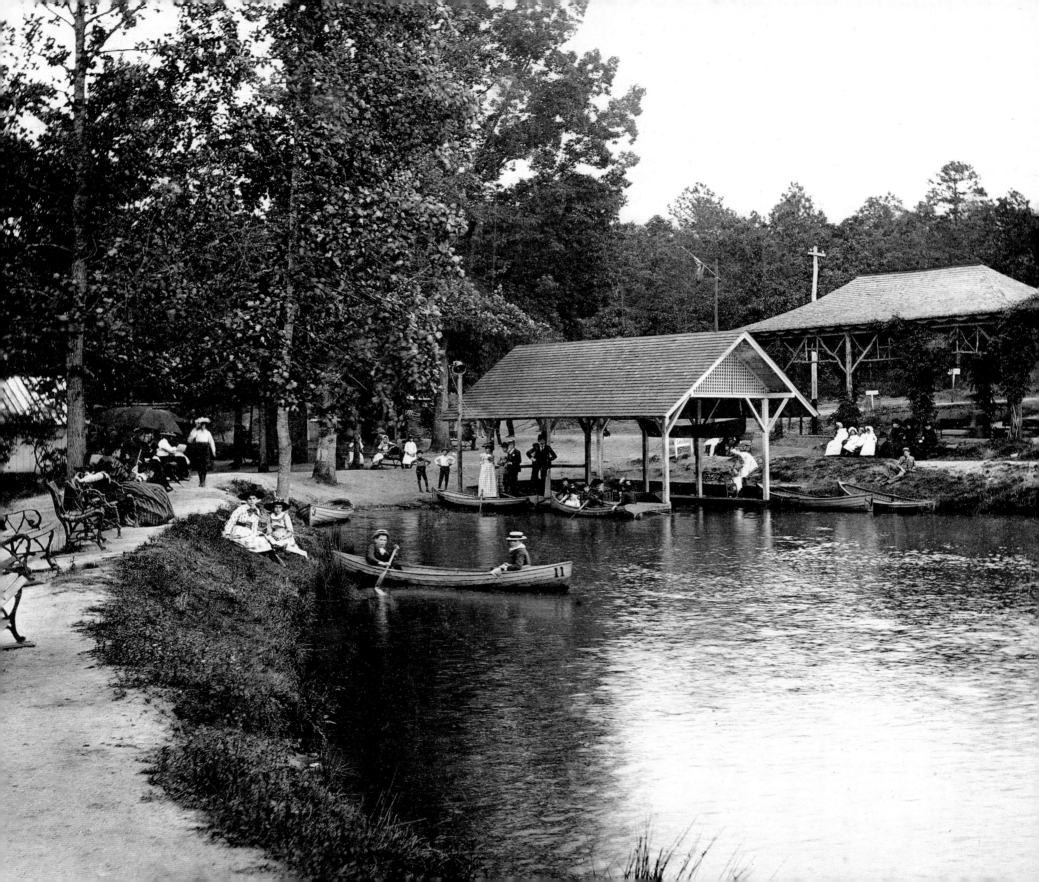

Peachtree Arcade DEMOLISHED 1964

Long before there were suburban shopping malls in Atlanta, the place to shop was the Peachtree Arcade. The brainchild of Atlanta real estate developer Robert R. Otis, the Arcade was a massive building connecting Peachtree Street with Broad Street and offering an indoor, multi-level shopping experience the length of an entire city block. Otis first conceived the idea in the 1890s following a visit to Cleveland where he visited the Standard Oil Company Arcade and heard tales of untold riches and business bonanzas for its tenants and developers. He returned to Atlanta determined to build a similar retail goldmine.

Yet, it took almost twenty years for Otis to see his plan come to fruition. An essential problem was the difficulty of finding a site large enough to locate his building close enough to or within the existing central shopping district in downtown Atlanta. It was virtually impossible to assemble a number of small land lots together in the same location – especially in what was already the most desirable window-shopping strip along the Peachtree-Whitehall Street corridor. Ultimately, Otis convinced John H. Flynn of Flynn Realty Company to make the site of the old National Hotel, which was then occupied by the Emory-Steiner Building, available for the development of his vision.

The Peachtree Arcade, built in 1917, was designed in the Beaux-Arts style by prominent Atlanta architect A. Ten Eyck Brown and was large enough to cover half of the entire city block bounded by Peachtree, Broad, Wall, and Marietta Streets in downtown Atlanta. The Peachtree façade of the building was six stories high, and the Broad Street frontage was four.

The main floor was designed to be as wide as a street; according to the *City Builder,* it was a street "with the exception of vehicle traffic." The most distinctive architectural feature was the three-story archway of the Peachtree Street entrance. The brass and marble interior was covered by an iron and glass roof, providing an indoor shopping experience contained within approximately 90,000 square feet of prime office and commercial space.

The intention of the Peachtree Arcade was to serve as a department store of experts. Each small shop could be run by a specialist who brought their own expertise to the merchandise being sold. The ground and main floors specialized in women's goods, including perfume merchants, milliners, and shoe stores. Upper floors housed shops for men's and children's goods. In addition to shops, the Arcade hosted the offices of lawyers, real estate agents, and other business enterprises.

An entire floor served as the headquarters of the Young Women's Christian Association in the early years of the Arcade. Other tenants included Draughon's Practical Business College, the Delpheon phonograph shop, and the headquarters of Otis & Holliday Real Estate. The Arcade also housed a post office, a reading room, public baths, two cafeterias, and a gymnasium for the use of tenants and customers.

In 1955, the Flynn family sold the property to the First National Bank of Atlanta, whose headquarters stood next to the Arcade at Five Points on the corner of Peachtree and Marietta Streets. Strategically, the bank sought additional office space to accommodate its anticipated growth. That decision came in 1964 when the bank decided to build a new, substantially larger building on the site of the Peachtree Arcade. Following the exodus of its remaining tenants, the Arcade was demolished. The new, forty-four story First National Bank of Atlanta building was completed in 1966. The tallest building in the southeast at the time, it is now known as the State of Georgia Building.

OPPOSITE PAGE *Jewelry stores and men's clothing shops line the Broad Street façade of the Peachtree Arcade in 1955.*

RIGHT *The Peachtree Street entrance to the arcade appears on the left of the street in 1950. The entrance to Plaza Park is just across the street. At the time, this area of downtown and Peachtree Street was the heart of the shopping district, with Rich's and other department and specialty stores located nearby.*

FAR RIGHT *A crowd gathers inside the Peachtree Arcade, crowding all three shopping floors, to hear a sermon by evangelist Billy Graham on November 1, 1950.*

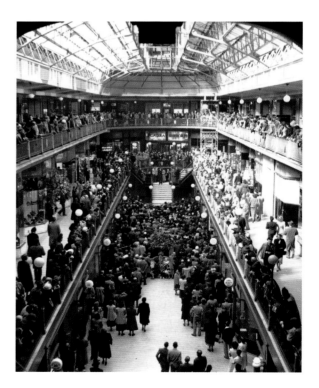

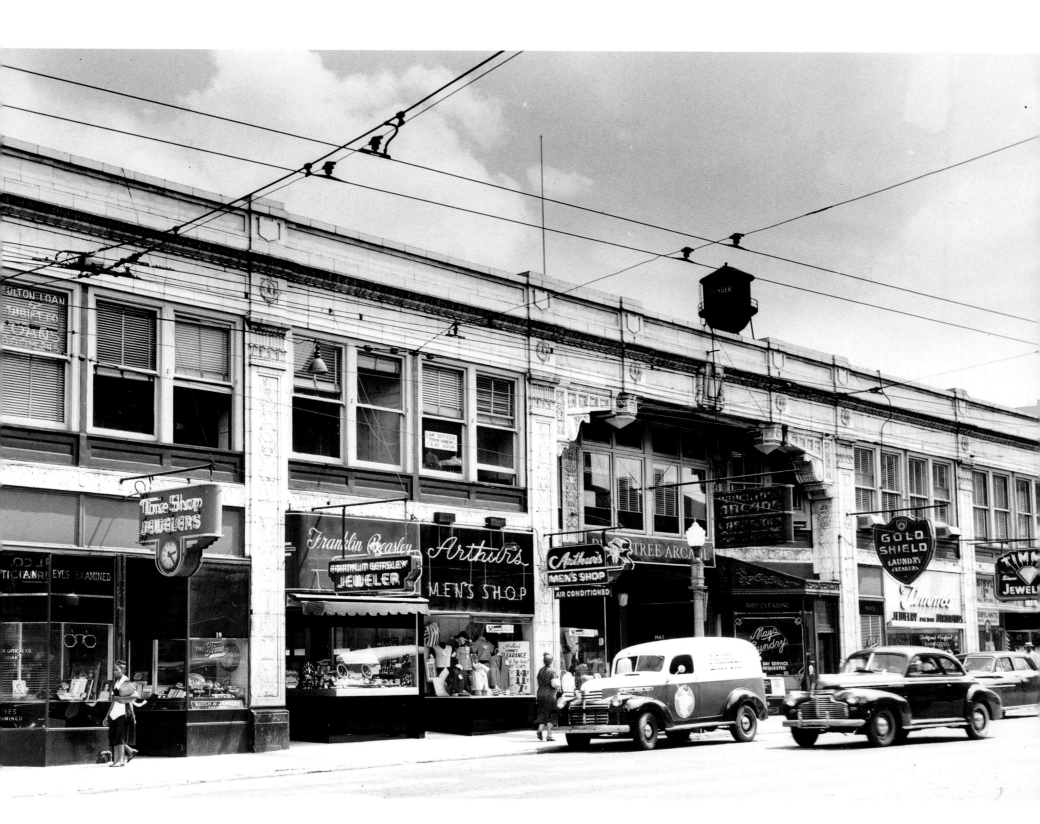

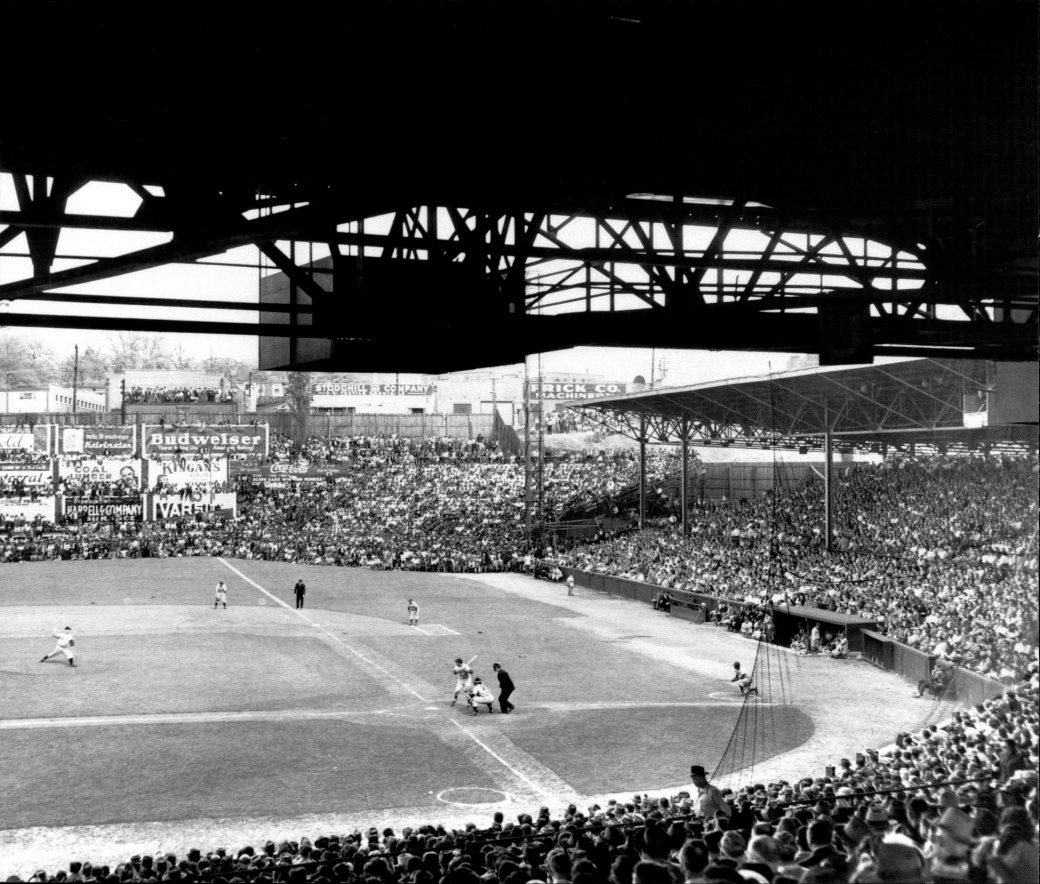

Ponce de Leon Park RAZED 1965

In 1907, a lake was drained across the street from the popular amusement park at Ponce de Leon Springs to build a baseball stadium. It seemed a sensible choice—the springs were a fashionable and respectable leisure activity, readily available to Atlanta residents by horse-drawn trolleys and later by streetcars. And so, drain it they did, and the stadium was finished in time for the 1907 season of the Atlanta Crackers.

Both the Atlanta Crackers and Atlanta Black Crackers played home games at Ponce de Leon Park, but it was not always so. The Atlanta Crackers played at Peters Park in present-day Midtown. They later played at Brisbane Park in what became the Mechanicsville neighborhood, and later still near Auburn Avenue as well as at Piedmont Park from 1902 to 1907. An athletic field had been placed at Piedmont Park in 1896 on the park's west side between the Fourteenth and Tenth Street entrances.

The Crackers played there through the 1906 season when the team was purchased by the Georgia Railway & Electric Company and relocated to company land along Ponce de Leon Avenue— the old lake bed, now home to Atlanta baseball— black and white for separate, segregated audiences. The Black Crackers played at the park when they were established in 1919 and continued

there for many years thereafter.

Ponce de Leon Park seated 6,800 fans and for many years the grandstand was situated adjacent to a streetcar line depositing fans directly to the stadium. In 1923 after a fire consumed the wooden stands, owner Rell Jackson Spiller announced plans to re-build with steel and concrete. The new ballpark dwarfed its competitors in size—14,000 seats, and cost $250,000 in pre-Depression dollars.

Ponce de Leon Park did not have a symmetrical field. The fence along left field was 365 feet from home plate, 462 feet in center, and 321 feet in left, so it was a left-handed hitter's ballpark. Most strangely, a large magnolia tree stood in the field of play in deep center field. According to the rules, if a ball hit the tree, it was in play. Only two players are credited with hitting a baseball that far: Eddie Mathews when he played for the Atlanta Crackers and Babe Ruth during an exhibition game.

In addition to Black Cracker and Atlanta Cracker baseball games, the stadium hosted football, wrestling, and revival meetings. In April 1949, the Brooklyn Dodgers came to play a three-game series with the Crackers. Televised locally, the games featured two black players, Jackie Robinson and Roy Campenella. This was the first integrated professional baseball game in Atlanta. On April 10, an overflow crowd of 25,000 people came to see

Robinson and the Dodgers play the Crackers in the final game—it was the largest crowd ever at Ponce de Leon Park.

The Black Crackers continued playing in the Negro League, but Jackie Robinson's entrance into sports had broken the color line in baseball. The league continued for the next few years, but disbanded in the early 1950s. By 1965, there was no longer a need for Ponce de Leon Park. The city had expanded its horizons and built Atlanta Stadium, a 52,000-seat arena helping fulfill the city's major league ambitions. The Atlanta Crackers played their final season at Atlanta Stadium in 1965 and Ponce de Leon Park was razed the next year. The only physical vestige of the park left behind was the magnolia tree that stood in center field. Today, it stands behind a shopping mall along the eastern path of the Atlanta Beltline.

OPPOSITE PAGE *The overflow crowd packs Ponce de Leon Park on April 10, 1949, when the Brooklyn Dodgers came to Atlanta to play a three game series with the Atlanta Crackers. Over 25,000 attendees watched the game along with a number of national media outlets there to see stars Jackie Robinson and Roy Campanella.*

LEFT *The magnolia tree in center field during an exhibition game between the Atlanta Crackers and Detroit Tigers reveals a sloped outfield in front of the tree. Ponce de Leon Park was the scene of many exhibition games with major league teams who travelled north from spring training.*

ABOVE *Ponce de Leon Park in 1956 during an Atlanta Crackers baseball game against an unidentified opponent.*

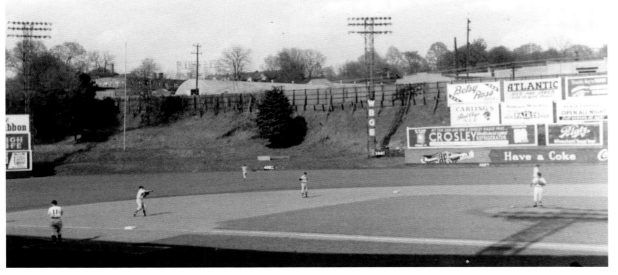

Atlanta Crackers RENAMED AND RELOCATED 1965

Professional baseball in Atlanta began in February 1885 when baseball enthusiast and *Atlanta Constitution* editor Henry Grady met with representatives of baseball interests throughout the Southeast at the Kimball House hotel in downtown Atlanta and formed the Southern League. Local newspapers simply referred to Atlanta's team as the "Atlantas" in their coverage. The name of the team seemed to constantly change. In the early days, they were also called the Windjammers, Firecrackers, Firemen, Crackers, or Colonels. In fact, during the 1903 and 1904 seasons, the *Atlanta Constitution* referred to the team as the Crackers while the afternoon paper, the *Atlanta Journal* referred to them as the Colonels—though the same players were listed in the same lineup in identical box scores, regardless of how the newspapers referred to the team.

The Southern League disbanded in 1899 and was replaced in 1901 by the Southern Association in which they played until 1961. Within that time period, they won fourteen league titles, earning them the designation of the "New York Yankees of the South." For most of their history they played at Ponce de Leon Park, an asymmetrical arena with expansive grandstands and a magnolia tree located in straight-away center field. The Crackers were not part of any major league farm system until 1950 when they became the Class AA affiliate of the Boston Braves and shed their status as an independent franchise.

The Atlanta Crackers were owned by several well-known entities, including the Georgia Railway and Electric Company (now Southern Company) and the Coca-Cola Company. The Coca-Cola Company purchased the franchise in 1929 from Rell Jackson Spiller for about $330,000. The company formed a wholly owned subsidiary called the Atlanta Baseball and Amusement Corporation in which they were the sole stock holder. There was a board of directors that included Earl Mann as president, beginning in 1934. Mann would himself own the team from 1949-1959. They turned a profit in most years, the exception being the early Depression years and shortly after the outbreak of U.S. involvement in World War II.

In addition to fan favorites like Clarence "Buck" Riddle, Bob Montag, and Ralph "Country" Brown, the Crackers featured players on their way to the major leagues, including Leo Durocher, Eddie Mathews, Tim McCarver, and Whitlow Wyatt. One of the most notable alumni of the franchise was not a player, he was announcer Ernie Harwell. Harwell was famous as the announcer for the Detroit Tigers, but from 1946 to 1948 he called games for the Crackers. Harwell was traded to the Brooklyn Dodgers for catcher Cliff Dapper, marking the only

time in baseball history in which an announcer was traded for a player.

The Crackers and minor league baseball in general experienced a steady erosion of attendance that began in 1950 and continued throughout the decade. Television and air conditioning encouraged fans to stay at home while others were enticed to the growing number of outdoor attractions the expanding metropolitan area offered. Despite fielding several championship teams in the 1950s, attendance plummeted, which had a dramatic effect on the team's finances. Losing money with a last place ball club, Earl Mann turned the franchise over to the Southern Association, at which time it was purchased by Los Angeles Dodgers owner Walter O'Mally.

After a four year stint in the Triple-A International League from 1962 to 1965, Atlanta obtained a major league team. As a result, the Crackers went to Richmond and became the Richmond Braves. Ultimately, the Richmond Braves returned to the Atlanta metropolitan area in 2009 and now play as the Gwinnett Braves in Lawrenceville.

RIGHT *The 1956 edition of the Atlanta Crackers inside the clubhouse at Ponce de Leon Park, probably photographed after they clinched the Southern Association Pennant. Manager Clyde King is on the right wearing glasses. King went on to briefly manage the San Francisco Giants, Atlanta Braves, and New York Yankees.*

LEFT *Before the Atlanta Crackers the professional baseball team was called the Atlanta Firemen. Photographed in 1902, the team was the first representative from Atlanta to participate in the newly-formed Southern Association.*

OPPOSITE PAGE *Outfielder Bob Montag in 1957 at Ponce de Leon Park; Montag was the all-time home run leader for the Crackers. The World War II veteran is the subject of a funny story in which he hit a home run that landed in an open coal car in a train that was headed to Nashville, Tennessee, on the railroad that ran beyond the right field fence at Ponce de Leon Park. The conductor retrieved the ball and Montag signed it after the train came back from Nashville. Montag credited himself with hitting the longest home run in history—500 miles.*

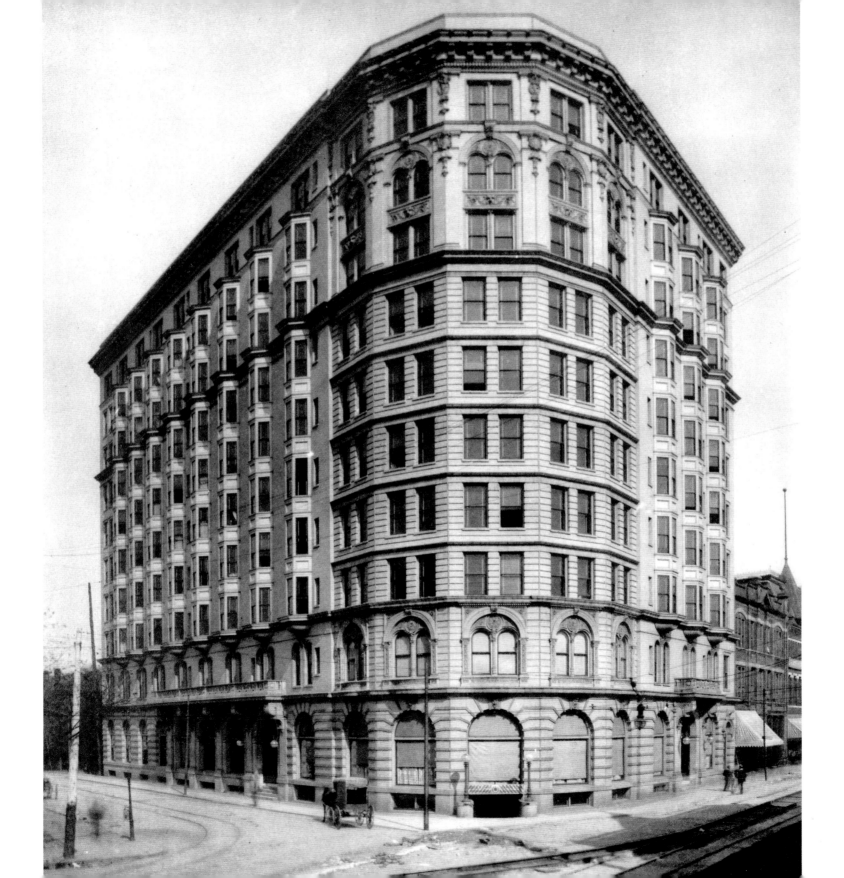

Piedmont Hotel DEMOLISHED 1966

When the Piedmont Hotel opened at the corner of Peachtree and Luckie Streets in January 1903, the *Atlanta Journal* reported that "the scene was one of remarkable beauty." Architect Willis F. Denny designed the ten-story structure with 306 guest rooms, a spacious lobby with a spiral staircase sweeping upward, separate cafes for ladies and for gentlemen, and what would quickly become one of the popular fine dining rooms in the city. All the interior furnishings were provided by the local department store, M. Rich & Bros. Company.

Denny had arrived in Atlanta after studying at Cornell University and his architectural career was quite brief—he died of pneumonia at age thirty-one—but he left a remarkable architectural legacy for the city. His surviving works include the First Methodist Church (1903); the Amos Giles Rhodes House (1903) now the Georgia Trust for Historic Preservation headquarters; Saint Mark United Methodist Church (1903); and the Victor Kriegshaber House (1900), now the Wrecking Bar Brew Pub. All these buildings were constructed utilizing rusticated granite from nearby Stone Mountain.

The Piedmont Hotel was Atlanta's first significant hotel of the twentieth century, designed at a time when the picturesque styles of the earlier century were replaced by the neoclassical style. It was termed as "modern and smart" and gained the distinction as being Atlanta's "New York Hotel." In nineteenth-century Atlanta, the hotel district had been concentrated around the downtown rail lines and the passenger depot. Beginning in the 1890s, several hotels, including the Aragon and the Majestic, located north to what became known at the time as Upper Peachtree Street.

The Piedmont Hotel hosted many well-known guests during the first three decades of the twentieth century, including President Theodore Roosevelt whose mother, Martha Bulloch, hailed from nearby Roswell, Georgia. In 1909, President-elect William Howard Taft stayed at the hotel while attending a banquet held in his honor at the newly-completed Auditorium-Armory building.

Thomas Dixon, author of *The Clansman*, a volatile portrayal of race relations during Reconstruction, stayed at the hotel while the stage production of his 1905 book was performed at the nearby DeGive Opera House. The Piedmont Hotel was owned by Hoke Smith, who promulgated his own racial prejudice in the pages of the *Atlanta Journal,* which he owned. Both Dixon's book and Hoke Smith's journalism fanned the tensions that erupted into the Atlanta Race Riot in 1906. Dixon's book would be transformed into D. W. Griffith's 1915 silent-film classic, *The Birth of a Nation.*

The grandeur of the Piedmont had faded by 1928 when it closed for a year for a complete interior remodeling. When it reopened, it advertised ceiling fans and circulating ice water in every guest room, as well as an air-conditioned dining room and coffee shop. The hotel regained popularity and remained a convenient and tasteful lodging choice through World War II.

Nevertheless, the hotel's amenities began to pale in contrast to the options of the city's newer high-rise hotels, such as the Henry Grady, Robert Fulton, and Atlanta Biltmore Hotels, all of which opened in 1924.

In May 1965, the building was purchased by the Equitable Life Assurance Company for $3 million. The city issued a demolition permit in January the following year and by May 1966, when ground was broken for the thirty-five-story International-style Equitable Building to rise on the site, Atlanta's "New York Hotel" was gone.

OPPOSITE PAGE *In 1903, the Piedmont Hotel construction is nearing completion with the main entrance façade opening on both Peachtree and Luckie Streets.*

BELOW LEFT *The distinctive curved entrance to the hotel is visible north of Trust Company of Georgia's roof-top sign in 1951. Unlike the Piedmont, other high-rises, including the Healey, the Flatiron, the Rhodes-Haverty, and the Candler buildings, all remain.*

BELOW *A souvenir cigarette lighter proclaims the Piedmont's popular location in the heart of Atlanta. At the time of its opening, the hotel was situated on the north edge of the city's business district.*

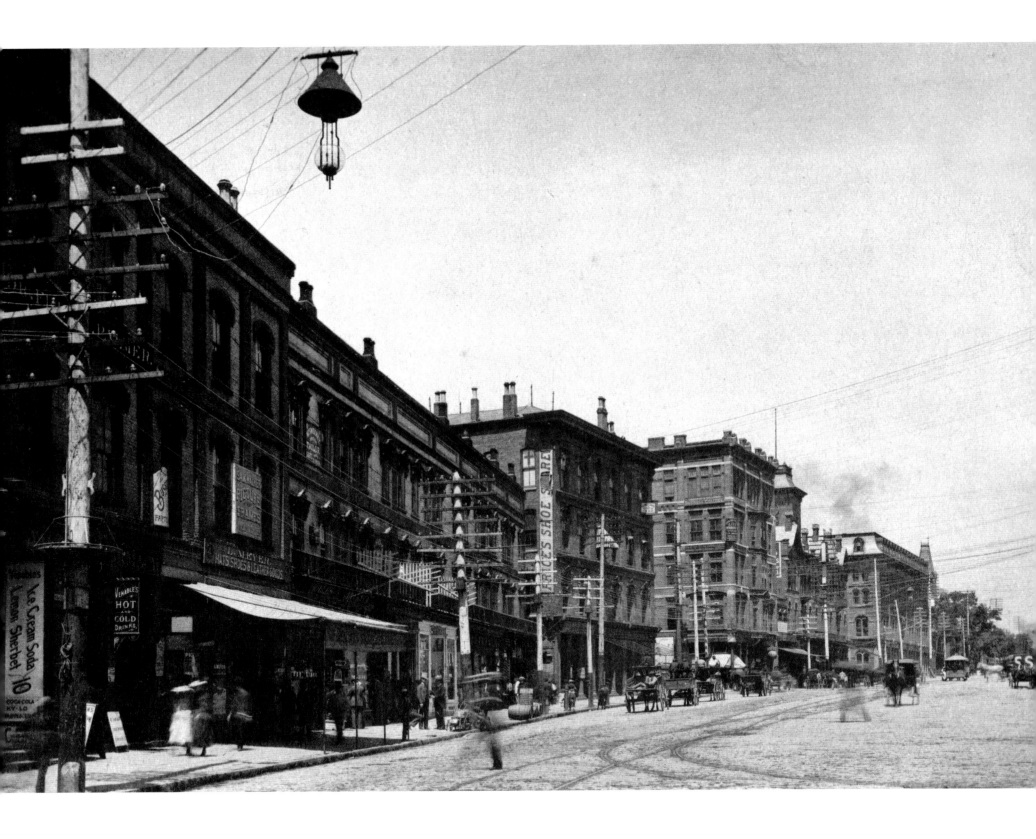

Jacob's Pharmacy BURNED 1902 / BUSINESS CLOSED 1966

In 1886, Confederate veteran Dr. John S. Pemberton perfected his patent-medicine remedy behind his home on Marietta Street. While Pemberton had invented and marketed many patent medicines, he also knew of the rapidly growing market of flavored carbonated water.

Not too far away, Dr. Joseph Jacobs operated a drugstore in the Norcross Building at the corner of Peachtree and Marietta Streets. Jacobs, born in Jefferson, Georgia, in 1859, had apprenticed as a youth in the drug business of Dr. Crawford W. Long, discoverer of the use of ether as an anesthetic. Inspired by his apprenticeship, Jacobs entered the Philadelphia College of Pharmacy and Science and on graduation entered into business in 1879 in Athens, Georgia. Five years later, with $1,500 in capital he opened his first drugstore in Atlanta—stylized as Jacob's Pharmacy. Jacobs leased his drugstore soda fountain to Willis Venable where Pemberton's concoction, the first glass of Coca-Cola, was sold in May 1886.

Venable's soda fountain sold over $150 of carbonated drinks in 1886, Pemberton, hoping for part of that market, considered his new syrup to be substantially different from his other concoctions, like Globe Flower Cough Syrup or Pemberton's Extract of Stillingia. The soda fountain had emerged in the late nineteenth century as popular local gathering places where light meals and ice cream were provided. The "soda jerk" provided customer service from behind the counter, taking his name from the jerking motion necessary to dispense the carbonated water by a lever from a pressurized tank.

In 1887, Pemberton sold part interest in his product to Venable and others, and the equipment for manufacturing Coca-Cola syrup was moved to the basement of Jacob's Pharmacy. Asa Candler, a rival druggist, acquired two-thirds rights to the product in 1888 and three years later, with expenditures totaling $2,300, became the sole proprietor of the fledgling company. By 1892, the company was incorporated to better oversee the growing business. By the end of the decade, fifteen salesmen were selling to businesses nationwide—300,000 gallons of Coca-Cola was sold at soda fountains that year.

Initially reluctant to bottle Coca-Cola, Candler permitted Joseph Biedenharn of Vicksburg,

Mississippi, to bottle the drink for local sales in 1894. A few years later, Benjamin F. Thomas and Joseph B. Whitehead contracted with Candler to establish bottling franchises at their own expense and opened their first plant in Chattanooga. They would purchase the syrup, labels and advertising materials from the company following strict instructions for their use. Whitehead opened the second Coca-Cola bottling plant in Atlanta in April 1900. By the end of 1910, 379 bottling plants existed across the country.

Early on the morning of December 9, 1902, a fire burned the central business district and Jacob's Pharmacy and the Norcross Building were destroyed. In January 1905, the sixteen-story Fourth National Bank Building opened on the site, and Jacob's Pharmacy reopened "drugstore #1" in the new building where it remained until June 1, 1963. By the mid-twentieth century, the soda fountain became less popular as a gathering place,

due in part to the automobile, the appearance of drive-ins, and the prevalence of self-service vending machines.

In 1966, the First National Bank of Atlanta located their headquarters on the site of Venable's soda fountain and constructed an adjacent forty-one-story tower. Today, the building and site are occupied by Georgia State University's Andrew Young School of Policy Studies.

OPPOSITE PAGE *In the late 1880s, the corner entrance to Jacob's Pharmacy is surrounded by advertisements for Venable's Ice Cream Sodas, Lemon sherbet, and other hot and cold beverages, including Coca-Cola.*

BELOW *The Coca-Cola Company adopts slogans for advertising purposes beginning in May 1886 with "Delicious" and "Refreshing." (Photo courtesy of Coca-Cola).*

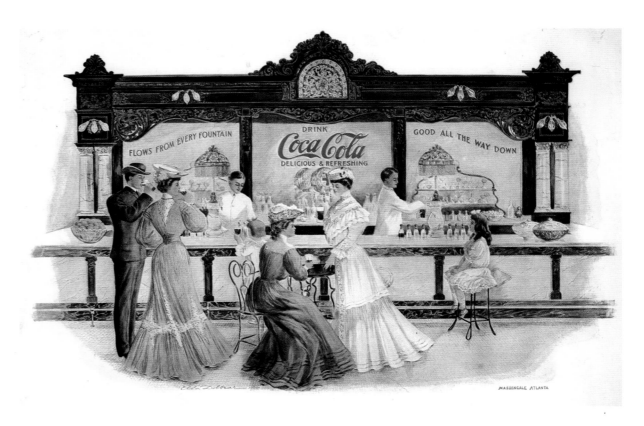

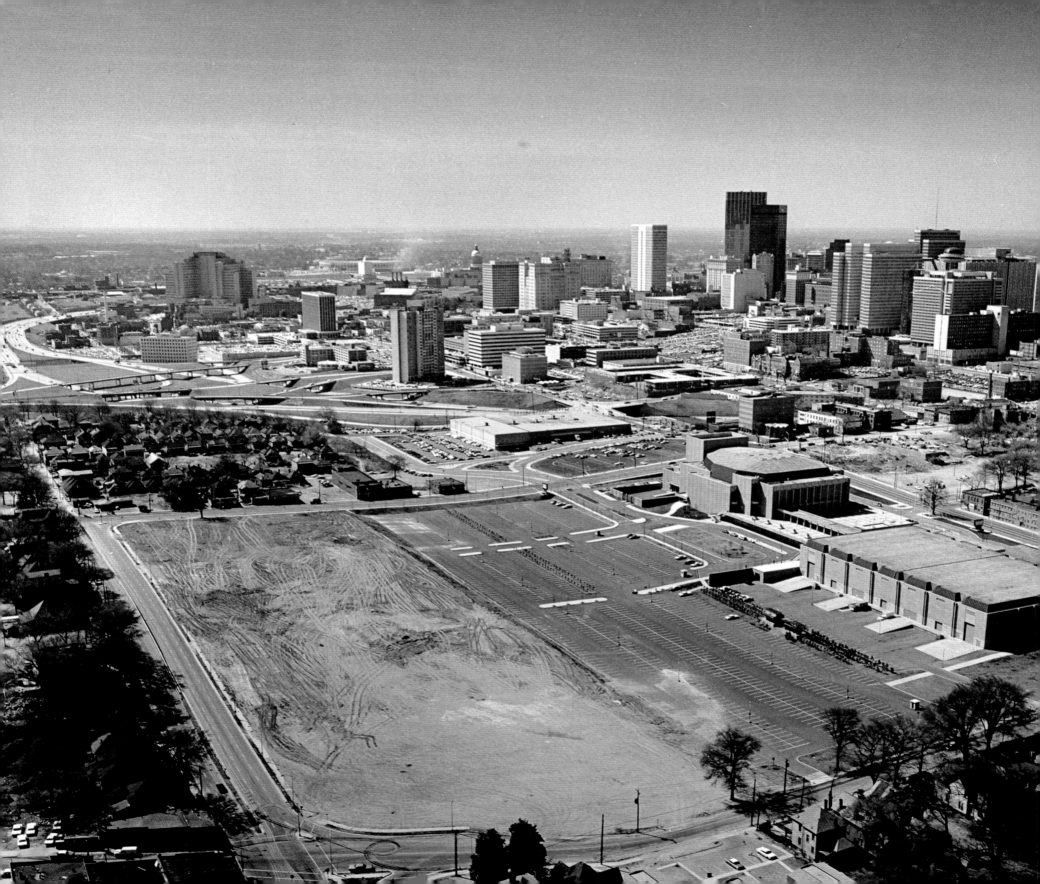

Buttermilk Bottom RAZED 1960s

As in many urban areas, Atlanta features a number of planned communities that often bear the name of their developer, benefactor, or a prestigious individual. Men such as Edwin Ansley (Ansley Park), Lemuel P. Grant (Grant Park), and Samuel Inman (Inman Park) are namesakes for some of the oldest and finest intown neighborhoods of Atlanta. Differing from the image of status and wealth are areas within the city that grew less deliberately. In some cases, their names are often unfortunately associated with despair and blight. Such is the case with the formerly named Buttermilk Bottom.

The name Buttermilk Bottom was given to a largely African American residential neighborhood on the east side of the central downtown business district, consisting mostly of wood frame, two-family or multi-family houses, and "shotgun houses." It was located in a narrow valley between two parallel ridges identified by Peachtree Street to the west and Boulevard on the east. In a 1959 report, the Atlanta Fulton County Joint Planning Board identified Buttermilk Bottom as a rectangular-shaped land mass of approximately 193 acres. The planning board recommended the area be cleared and redeveloped as the Bedford Pine Project, named for the crossing of Bedford Place and Pine Street.

References to Buttermilk Bottom appear as early as 1921 in the *Atlanta Constitution,* though it is unknown when the name was conferred. It is thought by some that the name referred to the odor originating from a battery plant in the area. Another theory holds that the smell of buttermilk, an often indispensable household ingredient in many African American households at the time, infused the air. A more plausible explanation is that the pooling of excess water on the neighborhood's unpaved streets created the appearance of buttermilk. By most accounts, the low-lying area was plagued by poor drainage and bad air.

Most all of Buttermilk Bottom residents were maids, cooks, janitors, and garbage collectors, but others were postal workers, teachers, or ministers. Nearby black institutions, such as the First Congregational Church on Courtland Street and the Butler Street YMCA, provided support to the community in the form of athletic programs for boys. Despite widespread poverty, the neighborhood featured some light industry and small businesses, including grocery stores and hardware stores that dotted the area.

In 1917, a fire of extraordinary power and reach destroyed many of the homes in Buttermilk Bottom and throughout the city's Fourth Ward. Houses of wealthy whites on Boulevard where some of the neighborhood's domestic workers were employed also burned. As the houses along Peachtree Street were replaced with office buildings and other commercial structures, the need for domestic labor dropped.

The impetus to finally develop Buttermilk Bottom came as a result of the federal government's urban renewal redevelopment program. In 1963, the city of Atlanta approved a $9 million bond referendum to improve over seventy acres at the corner of Piedmont and Forrest Avenues by building the Atlanta Civic Center. Most of the land in Buttermilk Bottom was cleared over the decade, resulting in the removal of nearly 1,500 homes and businesses in the area. Despite neighborhood protests and resistance to plans to relocate thousands of people, Buttermilk Bottom was effectively razed and the name changed to Bedford Pine in 1970. Decades later, residents who stayed still referred to their neighborhood as Buttermilk Bottom.

OPPOSITE PAGE *Developers cleared hundreds of acres in Buttermilk Bottom to make way for the Atlanta Civic Center (center right) which was completed in 1968. The remainder of the houses visible on the left side of the image would also be cleared as development proceeded into the 1970s.*

LEFT *Dilapidated houses and apartment homes in the shadow of downtown Atlanta show the poverty so endemic with Buttermilk Bottom.*

RIGHT *Buttermilk Bottom was nearly completely razed in the early 1960s. It remained that way throughout much of the decade.*

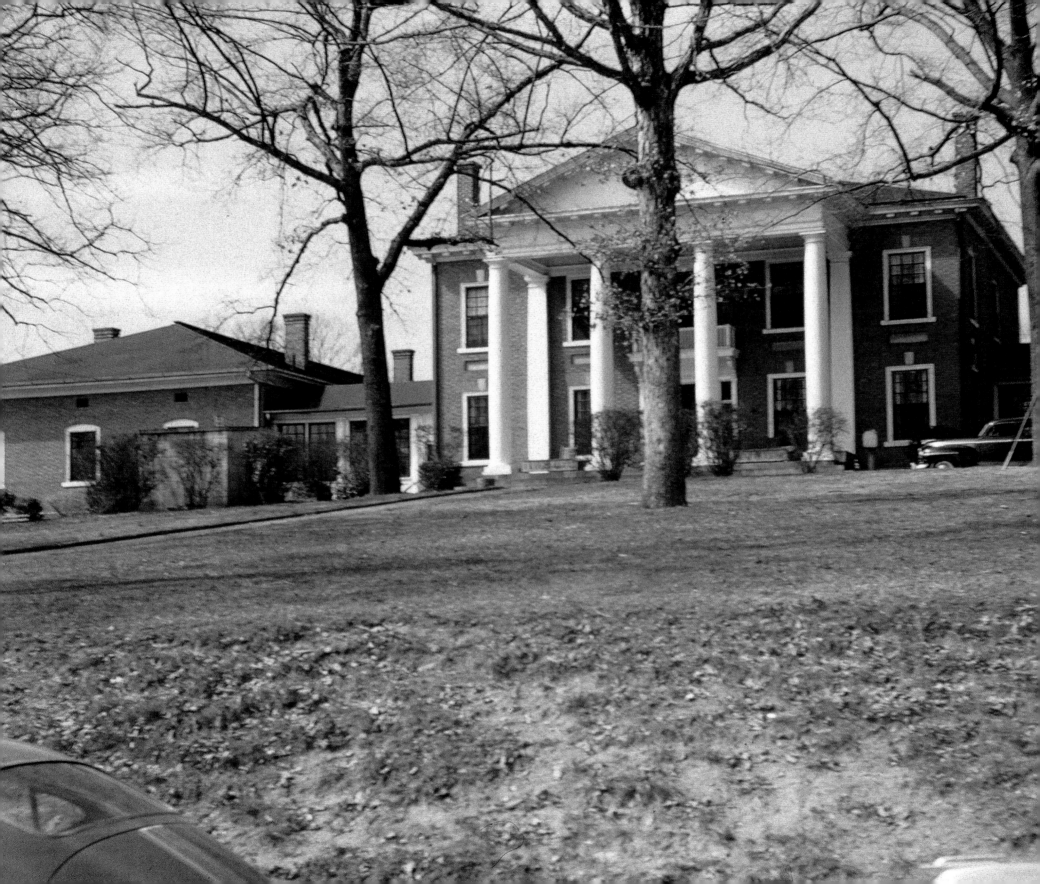

Fulton County Almshouses CLOSED 1961-1968

Prior to the establishment of a vigorous social safety net with programs administered at the federal, state, and local levels, an almshouse was the primary means by which governments sheltered and cared for their most vulnerable citizens. Almshouses—often called poorhouses—grew rapidly across the country in the nineteenth century and were mostly administered at the county level. Alms comes from the word meaning "pity" or "charity." In most cases, the internment of residents was largely voluntary and by 1900 many became "old folks homes" that cared for aged indigents.

Atlanta did not have an almshouse until 1860, which stood until 1864 when it was destroyed during the Civil War at the Battle of Ezra Church. From 1869 through 1910 an almshouse facility was located on 300 acres along Plaster's Bridge Road (now Piedmont Road) between Roswell Road and Peachtree Street. The city of Atlanta and Fulton County operated it until 1877 with Fulton County taking full responsibility for all expenses and administration thereafter. A new location was found on property two miles north of that location.

On New Year's Day 1911, over fifty residents walked or were carried in wagons to the new almshouse that stood along West Wieuca Road in unincorporated Fulton County, about nine miles north of Atlanta City Hall. The odious custom of segregation required the county to construct two houses, one for whites and one for blacks. The house for whites was a striking red brick neoclassical design by the architectural firm Morgan and Dillon, while the frame house for African Americans was handsome, but deliberately more pedestrian.

The Fulton County Almshouses sheltered individuals with severe physical ailments and the very poor and elderly. Admission to the almshouse was granted through application to the county board of commissioners. From 1932 to 1963 the almshouse was administered by Jessie Boynton. She was the first woman to have been appointed by the Fulton County commissioners to head a department and she lived on the grounds throughout her tenure.

When it opened at the new location in 1911, there were seventy-three residents, twenty-three of whom were African American. The population varied over the years, rising to over 200 during the

Great Depression but dropping off significantly in later years. Across West Wieuca Road from the buildings were over 300 acres of farm land tended by prisoners of the county, and the crops they harvested helped to feed the occupants of the almshouses.

In 1932, the almshouse was renamed Haven Home. Several years later, the farm was transformed into an eighteen-hole public golf course. As residents discovered decades afterward, in addition to providing food for almshouse occupants the farm also served as a cemetery. In 2014, a surveyor discovered dozens of graves on the site. Over the next several decades, the land around the golf course was used to build baseball fields, tennis courts, and a swimming pool.

All of these amenities are today features in Chastain Memorial Park, originally founded in 1933 and named in honor of Troy Green Chastain, Fulton County commissioner and supporter of the park.

As federal and state government began to absorb the costs for caring for the poor during the New Deal and Great Society, almshouses began to disappear. The white division of Haven Home closed in 1961 and the facility housing African Americans closed in 1968. However, both houses found use beyond the years of the almshouse. In 1969, the house for whites reopened as the Galloway School, one of Atlanta's elite prep academies. The facility for blacks is maintained as the home of the Chastain Arts Center.

OPPOSITE PAGE *The Fulton County Almshouse for whites was still in operation in 1954. It was converted to a private school in 1969 several years after it ceased being an almshouse. The building is on the National Register of Historic Places.*

ABOVE *Looking toward the western residential wing of the Fulton County Almshouse for whites—the white almshouse was built to house 145 residents while the almshouse for African Americans was built for eighty-five. In the foreground is a clubhouse for a swimming pool, one of the facilities built for Chastain Memorial Park.*

Equitable Building DEMOLISHED 1971

Atlanta's most prominent nineteenth-century structure was the Equitable Building completed in 1892 and designed by the acclaimed Chicago architectural firm of Burnham & Root. Daniel H. Burnham and partner John Wellborn Root contributed to the creation and development of the skyscraper building form. With Atlanta's Equitable Building, like earlier buildings in Chicago, the exterior was constructed of stone and brick, but steel formed the building's skeleton. The interior spaces, therefore, were much more open than older buildings of the same height.

Root hailed from Lumpkin, Georgia, and lived in Atlanta before the Civil War. With the city under siege in 1864, his father sent fourteen-year-old Root to England where he remained until 1866. He returned to the U.S. to study civil engineering at New York University, graduating in 1869. Root delivered plans to Atlanta of the Equitable Building just prior to his untimely death from pneumonia in January 1891.

The eight-story structure was commissioned by the East Atlanta Land Company headed by Atlanta businessman Joel Hurt, and financed by the Equitable Life Assurance Society. Hurt had developed the early neighborhood of Inman Park. In 1886, he chartered the Atlanta and Edgewood Street Railway Company between the neighborhood and downtown. Electric streetcars had been used successfully in other cities and Hurt decided to introduce them to Atlanta.

Across town, twenty-four Atlanta businessmen, including Joel Hurt, had founded the Commercial Travelers' Saving Bank in 1891. Two years later, board member Ernest Woodruff promoted a restructuring into a trust and investment bank. In

the fall of 1893, the Trust Company of Georgia was founded and established offices at the Equitable Building. The bank would prosper and grow with the city and the Equitable Building became their headquarters.

Early in 1969, the Trust Company of Georgia completed a twenty-six-story, marble-clad tower adjacent to the Equitable Building. Two years later, after salvaging marble architectural elements, the building was demolished.

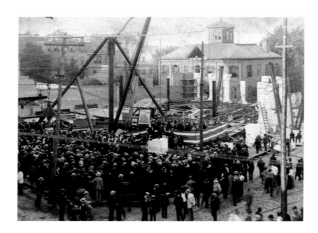

TOP RIGHT Acclaimed architect John Wellborn Root's printed funeral eulogy is placed within the building's cornerstone during elaborate Masonic ceremonies on June 25, 1891. He died of pneumonia the previous January after delivering the building plans to Joel Hurt in Atlanta.

RIGHT Both the Edgewood Avenue and North Pryor Street facades boasted identical stone entrance surrounds. New marble cartouches over the doorways were later supplied to reflect the building's status as headquarters to Trust Company Bank.

HISTORIC PRESERVATION

When the Equitable Building was demolished in 1971, historic preservation efforts in Atlanta were not well organized. While the National Historic Preservation Act of 1966 was in effect, it did not guarantee that buildings would be saved. Two years after the loss of the Equitable Building, the Georgia Trust for Historic Preservation was founded as a state-wide preservation advocacy organization.

Preservation efforts were galvanized the following year when Southern Bell announced plans to raze the opulent 1929 Fox Theatre and construct corporate offices on the site. The public rallied behind the cause to save the theater and Atlanta Landmarks, Inc., led a successful campaign in preserving and restoring the "Fabulous Fox."

In 1980, the Atlanta Preservation Center was established as a local advocacy organization. It co-founded Easements Atlanta in 1984, instituted a series of architectural walking tours, and hosts the annual city-wide Phoenix Flies tour of Atlanta historic sites each March.

As a city agency since 1975, the Atlanta Urban Design Commission nominates and regulates buildings and districts that are provided either historic, landmark, or conservation designation. The city's Historic Preservation Ordinance was enacted in 1989 seeking to insure that changes to designated properties respect the historic character of the original building or district. As a result, over seventy individual properties and eighteen districts have been brought under its protection.

OPPOSITE PAGE Massive and ornate carved marble columns at the corner entrance to the Equitable Building on North Pryor Street at Edgewood Avenue. In 2014, more than forty years after the building's demolition, three of the salvaged columns are erected at the Atlanta History Center.

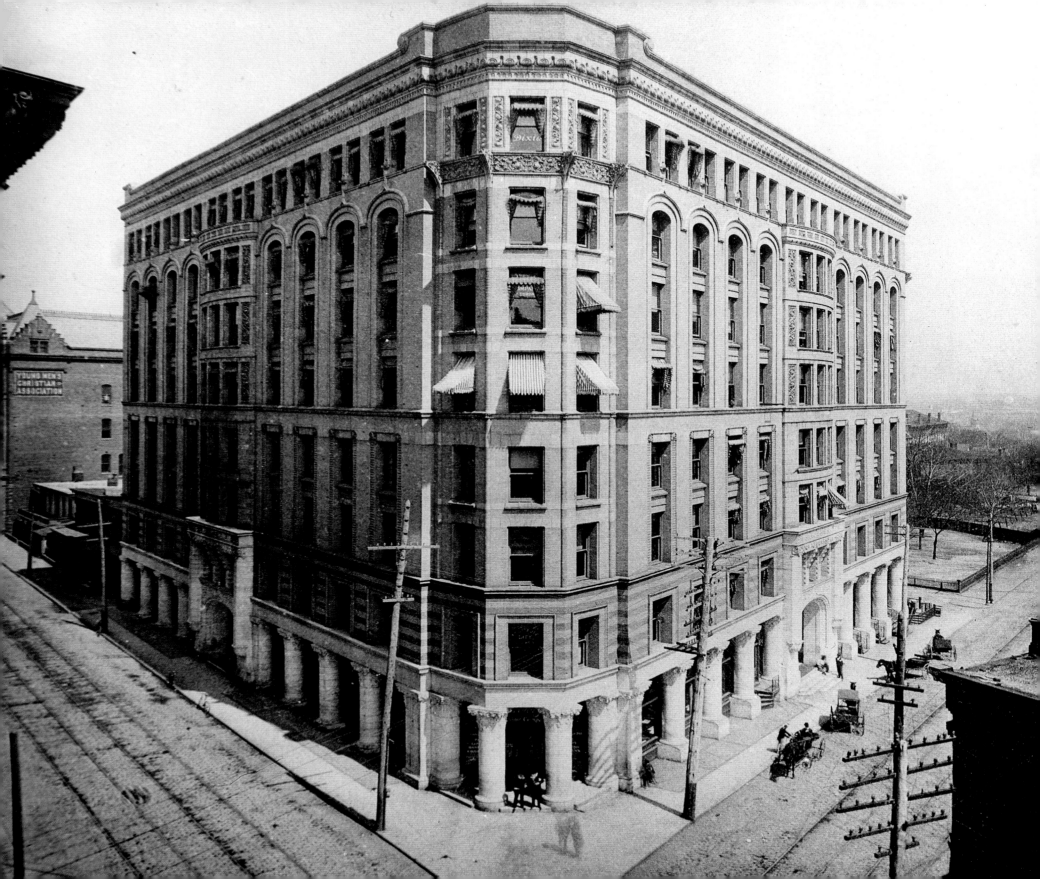

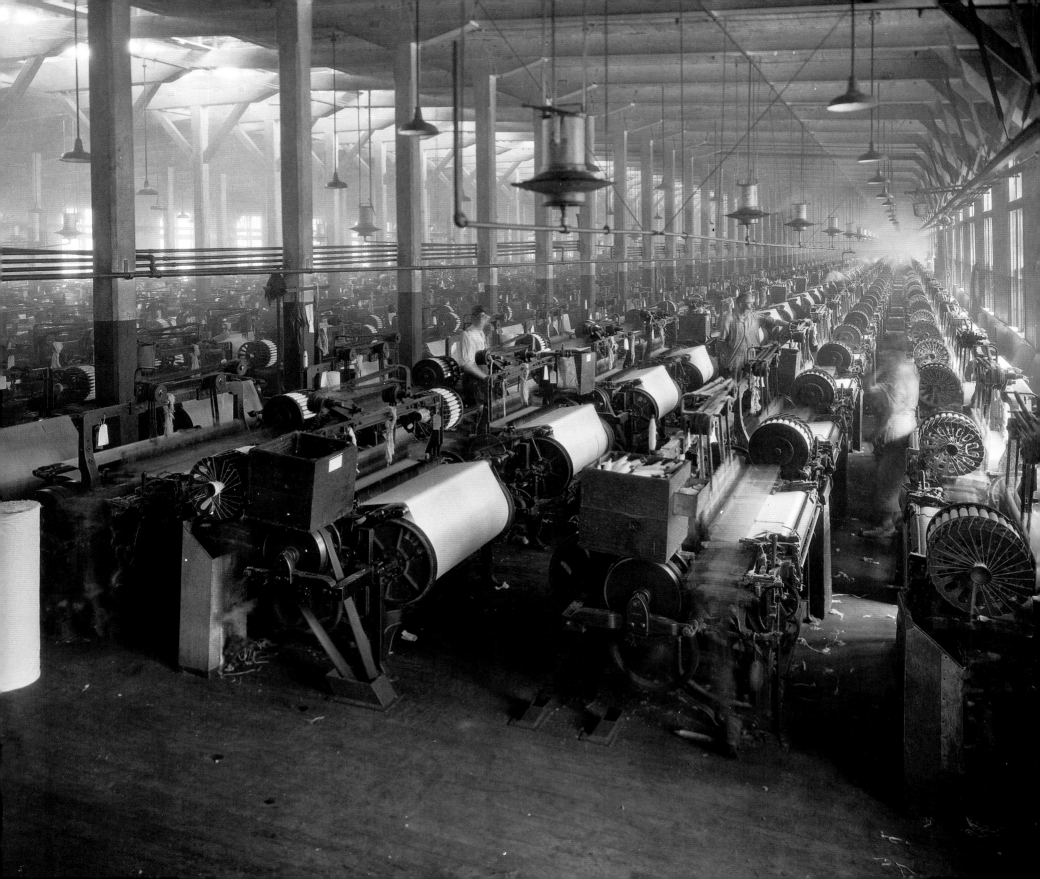

Oglethorpe Park and the Exposition Cotton Mills DEMOLISHED/BURNED 1971

Oglethorpe Park was plotted in 1870 under the direction of Hannibal I. Kimball, president of the Atlanta Cotton Factory, along what is today West Marietta Street. Dr. Chapmon Powell, a pioneer settler in the Atlanta area, sold the city just over forty-two acres at $112.50 per acre and an additional twenty acres were soon acquired.

Though not Atlanta's first park—City Park was established in 1850—Oglethorpe Park was the first large tract of land purchased by the city for recreational purposes. Used initially for the state agricultural fair, the park developed to include a track for horse racing. The park was named for James Edward Oglethorpe, founder of the colony of Georgia in 1733.

Within a decade, plans were advancing to stage a world's fair on the site to be the first international exposition held in Atlanta devoted to promote the industrial developments and economic advancements afforded from cotton. The Atlanta Cotton Exposition of 1881 included a model cotton mill outfitted with the most modern equipment and machinery.

After the Atlanta Cotton Exposition closed, the Exposition Cotton Mills Company was organized by twenty-four investors and a capital stock of $500,000. They negotiated purchase of the city property with Mayor James W. English in January 1882. The main building from the Exposition was modified to provide a six-story, nineteen-acre factory. Exposition Mills operated ten-thousand spindles, and three-hundred-and-thirty looms. The initial capacity of the mill was twenty-thousand yards of cloth per day.

Atlanta's street railway provided transportation to the cotton mill and the workers' housing village surrounding the factory. As with other Atlanta textile mills, including Fulton Bag & Cotton Mills, Scottsdale Cotton Mills, and Whittier Cotton Mills, the residents were afforded some measure of housing, health care, community services, and recreational offerings by their employer.

Exposition Mills was remodeled in 1930, expanded in 1942 and 1955, and purchased by the J. P. Stevens Company in 1962. Ultimately, the textile mills in Atlanta all suffered economic loss due to aged machinery and foreign competition. Exposition Mills closed in 1969, based on a decision of "sheer unadulterated economics." In 1971, a spectacular fire destroyed the remnants of the mill as demolition was underway.

EXPOSITIONS AND PIEDMONT PARK

The loss of the public racetrack at Oglethorpe Park precipitated the purchase in April 1887 of 189 acres of Benjamin F. Walker's farmland by the newly established Gentleman's Driving Club. Walker's stone farmhouse became the first headquarters for the club. The land provided space for a racetrack as well as the venue for what became the second cotton exposition held in Atlanta. Many of the investors in the development of the driving club were the same investors promoting the exposition.

The Piedmont Exposition opened in October 1887 and ran for twelve days, during which President Grover Cleveland visited the Piedmont Exposition with his bride, Frances Folsom. As the only U.S. President to serve non-consecutive terms, Cleveland also visited Atlanta's Cotton States & International Exposition in 1895 during his second term.

In 1904, the Piedmont Exposition Company sold 185 acres of their property to the City of Atlanta for $50,000. That land became the nucleus of Piedmont Park. Four acres were retained for the Gentleman's Driving Club, renamed the Piedmont Driving Club. The club still occupies the site of Benjamin Walker's stone farmhouse on Piedmont Avenue.

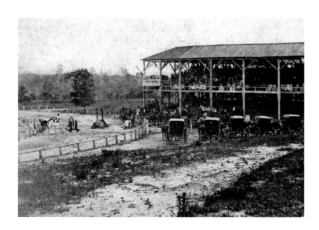

ABOVE *With a row of buggies parked in the foreground, the grandstand overlooks the track at Oglethorpe Park. Equipment on the track appears to be for jumping events rather than a race.*

RIGHT *Edward C. Peters owned five shares of common stock—his certificate provides views of both the racetrack at Oglethorpe Park and the textile mill constructed in 1881.*

OPPOSITE PAGE *Textile machinery fills the Exposition Mills in 1925. While Exposition and other Atlanta textile mills updated their machinery in the twentieth century to remain competitive, they eventually fell victim to increased production costs and foreign competition.*

Union Station RAZED 1971

On April 18, 1930, Atlanta rail passengers celebrated the opening of a new downtown Union Station. Ground was broken in the summer of 1929 for a series of twenty-eight-foot-high iron support beams, erected at railroad grade, to support the station above. The development of the city's viaduct system, intended to provide traffic bridges above the downtown rail lines, had resulted in raising street level above ground. As a result, the station was among the first buildings in the city to be constructed utilizing air rights. When the new station opened, the antiquated 1871 depot, three blocks to the southeast, was demolished.

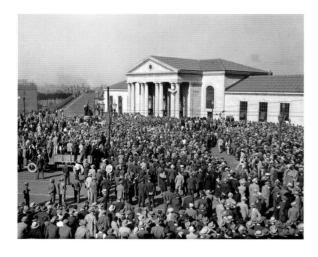

Union Station was constructed for the Georgia Railroad, the Atlanta Birmingham & Coast Railroad (later to become part of the Atlantic Coast Line), and the Nashville, Chattanooga & St. Louis Railway (which later merged into the Louisville & Nashville Railroad).

The marble-columned, classically designed station was faced with cut limestone and roofed with red-clay mission tile. The main level of the depot provided two main waiting rooms walled with Italian travertine wainscoting and textured plaster walls. Thirty-foot-high coffered and gilded ceilings covered both the 3,000-square-foot, whites-only waiting room and the smaller, segregated waiting room for African Americans. Three covered staircases led to the train platforms below, which were situated at ground level.

McDonald & Company of Atlanta served as architects and engineers for the $250,000 building. In addition, the firm designed and directed significant engineering enhancements to the Forsyth Street viaduct that provided automobile parking, a plaza in front of the station, and street access to the adjoining Spring Street viaduct. These engineering costs totaled $350,000, exceeding the cost of the station itself.

By 1955, sixty-eight trains served the station daily. Among the notable trains operating in the late 1950s was the Louisville & Nashville train, *The Georgian*, which provided popular passenger rail service between Atlanta and Chicago. *The*

Georgian debuted in November 1946 in Atlanta with a new fleet of streamlined passenger cars. The twenty-eight cars had been on order since 1944 but had been delayed in production due to World War II. Among the cars, the sleek, eighty-five-foot-long Duncan Hines Dining Car seated forty-eight diners at twelve tables.

Another iconic railroad that served Union Station through the years was the Georgia Railroad, known as the "Old Reliable" and one of Atlanta's oldest railroads. It adopted a policy after the Civil War to transport Confederate veterans home at no cost, and continued to honor the Confederate notes it had issued well into the twentieth century.

As travel by air and interstate highway became commonplace in the 1950s and 1960s, passenger traffic at Union Station dramatically decreased. The Louisville & Nashville Railroad ultimately became the last railroad to have operated at the station, ending service in May 1971. The station was razed in August of that year. While the site of Union Station itself is now a parking lot, the Omni Coliseum and later Philips Arena were both built as elevated structures in this area. Similar to Atlanta Union Station, they were constructed above the network of railroad tracks at ground level below. Remnants of a few of the station's platforms still exist alongside the tracks beneath Philips Arena to this day, a tangible reminder of Atlanta's "underground" past.

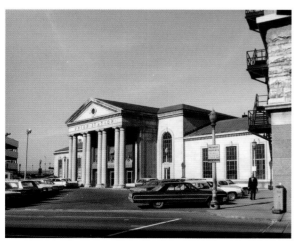

OPPOSITE PAGE *The building and the plaza in the foreground are both constructed entirely over the tracks below. As a result, riders had to descend to the ground level tracks to board the trains.*

TOP LEFT *A crowd composed almost entirely of men gathers in front of Union Station awaiting the arrival of New York Governor Franklin D. Roosevelt during the election of 1932. Roosevelt had a unique relationship with Georgia, having established a polio treatment center in 1927 in Warm Springs, where he built a home, popularly known as the Little White House.*

LEFT *Elements of the art deco style are evident over the entrance doors on an otherwise classically-inspired façade.*

RIGHT *Demolition nears completion in August 1971 after which a parking lot will occupy the site.*

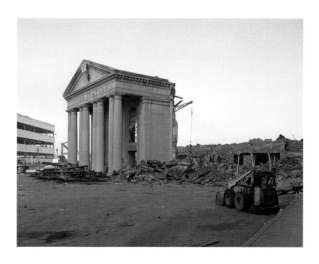

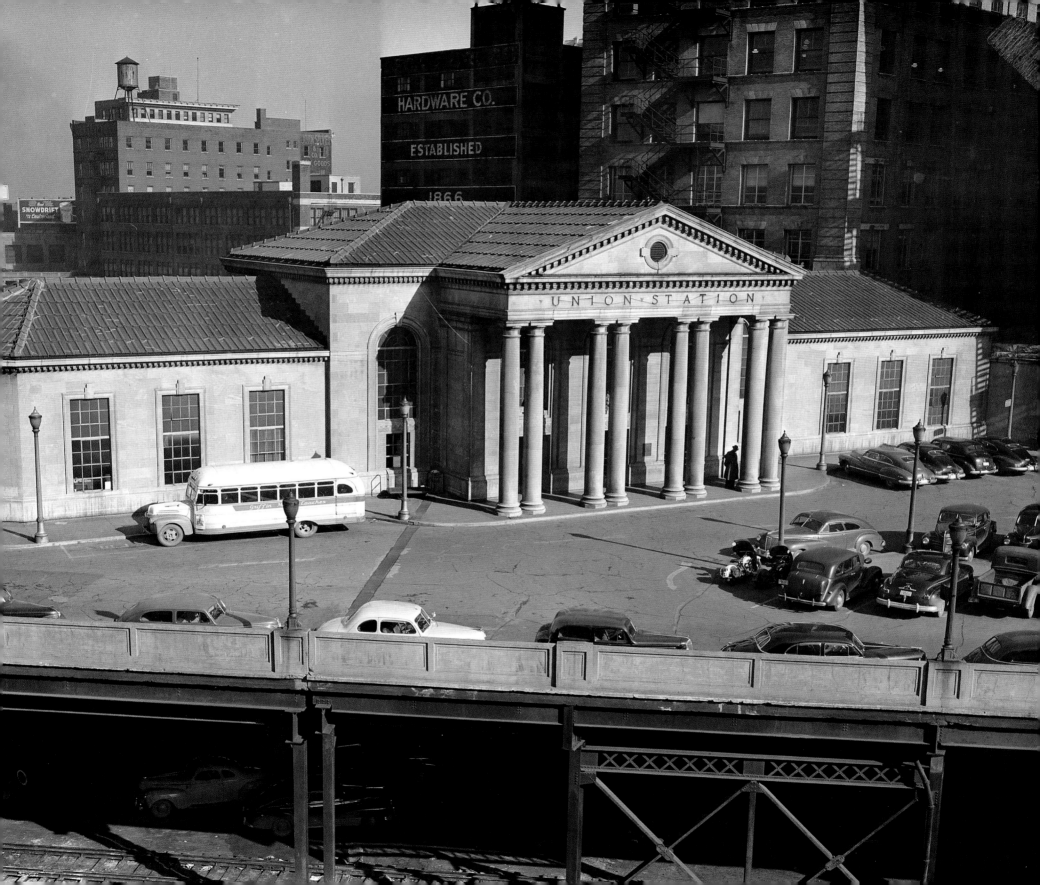

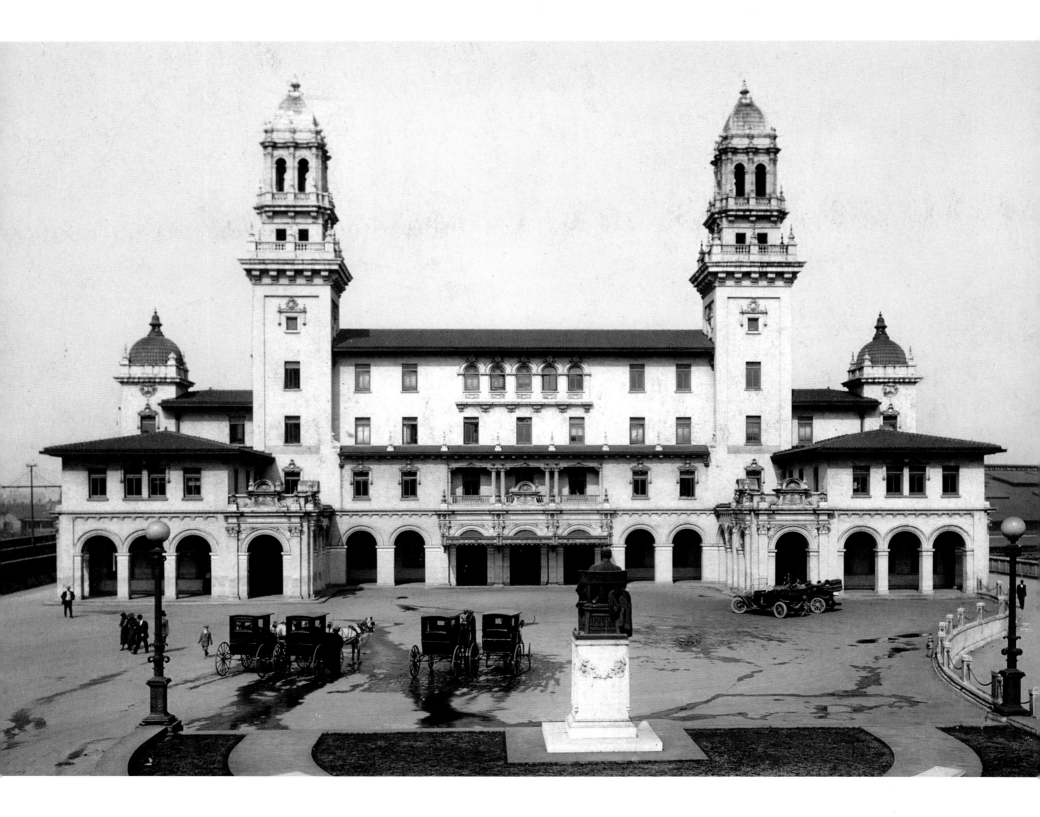

Atlanta Terminal Station DEMOLISHED 1972

When Atlanta's Terminal Station was completed in May 1905, it was recognized as one of the finest passenger depots in the world. The grand Mediterranean-Revival style station featured glazed terra-cotta ornamentation, arched entranceways, soaring domed towers, marble wainscoting, coffered ceilings, and electric lights.

Architect P. Thornton Marye designed the thirteen-acre building and accompanying train shed. Nine years prior, the US Supreme Court ruled in *Plessy v. Ferguson* that "separate but equal" facilities were constitutional. Therefore, two waiting rooms, two cafes, and two dining rooms allowed for the racial segregation of customers.

The cavernous shed was one the world's longest, extending behind the station for a length of 745 feet. Twelve tracks entered the shed, each with a capacity for two trains. Designed to handle 1,000 trains and 150,000 passengers per day, final construction costs for the depot and shed together totaled just short of $1 million.

Atlanta Terminal Company president, banker, capitalist, and former mayor of Atlanta, James W. English, sent the first telegraph from the station to New York for Samuel Spencer, president of Southern Railway, expressing his gratitude on behalf of "all who enter Atlanta's gates."

In 1925, the train shed was replaced with covered passenger platforms, and in 1940, after repeated lightening strikes, the depot's two towers were shortened by thirty-five feet compromising the station's architectural prominence. By mid-decade the station had reached its peak, typically serving 160 trains and thirty-thousand passengers per day. Though the station witnessed tremendous passenger use in the first half of the twentieth century, following World War II the automobile led to a steady decline in passenger rail travel.

The popularity of long-distance auto travel was complemented by the speed of air travel. As a result, Terminal Station lost Southern Railway $1 million annually by 1970, and the station closed that June. The tracks and platforms were dismantled and in early 1972, the mammoth landmark was down. Atlanta's remaining rail passengers were served exclusively by Southern Railway's small Peachtree Station at Brookwood that had opened in 1917.

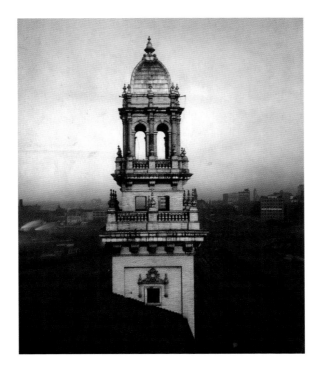

OPPOSITE PAGE The majesty and scale of Terminal Station is evident from the plaza where Daniel Chester French's statue of Samuel Spencer, president of Southern Railway, is dwarfed by the soaring twin towers of the station and the immense train shed situated behind at right. French was the sculptor of the statue of President Abraham Lincoln at the Lincoln Memorial in Washington, D.C.

A TRANSPORTATION CROSSROADS

The site that became Atlanta is a geological intersection of three granite ridges. This high ground defined watersheds and influenced natural habitats. It later guided Native American people in selecting their best paths and roads.

In the nineteenth century, the granite ridges guided civil engineers in plotting railroad routes and intersections. In the 1830s, as the Georgia Railroad approached from the east and the Western & Atlantic Railroad from the northwest, the rails aligned to the granite ridges led them to their eventual intersection. Other early towns already existed nearby, but the railroad junction was in the middle of nowhere.

Atlanta did not remain "nowhere" for very long. By 1850, the city had earned the nickname, the "Gate City." As an increasingly important railroad hub, Atlanta's growth was guaranteed. Businesses emerged and prospered. At the outbreak of the Civil War, what had begun as a cluster of railroad shanties less than three decades earlier became a military target. When Atlanta recovered from the destruction of the Civil War, it again emerged as a railroad hub.

In the early twentieth century, Atlanta embraced the promise of aviation, and the city built itself to become a global aviation crossroad. So too, the automobile has shaped and impacted the metropolitan area and the region. Decades before the intersection of interstate highways in Atlanta, the city was a crossroads for automobile traffic far beyond the region.

FAR LEFT The architectural integrity of the station was compromised after the towers were shortened in 1940.

LEFT The details of the tower domes were among the most sumptuous elements of the building.

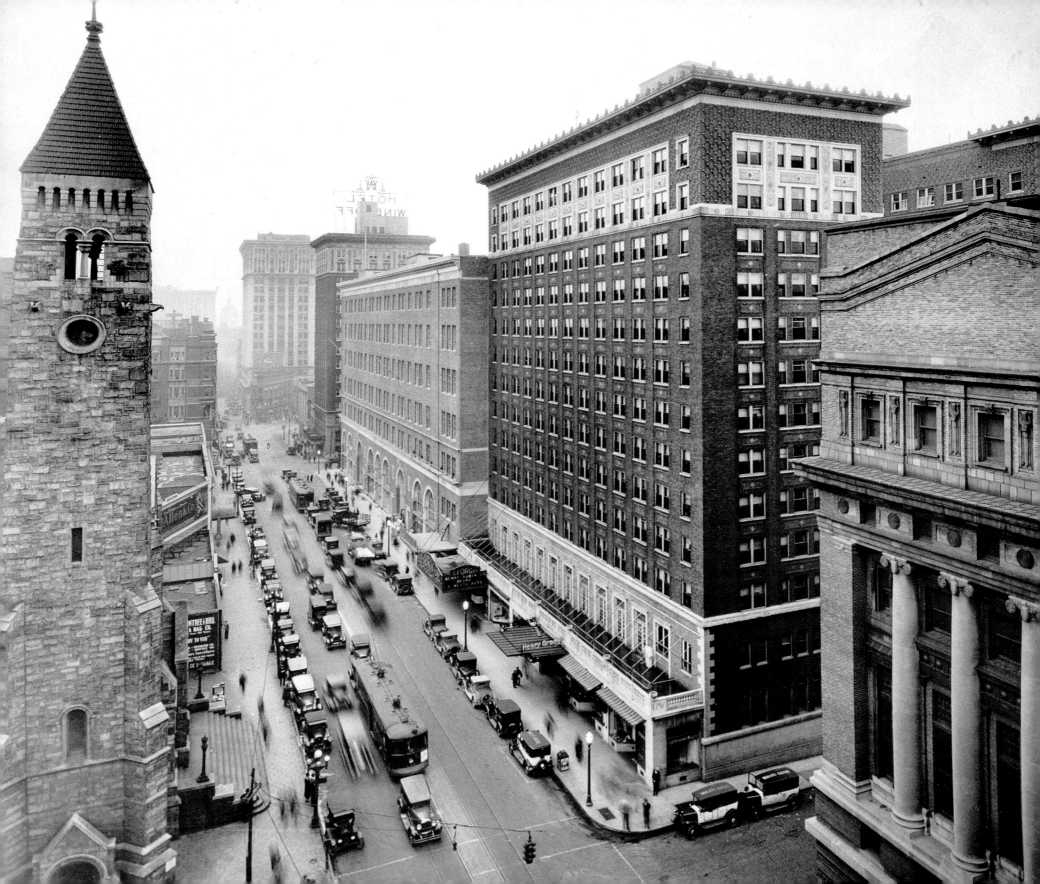

Henry Grady Hotel IMPLODED 1972

The Henry Grady Hotel opened with much fanfare on Thanksgiving Day, 1924. Excavations had begun in December 1923 on the site of the former Georgia Governor's Mansion. Cecil R. Cannon and his business partners leased the land from the State of Georgia on which to build their hotel. Architect G. Lloyd Preacher, a native of South Carolina, designed the thirteen-story structure as one of his first commissions on arriving in Atlanta. He remained to design other hotels, including the Winecoff Hotel, office buildings, apartment houses and his 1930 masterpiece, the ornate Neo-Gothic Atlanta City Hall.

The top floor rooms at the Henry Grady were numbered in the fourteen-hundreds. Owner Cecil Cannon remarked at the time, "You have no idea how many persons are superstitious regarding the number thirteen. While I have no reason to be afraid of the number, I'm not going to have it if the patrons do not want it. I've known travelling men who would sit up all night rather than occupy a room with the number thirteen."

The hotel served as state legislator's home-away-from-home as special rates were offered. Running ice water and ceiling fans were provided in every room. Journalists reported that more laws were passed at the Henry Grady Hotel than under the dome of the state capitol.

In 1948 the hotel acquired air-conditioning and the Paradise Room gained prominence as providing one of the few luncheon floor shows in the country. Andy Griffith entertained crowds with his "What it Was, Was Football" monologue and Dick Van Dyke performed his earliest stand-up comedy routines there. Other entertainment offerings at the Henry Grady included the Rainbow Roof, and—after the repeal of prohibition—the Dogwood Room provided cocktails and dancing.

The weather-worn hotel fell into decline in the 1960s just as John Portman's modern Peachtree Center began to redevelop the downtown area. The last guests at the Henry Grady checked out on May 1, 1972. Harvey B. Watts came back to the hotel's closing. He had joined the staff as a bellman in 1936, rose to Superintendent of Services, then manager of the Paradise Room, and eventually served as Vice President and General Manager before his retirement.

Portman's Peachtree Center Corporation negotiated a ninety-nine year lease on the property and a spectacular implosion brought the entire structure to the ground late in 1972. On the relatively confined downtown lot, the seventy-three-story, 1078-room Westin-Peachtree Plaza Hotel opened as the world's tallest hotel at the time in 1976.

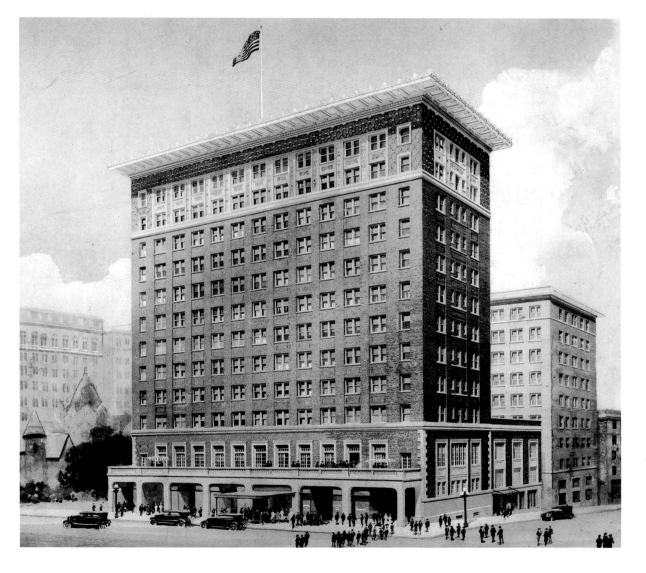

OPPOSITE PAGE *The Henry Grady Hotel is handsomely situated on the west side of Peachtree Street between the columned Masonic Temple and Davison-Paxon's Department Store. Across the street looms the granite belfry of the First Baptist Church completed in 1906.*

LEFT *Architect G. Lloyd Preacher's rendering of the Henry Grady Hotel depicts a twelve-story building. In actuality, the building became thirteen stories.*

The Strip ENDED 1973

In Lester Maddox-era Georgia, there was an area in today's Midtown Atlanta that was a haven for a community defined by their rejection of mainstream values. The area was called "the Strip" and it was there on Peachtree Street between Eighth and Fourteenth Streets where Atlanta's hippie community congregated.

The center of the area had been known as "Tight Squeeze" after the Civil War. The name referred to a shallow ravine along the present site of Peachtree and Tenth Streets, which was briefly inhabited by surly villains who sometimes victimized passersby. As the saying went, "getting through there with your life was a tight squeeze." After the street was improved and much of the ravine filled, wealthy Atlantans built stately mansions and fine schools there that sustained businesses of all types through the 1950s.

Affordable apartments and boarding houses attracted young people, some of which were drawn to the art houses, dancing schools, and theater groups scattered in the area. "Atlanta's Own Greenwich Village" was how one newspaper defined it. But as new shopping malls opened further north, business suffered and many of the area's older residents left, leaving their large, now-subdivided houses to renters.

In 1967, the economic and demographic realities of Midtown collided with the counterculture youth movement called the hippies. A small group of creative and free-thinking people began referring to the patch of city blocks along Peachtree Street as "The Strip." They were drawn to music clubs, like the Twelfth Gate, the Catacombs, the Bistro, and the Bottom of the Barrel. The area offered alternative bookstores and a radical underground newspaper called *The Great Speckled Bird*.

Nearby Piedmont Park featured free concerts by the Allman Brothers and other acts. Soon, the area was flooded with young people migrating from around the city and throughout the South. Live bands played along Peachtree Street, sometimes in the gully that had been part of Tight Squeeze. Recreational drug use, promiscuity, Vietnam War protests; all of the hallmarks of 1960s youth culture were on display. The weekend crowds, already thick with teenagers grew even more when curious onlookers from the suburbs drove up and down Peachtree Street to witness for themselves what they had been seeing on television and reading in the newspapers.

Longtime residents begrudgingly accepted hippies congregating peacefully along "their Peachtree Street." But in 1970, an influx of biker gangs and criminals who preyed on young runaways and the appearance of hard drugs led to police crackdowns. The original crowd of beatniks and true hippies soon left. While contemporaries sometimes differ on the end year of the era of the Strip, it had dissipated significantly by 1973. And while many remained tethered to the ideals of the era, most moved out and moved on.

On Peachtree Street the post-hippie Midtown of the 1970s was populated with small transient shops and adult stores. But in the 1980s, the city expanded its public transportation system, adding three MARTA subway stops in Midtown. Glitzy office buildings were built in the mid-1980s, including Fortune 500-giant IBM, which constructed a mammoth office tower in 1987 on West Peachtree Street. The building boom has continued ever since and the Strip has transformed into an area that thoroughly embraces the values of status, wealth, and consumerism once questioned by hippies.

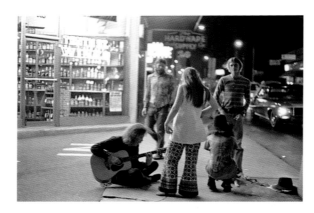

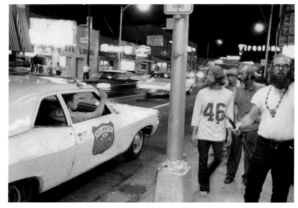

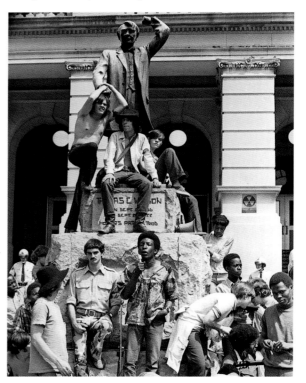

OPPOSITE PAGE *An iconic feature of the Strip was the "hippie Jesus" mural painted on the side of a building near the corner of Peachtree and Tenth Streets in Midtown. The sloped landscape that once formed Tight Squeeze is visible at the left of photo in 1970.*

BELOW LEFT *Hippies at Tenth and Peachtree in 1969 (Photo courtesy of Carter Tomassi).*

BOTTOM LEFT *A patrol car cruises along the sidewalk on Peachtree Street in July 1969. (Photos: AP Photo/Atlanta Journal-Constitution. Courtesy of Georgia State University)*

BELOW *Protesters at an anti-Vietnam War demonstration swarm the monument of populist Thomas Watson at the Georgia State Capitol in May 1970.*

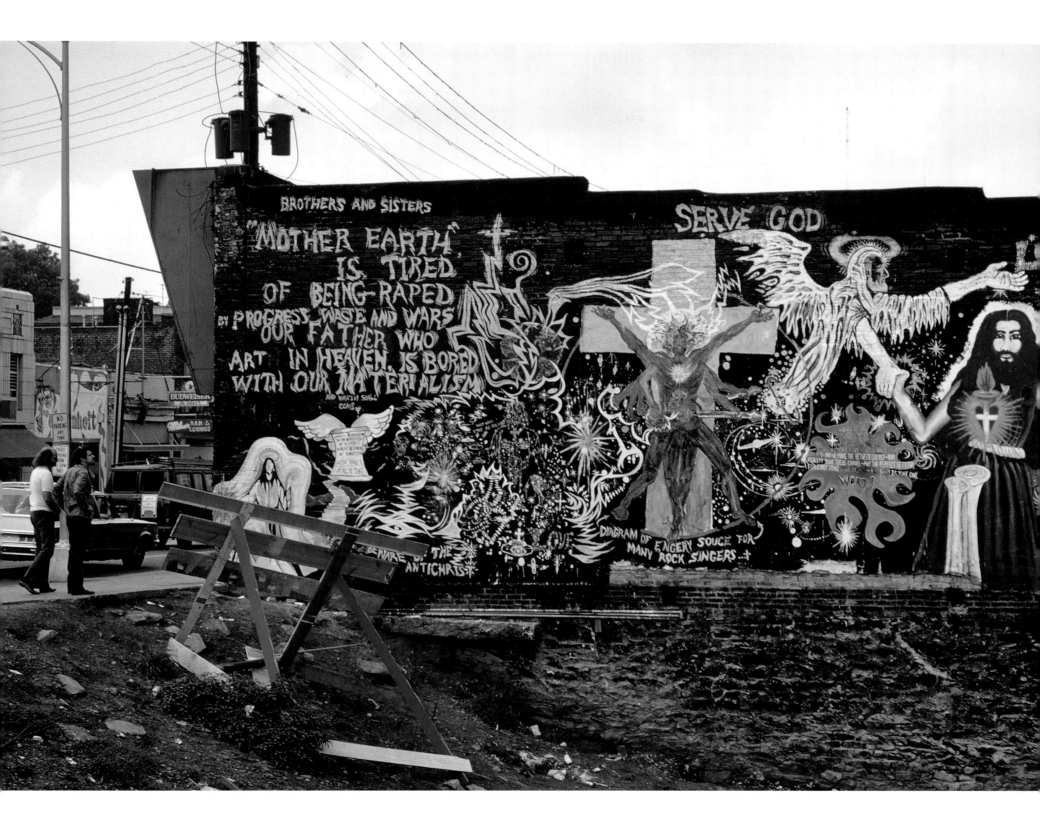

Top Hat Club / Royal Peacock CLOSED 1973

In the 1930s in the midst of the Jim Crow South, segregation prevailed throughout Atlanta nightclubs and music halls, including the dance floor. The Top Hat Club was founded on Auburn Avenue in 1937 as an African American nightclub by businessmen Jessie B. Blayton, Lorimer Milton, and Clayton R. Yates. At the time, Auburn Avenue was the site of a thriving African American business community. Known as the "richest Negro street in the world, it was dubbed "Sweet Auburn" and included a variety of black businesses and professional services, churches, and the *Daily World*, the nation's first black daily newspaper.

Built in the 1920s, the original building contained two store fronts: one a restaurant and the other the night club. During its decade of business, the Top Hat Club was one of Atlanta's finest African American clubs. Though African Americans were barred from attending white dance halls and clubs, whites often patronized black nightclubs known for having some of the best musicians and entertainers in the South.

In 1949, former circus performer and businesswoman Carrie "Mama" Cunningham bought the Top Hat Club and remade it into the Royal Peacock, marketing it as "Atlanta's Club Beautiful." Cunningham possibly bought the club for her son, jazz musician "Big Red" McAllister Evans, in an effort to keep him grounded – and out of trouble. She decorated the establishment in an Egyptian Revival motif and decorated it with peacock feathers, some flowing from the club's upper windows.

For his part, Evans used his connections from touring on the "chitlin' circuit" to book what became some of America's biggest acts and most famous musicians. The circuit was comprised of theaters and other locations in the nation that provided venues for black performers during segregation. In addition to the Royal Peacock, Southern sites on the circuit included the Royal Theatre in Baltimore, the Hippodrome in Richmond, and the Ritz Theatre in Jacksonville.

For the Royal Peacock's customers, the playbills are an entertainment dream and included some of the most famous American musicians of all time. B.B. King, Aretha Franklin, Muddy Waters, Fats Domino, the Drifters, local Atlanta artist Gladys Knight, Ben E. King, Ray Charles, Stevie Wonder,

Miles Davis, the Four Tops, Otis Redding, Marvin Gaye, Etta James, and "Little Richard" Penniman all played the Royal Peacock. At the time, most were unknown artists, attesting to the nightclub's importance as an "incubator" for talent – talent that then went on to become national headliners at venues such as New York's Apollo Theater or on *The Ed Sullivan Show*.

Importantly, the location of the Royal Peacock on Sweet Auburn gave it a front row seat to the Civil Rights Movement. Music has the ability to break down social barriers and the Royal Peacock served as a conduit for social change and acceptance. Although situated in a segregated Southern city, inside the Royal Peacock whites and African

Americans shared a love and passion for jazz and rock and roll music that brought them together, if only for a few hours a night.

The club evolved as the music did, from jazz to rock and roll, and into the disco era. In 1973, Mama Cunningham passed away and the Royal Peacock closed as Sweet Auburn went into decline. The neighborhood has since revitalized and the building has changed hands several times, even reopening as a new Royal Peacock for a period of time. Just as entertainers of the 1950s and 1960s got their start at the Royal Peacock, a new generation of young African American artists now regard Atlanta as the capital of the African American music scene.

OPPOSITE PAGE *The Top Hat Club was known as "Club Beautiful," a title that remained with the club as it changed owners and names in 1949 and became the Royal Peacock. New owner Carrie "Mama" Cunningham, named the club after her favorite bird. The iconic building still stands on Auburn Avenue and was featured in Atlanta hip-hop group OutKast's music video for their hit song* Rosa Parks *in 1998. Atlanta remains an important base for African American music, considered the "center of gravity" for hip-hop.*

LEFT *Atlanta businesswoman Carrie "Mama" Cunningham bought the Top Hat Club on Auburn Avenue in 1949 for her son, McAllister Evans, a traveling musician. Cunningham circa 1945, was a vivacious lady who was known to pamper her entertainers and show her patrons a good time. (Photo:* Atlanta Journal-Constitution, *courtesy Georgia State University.)*

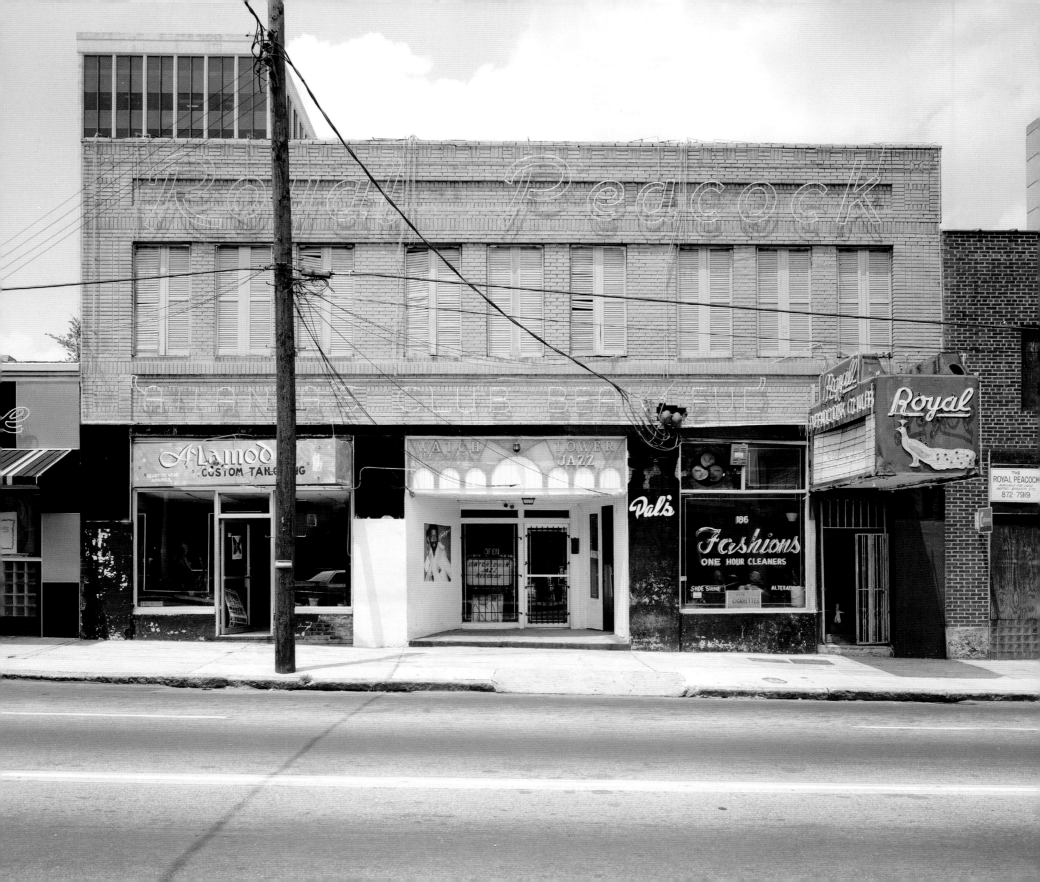

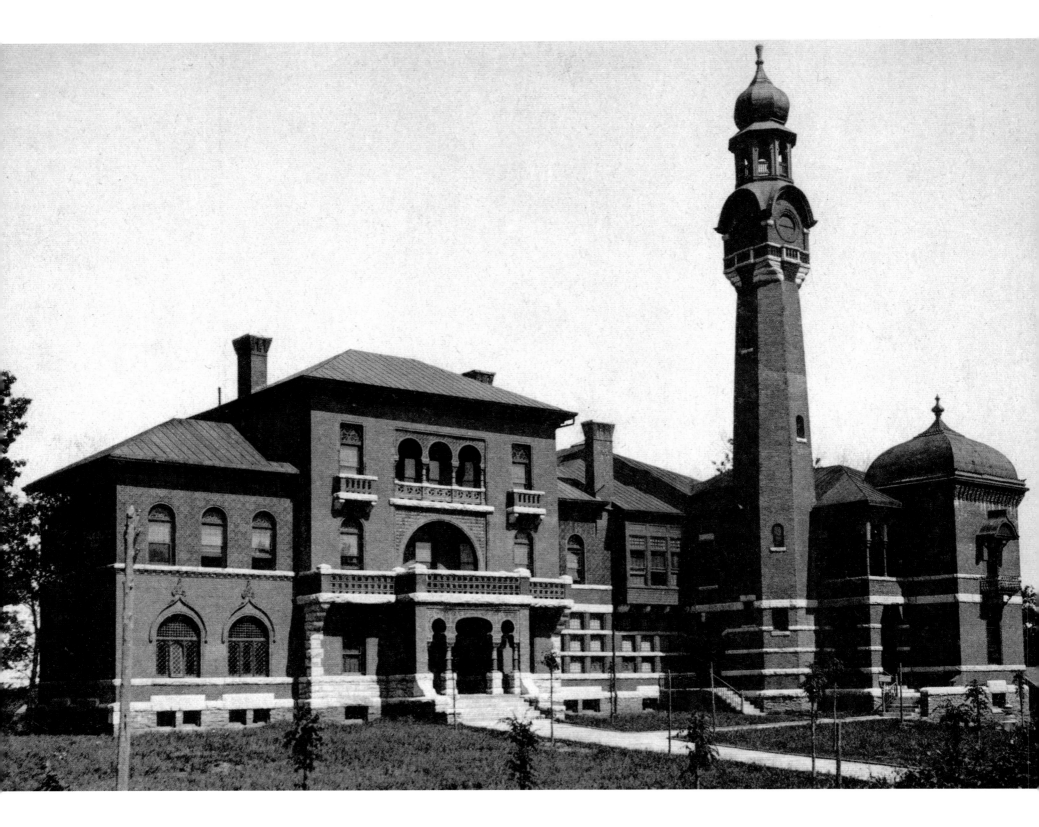

Hebrew Orphan Asylum **RAZED 1974**

Jewish orphanages and foster homes in America date to the mid-1850s when philanthropists, such as Rebecca Gratz, helped found the Jewish Foster Home in Philadelphia. Orphanages were established for Jewish orphans and otherwise impoverished children who, it was feared, would grow up without a sense of Jewish culture and faith. Many of those housed in orphanages were children of recent immigrants from Eastern Europe who arrived in American between 1880 and 1920. Most Jewish orphanages in the United States were established in the Northeast.

Discussions about an orphanage in the South resulted in a meeting in Atlanta in 1886 when it was resolved that a facility should be built in either Washington, D.C., Richmond, or Atlanta, dependent on which city raised the funds. Ultimately, Atlanta was selected as the site and the cornerstone was laid in 1888 at 478 Washington Street south of downtown. Originally called the Hebrew Orphan Asylum in 1889, the name was changed to the Hebrew Orphan's Home in 1901.

The first residents were a dozen children from the crowded orphanage in Baltimore as well as nine from several Southern states. It was initially operated by the Atlanta B'nai B'rith Lodge, though supported by foundation grants, endowment funds, and contributions from the community. In 1924, funds from the Atlanta Community Chest were allocated for the operation.

The facility was managed by its superintendent, Ralph Sonn, assisted by a small staff of nurses, doctors, and cooks until he retired in 1924. Soon after opening, the orphanage ran out of space to house additional children, prompting officials to create an extension to double its capacity in 1895. Space was provided for nearly 140 beds in the home. The children of the orphanage attended school at Fraser Street School for their formal education, but also received vocational training, music lessons, and religious instruction at the home.

By 1910, administrators decided that institutional care provided throughout childhood was not in the best interests of their charges. Instead, it sought to place children in foster homes or with their mothers, which the home subsidized. The facility on Washington Street still housed children, but by 1930 none resided full-time. In 1938, the organization vacated the building, which was then occupied for many years by Our Lady of Perpetual Help Cancer Home, a center providing free care to terminal cancer patients. The building was razed in 1974, and the land where it once stood is a parking lot.

In 1948, the Jewish Orphan's Home changed its name to the Jewish Children's Service and the organization altered its focus from providing shelter and care for orphans to facilitating adoptions and foster homes. The name changed again in 1988 to the Jewish Educational Loan Fund to reflect its practice of providing interest-free loans to Jewish students.

OPPOSITE PAGE *Designed by architect Gottfried L. Norrman, the Hebrew Orphan Asylum was built at a cost of approximately $75,000. The building housed orphans from states contained in the fifth district of B'nai B'rith, which included the District of Columbia, Virginia, Maryland, the Carolinas, Georgia, and Florida.*

LEFT *Moorish in design, the Orphan Asylum was about 150 feet in length and 100 feet deep, finished in brick and terra-cotta. The 118-foot tower contained a clock and a dome-shaped cupola.*

ABOVE *These decorative terra-cotta ornaments with leaf and ribbon design were pieces of the orphanage on Washington Street saved when the building was levelled in 1974. The ornaments are in the collection of the Atlanta History Center.*

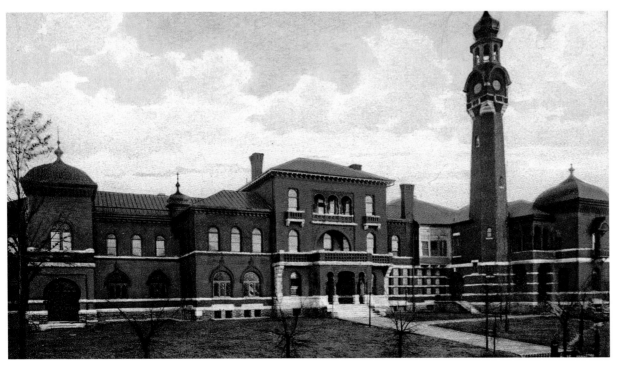

Carnegie Library DEMOLISHED 1977

The first library in the city of Atlanta, opened in 1867, was a small affair in rented rooms on Alabama Street. The library was begun by the Young Men's Library Association (YMLA), a new organization consisting of "a few earnest young men" under the leadership of Darwin G. Jones. After a brief peripatetic existence, the YMLA expanded enough to buy their own building on Decatur Street between Forsyth and Pryor Streets in 1881.

By 1892, the Decatur Street location was inadequate for the library, and the association purchased the old Markham House on Marietta Street, moving in the following year. According to the *Atlanta Journal*, the new location included "rocking chairs for the fair sex while they perused *Godey's Lady's Book* before an open fire" and a tennis court for "elegant young gentlemen when the classics palled."

The YMLA Library, although open to the public, was supported by membership, not city funds, and only members who paid $4 per year, could check out materials from the library. In 1899, during attorney (and father of Margaret Mitchell) Eugene Mitchell's presidency of the YMLA, businessman and philanthropist Andrew Carnegie's Southern

representative, Walter M. Kelly, was invited to join the organization. Kelly persuaded Carnegie to donate $100,000 to the YMLA to build a public library for the city of Atlanta on the condition the YMLA Library would merge with the new fully public library.

Accordingly, the association purchased a site on the southwest corner of Forsyth Street and Church Street (now Carnegie Way) for $35,000 and offered the site and their collection of 20,000 books to the city in February 1899. The building, named the Carnegie Library of Atlanta, was designed in the Beaux-Arts style by New York architecture firm Ackerman & Ross. Construction began in 1900 and the building opened to the Atlanta public on March 4, 1902. Carnegie also provided funds to establish branches on Luckie Street, Capitol Avenue, and a branch for African Americans on Auburn Avenue. Atlanta became the first city in the southeastern United States to have a municipally supported public library.

The Carnegie Library served as the main public library for the city for the next seventy-five years with several additions, including one in 1950 when Mayor William B. Hartsfield referred to the library as his "alma mater" and "the poor man's university." By 1977, however, the library could not be expanded further and was too small to serve the growing city. Despite a campaign to save the building, it was demolished to make way for the present Central Library & Library System Headquarters of the Atlanta-Fulton County Public Library System.

ANNE WALLACE HOWLAND (1866-1960)

When Atlanta opened its public library in 1902, the librarian in charge was Anne Wallace. She was librarian of the YMLA library beginning in 1893 and had played a large role in the founding of the Georgia Library Association in 1897. Without the efforts and influence of Wallace, the Carnegie Library of Atlanta may not have been realized. When construction delays depleted Andrew Carnegie's initial finances, Wallace was dispatched twice to New York and personally convinced Carnegie to grant an additional $45,000 to complete and furnish the building.

Once complete, Wallace and her small staff soon realized the need for trained library employees. In 1905, she again sought help from Carnegie, convincing him to provide $4,000 per year for a three-year pilot program to establish a library training school in Atlanta. Ultimately, she persuaded him to make the funding permanent. The Carnegie Library School of Atlanta was the first library training school in the southeastern United States.

Wallace left the Carnegie Library in 1908 to marry Max Franklyn Howland, but returned to librarianship following his death in 1922. She was hired by the Drexel Institute in Philadelphia to reestablish their library training school, where she served as dean until 1937.

OPPOSITE PAGE *The Carnegie Library of Atlanta stands on the corner of Forsyth Street and Carnegie Way, ca.1910, a few years after its construction. It was completed at a cost of $145,000.*

LEFT *Following demolition of the Carnegie Library, some of the columns and portions of the façade were saved. Today, they stand in Hardy Ivy Park at the intersection of Peachtree and Baker Streets in downtown Atlanta. The park is named for the man who has traditionally been credited as the first permanent white settler in what is now Atlanta.*

Southeastern Fair ENDED 1978

Agricultural fairs were certainly nothing new by the time Atlanta's boosters, movers, and shakers decided to create their own in 1915. The tradition of staging state fairs goes back to 1841 when New York held such an event in Syracuse. Georgia's own State Fair traces its history to 1850, and most of the 159 counties in the state of Georgia have participated in agricultural fairs since then. It is a largely rural tradition that helps build a sense of community identity.

The Southeastern Fair was organized in 1915 as an economic measure to support agriculture and associated industries throughout the region. The Atlanta City Council, Fulton County Commissioners, and Atlanta Chamber of Commerce each contributed $75,000 toward improvements at Lakewood Park where the fair was held. Lakewood Park was located five miles south of downtown Atlanta and featured over 300 usable acres.

Two exhibition halls were constructed and an access road was developed. Prior to building, planners suggested erecting a stadium to help attract the 1916 Olympic Games that had been scheduled for Berlin, but were under threat of cancellation because of the outbreak of World War I.

The Southeastern Fair Association that organized the annual event was owned by the Atlanta Chamber of Commerce. The Association leased over 130 acres of Lakewood Park for the fair from the city and also operated the property year round to accommodate other shows and exhibits and to run the amusement park. The fair usually lasted about ten days and opened in late September or early October. It was billed as "Georgia's Largest Annual Event."

The primary proceedings of the first fair were livestock exhibitions and displays of agriculture and domestic products, but the scope expanded to include spelling bee contests, circus performers, beauty pageants, parachute jumps, free movies, nightly fireworks displays, and the annual Homemaker of the Year award.

Some of the top attractions of the fair were the bumper cars and thrill rides, which included a giant wooden roller coaster known as the Greyhound. Other amusement park attractions included the "Rock-O-Plane," the "Dodgem," the "Moon Rocket," and the "Octopus." For decades, the opening of the fair was initiated by a giant balloon parade down Peachtree Street featuring circus animals, floats, military units, and marching bands.

The event also featured low-brow attractions, such as (often rigged) games of chance, sword swallowers, knife-throwers, and grotesque oddities, like Reptile Boy, Ape Girl, Jo-Jo the Dog-face Boy, and the Human Blockhead who drove nails through his block-shaped dome.

At Lakewood Speedway's dirt race track, auto races and daredevil stunt cars included showmen

OPPOSITE PAGE *Race car drivers, including Jap Brogdon —whose name is misspelled on the door of his car—graced the track at the Lakewood Speedway at the Southeastern Fair for many decades. Brogdon was one of the more prominent names on the local racing circuit.*

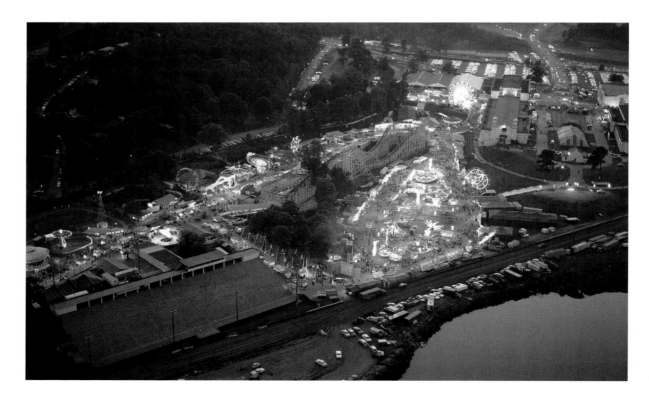

TOP RIGHT *A photographer's long exposure captures the movement of the Ferris wheels at the fair in the early 1940s.*

RIGHT *An aerial view from the late 1960s displays the scope of the area used for the fair. The exhibition halls are located on the right side of the image and the edge of the lake at the bottom.*

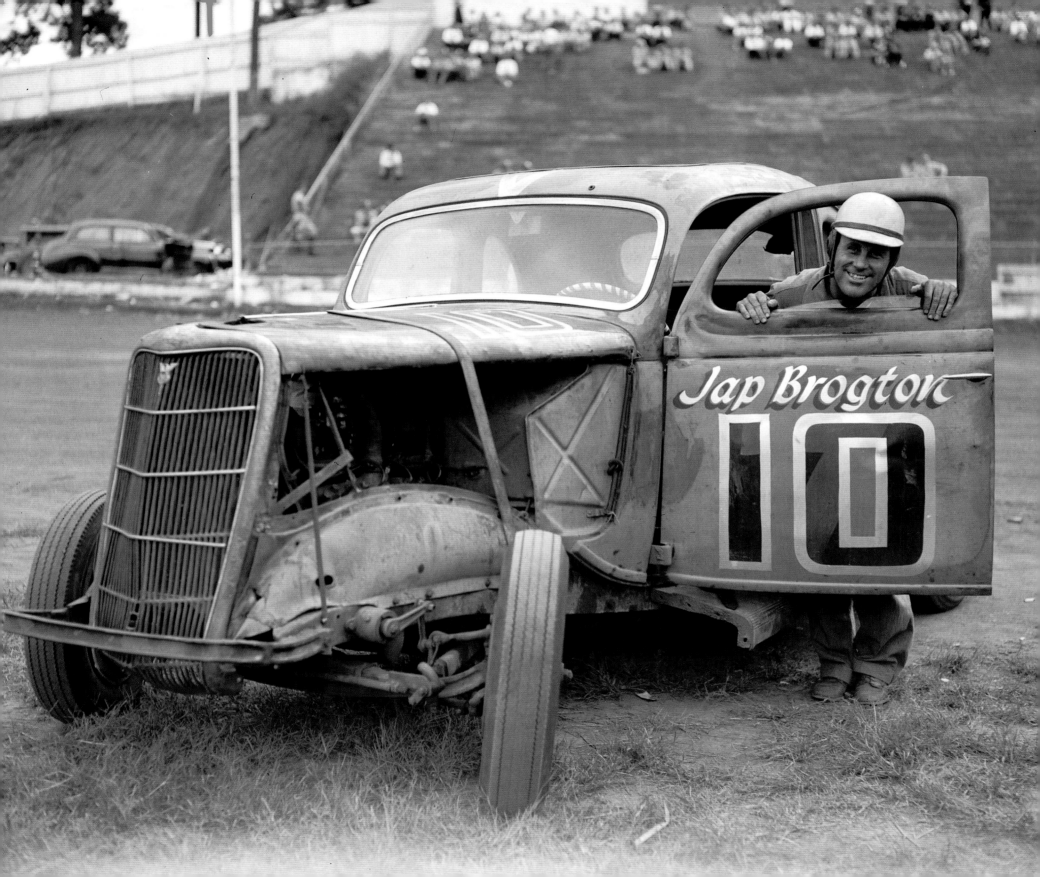

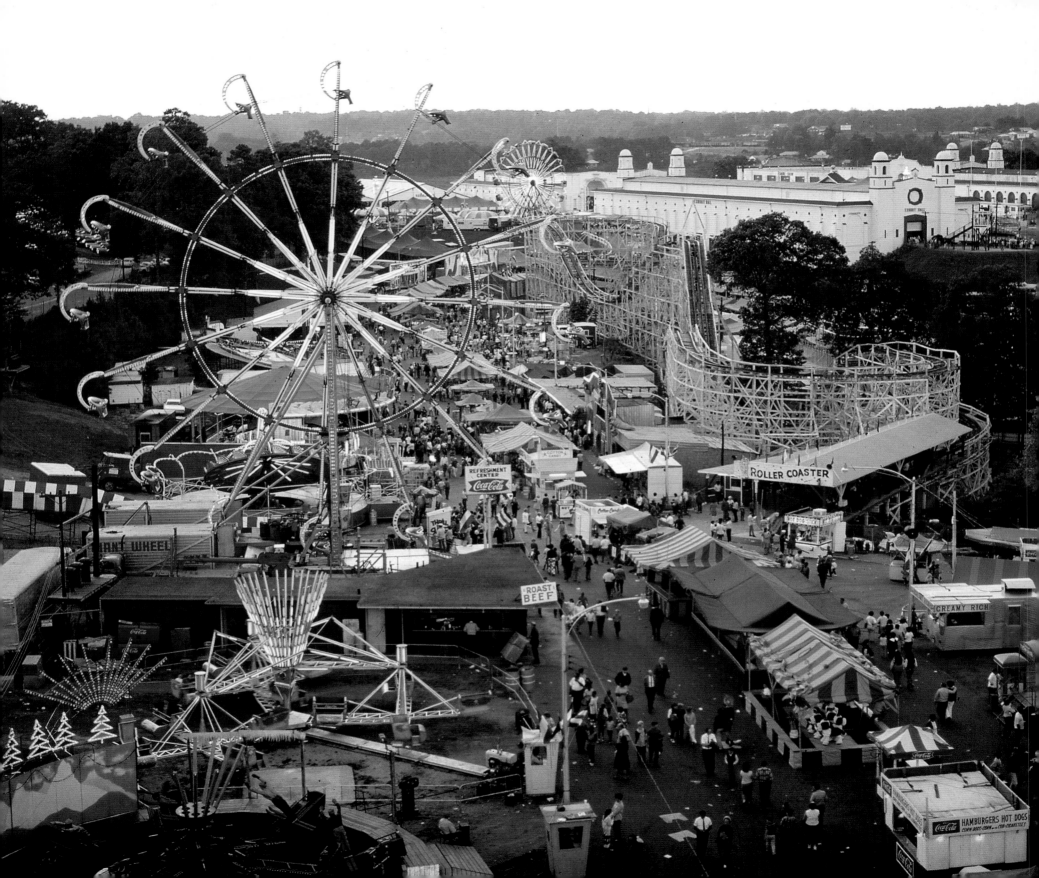

The Ramblin' Raft Race ENDED 1980

The Ramblin' Raft Race was a spectacular culture phenomenon of the 1970s that had all the elements of the era one would expect: youth, beer (plus other intoxicants), and lots of fun. Part Woodstock and part Peachtree Road Race, the event was usually held on a Saturday in late May from 1969 to 1980 on the Chattahoochee River.

For many, the occasion served as the unofficial kick-off to summer. The event began as a competition when Delta Sigma Phi fraternity brothers from Georgia Tech challenged the staff of Top-40 radio station WQXI. That first race drew roughly 500 participants in fifty rafts and inspired similar races in other Southern cities. While there was a competitive aspect to the event, for many participants and onlookers it was more of a ramblin' party than a race, as people soaked up the sun, fun, booze, and loud rock music.

The course changed slightly over the years, but generally ran from Morgan Falls near Sandy Springs in north Fulton County and continued for about nine miles southwest down the river just off Georgia Highway 41 near Interstate 285 in Vinings. In 1971, the race grew to 20,000 participants, some of which came to Atlanta from as far away as Canada. The race was filmed that year for a documentary, *The Great American Raft Race*.

Later in the decade, the event drew national news coverage from CBS and Dan Rather. Onlookers watching the race from along the course of the river bank and on highway overpasses added to the festival-like atmosphere. The partying often

began on buses that transported spectators from the starting line, to the banks of the river near the notorious Riverbend Club Apartments, and then to the finish line miles ahead. Sometimes Riverbend hosted a pre-race party on Friday night. At its height, the race drew an incredible 300,000 spectators and participants. *The Guinness Book of World Records* called it the world's largest outdoor spectator sporting event.

The race was also known for the creative and unusual raft designs. Designers created Titanic replicas or sat automobiles on top of wooden rafts. The race organizers created competition divisions based on the type of vessel used with the more elaborate designs entering the Showboat Division. The more mundane entries used rubber rafts, kayaks, and inner tubes. Occasionally, some less-well-thought-out designs periodically wrecked on the river's mini-rapids, tossing passengers and beer coolers into the cold waters of the Chattahoochee. Many rafts were stitched together

with lumber, oil barrels, scrap metal, rubber, and masts made from bed sheets and often festooned with witty and risqué language.

By the late 1970s, many in the community had enough of the festivities. Residents of the fine homes along the river complained of loud music, lewd behavior, and refuse left by party-goers. The largest threat to the event came in 1978 when President Jimmy Carter signed a bill creating the Chattahoochee River National Recreation Area. Federal control over the race course meant more strict law enforcement and citations curbed the enthusiasm of the contestants.

In 1980, a rafter drowned and local county governments along the course announced they would no longer provide security or perform cleanup duties. Yet for twelve years, the Ramblin' Raft Race on the Chattahoochee River provided entertainment and great memories for people who joined in the fun and along the way occasionally enjoyed the natural beauty of the river.

OPPOSITE PAGE *The road overpasses and railroad bridge trestles would often be overflowing with spectators crowding to catch a view of some of more creatively-designed rafts or the people on them.*

RIGHT *Chaos often reigned on the loading area near Morgan Falls on the Chattahoochee as participants waited their turn to splash into the river. This was often the area to do last-minute construction of floats or just drink a lot of beer in preparation.*

FAR RIGHT *The floating party that was the Ramblin' Raft Race attracted thousands of participants and spectators every year from 1969 to 1980. This image of raft racers taken in 1971 was taken on one of the Chattahoochee's road overpasses.*

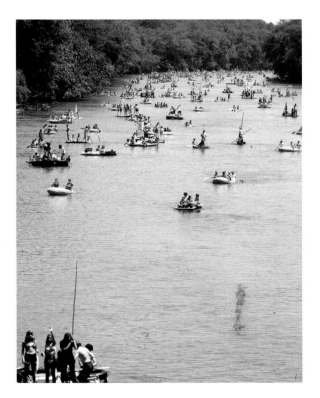

Coca-Cola Neon Spectacular **REMOVED 1981**

For almost fifty years, the Coca-Cola sign at the intersection of Peachtree and Pryor Streets provided a bright and colorful focal point on the Atlanta landscape and a backdrop to downtown celebrations and events. It also promoted, to all within sight, the delicious and refreshing beverage invented a few blocks away. The prominent intersection at Margaret Mitchell Square is visible for a distance of several blocks as drivers on Peachtree Street approached from the north.

Through the years, the sign was framed from behind by the elegant, marble-clad Candler Building completed in 1906. The opulent office building was constructed for $2 million to specifications provided by Asa Candler, founder of the Coca-Cola Company. With several other investors, Candler bought the rights to the "secret formula" in 1888 for $550 and led the company to early growth and marketing success.

For its many years at such a significant public location, the sign served not only as an indication of

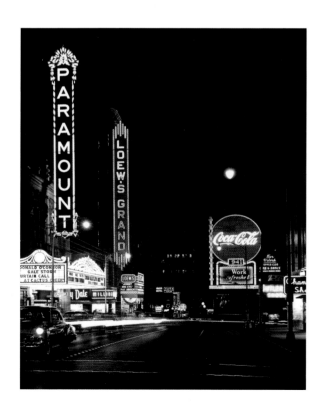

company marketing talent, but with the company's solid identification with the city of Atlanta. Coca-Cola's first monumental advertising sign was constructed on the roof of the Peck Building as early as 1932. It featured nine-foot-tall letters spelling "Coca-Cola" in Spencerian Script, which was the standard handwriting style for business correspondence from 1850 until rendered obsolete by typewriter. The logo, trademarked in 1893, is arguably the most recognized business image in the world.

In 1938, the sign was modified to provide images of snowflakes, raindrops, clouds, or sunshine to forecast the next day's weather. This sign lasted for three years until the second sign was dismantled to make way for a new building on the site. Through much of World War II, Coca-Cola advertised at the site on an existing billboard for the S & W Cafeteria, but by 1945, the Coca-Cola sign again dominated the intersection and provided a backdrop seen in countless victory celebration photographs.

In 1948, work was completed on the "neon spectacular" sign that remained for the next three decades. This sign was 48 feet tall and 33 feet wide, featuring a 28-foot-wide trademark. It was the only neon spectacular in the country to feature a 44-foot-tall thermometer. At night, the lights of the Coca-Cola sign co-mingled with the nearby lights of the Paramount and Loew's Theatre marquees. The intersection was Atlanta's version of New York City's Times Square.

By 1979, city planners were grappling with designs for a proposed Margaret Mitchell Square

which included the site of the Coca-Cola sign. With the Peachtree Center MARTA station operational, the new Atlanta-Fulton County Public Library scheduled for opening in 1980, and the fifty-two-story Georgia-Pacific Building under construction, the busy intersection needed new urban plans. As a result, the Coca-Cola sign was removed. Margaret Mitchell Park was completed on the small triangle of land in 1986, fifty years after the author's Pulitzer Prize-winning novel was published. The Georgia-Pacific Building, completed in 1982, occupies the site of the Loew's Grand Theatre where the motion picture *Gone With the Wind* premiered in 1939.

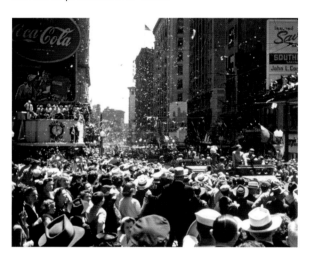

OPPOSITE PAGE The 1948 neon spectacular contains over one mile of red neon tubing and 10,280 light bulbs. Loew's Grand Theatre, site of the premiere of the film, Gone With the Wind, *is at left.*

LEFT *On a balmy October night in 1950, the intersection of Peachtree and Pryor Streets glows with the lights of not only the Coca-Coca sign, but those of the theaters and businesses nearby.*

TOP RIGHT *Streets are filled with the celebration of World War II victory on May 24, 1945.*

RIGHT *Atlanta Christmas shoppers hustle along Peachtree at Ellis Street in December 1968.*

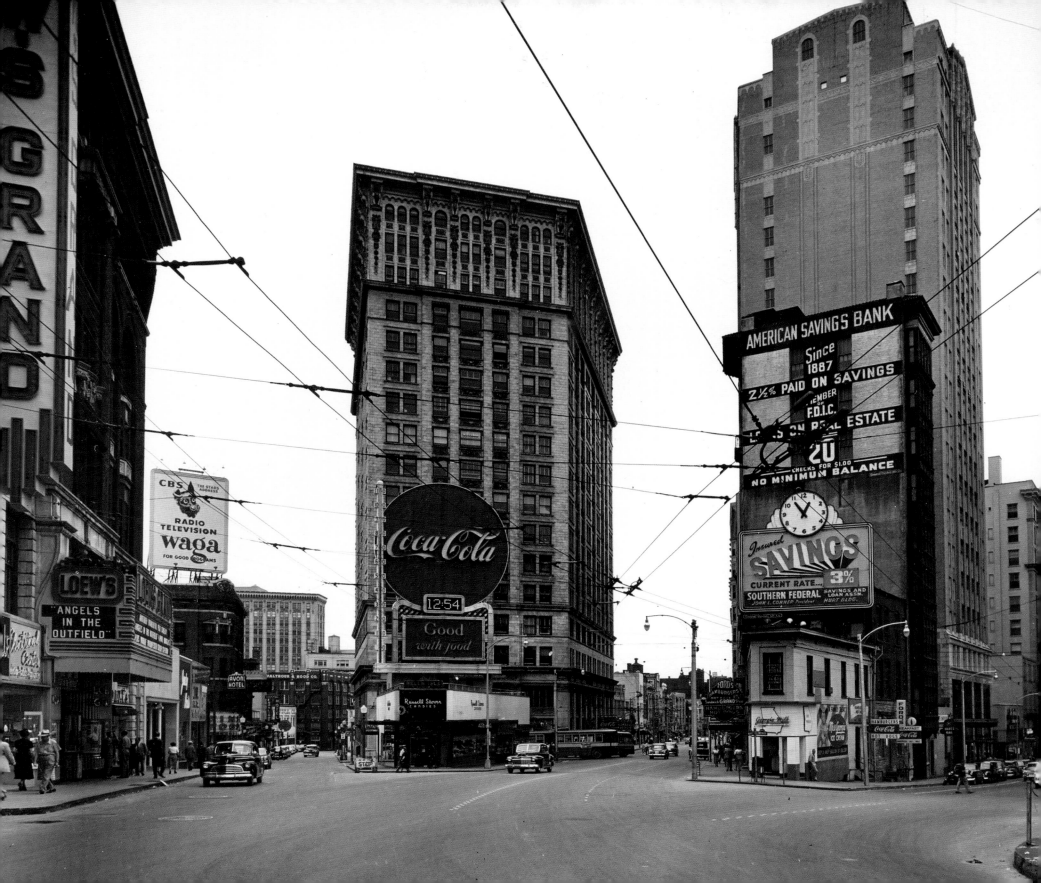

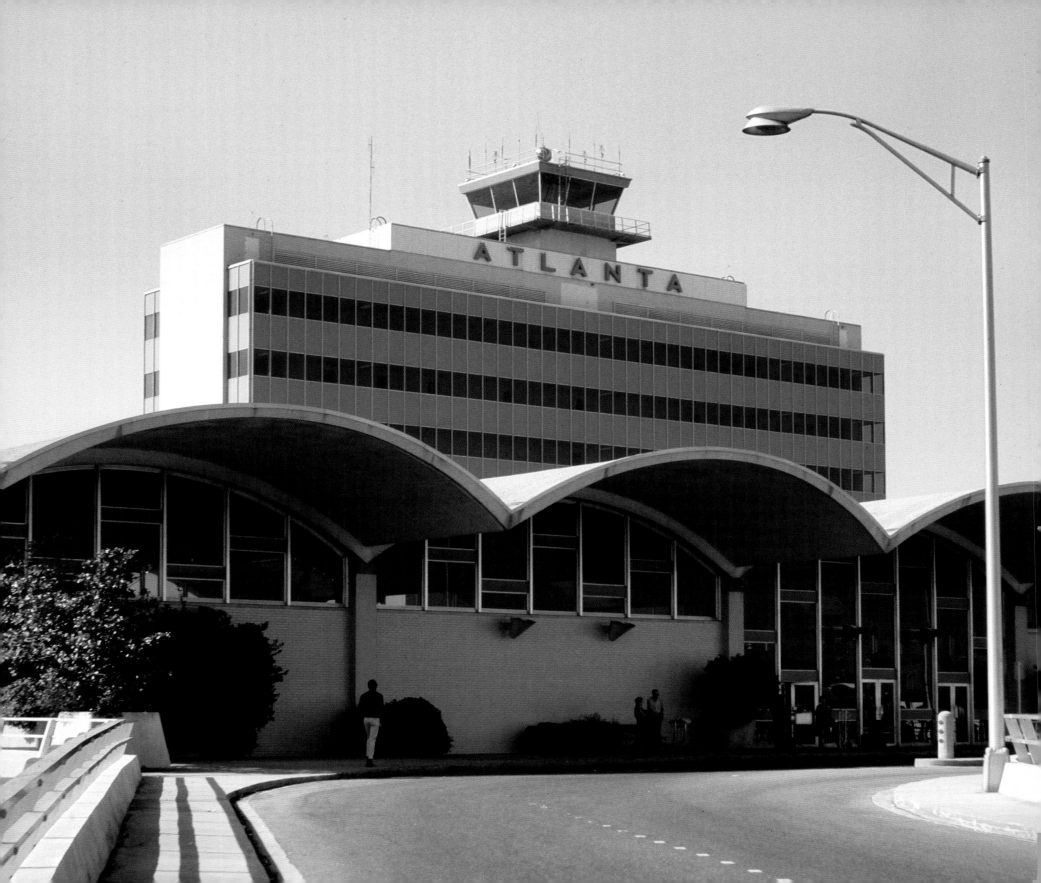

Atlanta Airport Terminal IMPLODED 1984

Atlanta's new jet-age airport terminal, dedicated in May 1961, was the largest single construction contract undertaken by the City of Atlanta at that time. Robert & Company architects and Blount Brothers Construction Company completed the twelve-story, $13 million structure and coordinated another $7 million in infrastructure improvements covering sixty acres, including parking for 4,500 automobiles.

The design, for what would open as a racially-integrated terminal, began in 1955 after Mayor William B. Hartsfield stressed the need for more modern airport facilities. He remarked: "Transportation is the life of Atlanta. We can't afford to be caught behind."

When it opened, elevated ramps carried automobile passengers to the terminal's main lobby where travelers encountered a check-in counter extending over 400 feet. The Sky Lounge for business travelers, dining areas, and newsstands were all within convenient proximity. For ten cents, a vending machine on the rooftop observation deck offered passengers a live audio feed of communications between pilots and air traffic controllers. Escalators facilitated ease of movement from the lobby to baggage claim below. At the time, the airport terminal handled 524 scheduled flights daily and was designed for a capacity of five million passengers annually.

At the opening, Mayor Hartsfield remarked, "The air terminal, for me, is the culmination of a dream, which began before 1924." Hartsfield had championed Atlanta as an aviation center while he served as a young city alderman and convinced city leaders to purchase Asa Candler's previous automobile race track site, Atlanta Speedway, in 1929. The track's straightaways provided the first two 1,500-foot airport runways.

The Atlanta Airport Terminal debuted as the "new face of the South" and a centerpiece for the region. The modern structure featured eleven reinforced-concrete barrel-arched shells cantilevered outward twenty-five feet over the automobile lanes. A mile of pedestrian corridors led passengers to and from the gates. The corridors were hailed as ample (for that time) with twenty-foot widths. A total of sixty television screens were provided by Delta Air Lines for relaying "up-to-the-minute" information for passengers. As a passenger left their departure gate to board the airplane, new "telescoping equipment" allowed convenient access right into the aircraft without climbing an old-fashioned gangway on the tarmac.

Within a one-hour jet journey from Atlanta lay ten states, forty million people, and twenty-five percent of the nation's population in 1961. Due to Atlanta's location and the burgeoning growth of air traffic, planners began discussing the airport's need for expansion and the new terminal's limitations soon after its dedication. Runway improvements began immediately. In April 1964, Mayor Ivan Allen Jr. broke ground for the extension of the cross-wind and the east-west runways, and a new parallel runway. Heated discussions and extensive newspaper reporting soon began about Atlanta's need for a second Atlanta airport.

Late in 1967, architects and engineers turned their focus to expansion at the existing airport. Designs evolved into a $400 million midfield terminal to include two "land-side" terminals, and

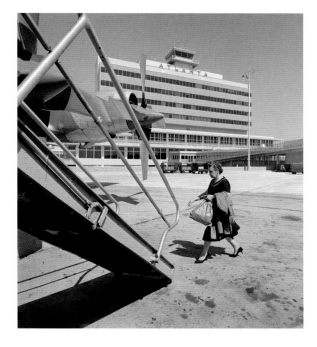

four "air-side" terminals connected by underground trains with a capacity for fifty-five million passengers per year.

In 1976, the air-traffic-control tower atop the 1961 terminal was retired with the opening of a new midfield tower rising 220 feet in height. In September 1980, the Atlanta terminal was retired as a new midfield terminal opened and on July 1, 1984, the obsolete building, hailed as a dream-come-true twenty-three years earlier, was imploded.

OPPOSITE PAGE *The reinforced-concrete, barrel-arched shells are the most distinctive architectural features of the 1961 terminal. The forms are constructed and the building elements poured on site.*

LEFT *A souvenir pamphlet announces Atlanta's "amazing new airport" and provides both conjectural and construction images of the terminal and surrounding infrastructure.*

ABOVE *Prior to the introduction of the jetbridge leading directly from the terminal gate to the airplane cabin, passengers boarded using mobile, ground-level ramps, such as here.*

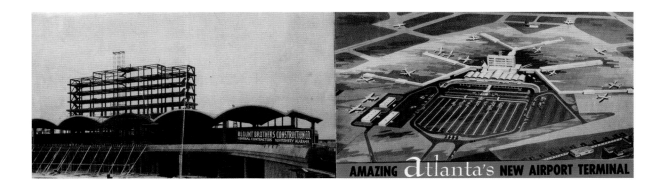

AMAZING *atlanta's* NEW AIRPORT TERMINAL

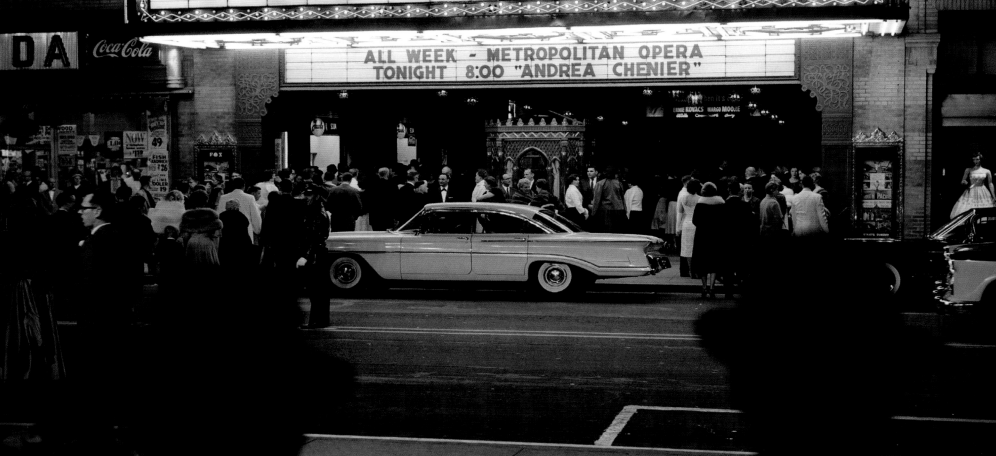

Metropolitan Opera Week CEASED 1987

The house lights dimmed, the curtain rose, and the legendary voice of opera great Enrico Caruso captivated the audience with a thrilling performance of Verdi's *Aida*. The year was 1911 and Caruso was playing to the largest audience of his career—not in New York, Philadelphia, or Boston, but in Atlanta. More than 7,000 devoted opera fans boarded trains in cities and small towns across the South to travel to the Atlanta Municipal Auditorium to experience the magic of New York's Metropolitan Opera.

Organizers of the Met's first annual tour in 1910 thought coming to a Southern city like Atlanta was a bold venture with little hope for success. No one predicted record-breaking audiences for the next two decades. The nation's entry into World War I interrupted the annual event in 1918 and the Great Depression cancelled opera week for a decade until performances resumed in 1940.

When it resumed, grand parties were again staged to welcome the biggest stars to Atlanta and celebrate opening performances. The beautiful soprano Geraldine Farrar was offered an "allegro spin" around Atlanta's Candler Racetrack in 1910, reaching a speed of eighty-five miles per hour. Not to be outdone, Caruso requested a tour of the racetrack the following season and Asa Candler, founder of Coca-Cola and the builder of the track, took him for a fast ride. When the century's greatest soprano, Rosa Ponselle, performed during a WSB radio interview in 1920, she blew the station's fuses and engineers scurried to get back on the air and adjust for the "new sound."

Opera week was interrupted by World War II from 1943 to 1946. In 1947, the curtain went up for the first time on the stage of the exotic and incomparable Fox Theatre in Midtown. The Georgian Terrace, known as "Atlanta's Parisian hotel" and located conveniently across Peachtree Street, became the center of social events and luxurious lodging for stars and guests.

The 1947 season marked the beginning of a forty-year relationship between the Junior League, the Atlanta Music Club, and the Met—admittedly a "highbrow" experience as opera passed from the public marketplace to an elite culture. Midnight suppers at the Capital City Club, barbecues at the Druid Hills Golf Club, breakfasts, luncheons, teas, and balls at the Georgian Terrace and the Atlanta Biltmore Hotel filled the week, known by many as the fifth season in Atlanta—after winter, spring, summer and fall. With new hats, gloves, evening gowns, capes, coattails, and top hats to acquire, Metropolitan Opera Week, in early May, marked the beginning of the spring fashion season in the city.

Performances moved to a newly-completed Atlanta Civic Center in 1969. By this time, railroads no longer took the Met on tour: costumes, props, and sets arrived in thirty tractor-trailer trucks and the staff and performers arrived in chartered jets. By the 1980s, performance costs were near $30,000 and the Metropolitan considered discontinuing their national tour. After 1986, Atlanta was the only remaining city in the nation to meet the obligation to guarantee tour costs in advance. Yet, the Met could not justify a one-city tour. The Metropolitan Opera Company's 1987 national tour was its last. Metropolitan Opera Week ended in Atlanta.

BELOW *Soprano Frances Alda poses in costume for the role of Aida in 1910, the year of the Met's first appearance in Atlanta and also the year that Alda married Giulio Gatti-Casazza, director of the Metropolitan Opera in New York.*

OPPOSITE PAGE *The Fox Theatre marquee announces Metropolitan Opera Week in 1960.*

ABOVE *Opera star Enrico Caruso and Henry M. Atkinson, a prominent Atlanta businessman, depart Atlanta Terminal Station by automobile in 1913.*

RIGHT *Opera singers Jean Madeira and Jerome Hines enjoy an after-opera party at the Capitol City Club in 1953.*

Plaza Park DEMOLISHED 1987

Building a plaza over the span of railroad tracks in the center city was envisioned as early as the 1880s. In 1909, Atlanta architect Haralson Bleckley proposed an ambitious strand of parks and thoroughfares over the railroads, though it was never realized. Individual street bridges had been built to span some of the downtown rail crossings in the nineteenth and early twentieth centuries – the antebellum Market (current Broad) Street bridge was the first in 1853.

Beginning in the 1920s, a coordinated network of bridges and viaducts were constructed over the downtown tracks and ground-level streets to finally provide safe traffic in the downtown rail district. Plaza Park, occupying one-half of a city block, was the only green space to be built above the tracks.

Mayor William B. Hartsfield embraced the concept of a downtown public park during the 1940s. At the time, the central business district had no public green spaces offering downtown shoppers and workers a space for rest and relaxation. Landscape architect William L. Monroe and his son, William L. Monroe Jr. also a landscape architect and a recent graduate of the University of Georgia, designed the park built entirely over the railroad's infamous Smoky Gulch.

The park was dedicated by Mayor Hartsfield in August 1949, "to Atlanta's women, and children, the tired worker, and the weary visitor." A fountain provided the sound and motion of water in the park's center. Bound on the north by Wall Street, the west by Peachtree Street, the east by Pryor Street, and the south by Alabama Street, the "pocket park" contained magnolias and elms planted in containers, and a peach tree nicknamed "Maggie" that provided white blossoms in the early spring.

Four sculptural concrete seating pods accentuated the south edge of the park. In reality, the mushroom-shaped pods were hollow chimneys with seating around their bases. They served as vents for locomotive smoke accumulating below the park. A covered canopy extended along the northeast corner of the park offering additional seating and providing shady relief from Georgia's hot summer sun. The park was convenient for downtown workers and visitors, as well as for nearby hotel guests, situated as it was close by the Kimball House Hotel. The hotel was demolished one decade after the park's dedication.

Despite decades of popularity, the urban landscape changed around Plaza Park. Plaza Way, the pedestrian walkway through the park, was closed in 1975 for MARTA rapid transit construction and remained closed until 1979. In 1976, rather than maintain the fountain's plumbing the basin was filled and converted to a flowerbed. By the early 1980s, the park slumped into steady decline and disuse. In 1987, the park was demolished to create a terraced entrance leading to the new Underground Atlanta redevelopment constructed by the Rouse Company.

For today's downtown workers, tourists, in-town residents, and a significant population of Georgia State University students, the downtown area offers other green spaces not far from the heart of the city. A similarly-named "Georgia Plaza Park" is situated at Washington and Central Avenues west of the State Capitol Building. Four blocks east of downtown at Gilmer and Courtland Streets, Hurt Park opened in 1940, Robert W. Woodruff Park, two blocks north of Plaza Park opened in 1973, and since 1996 Centennial Olympic Park has provided twenty-one acres of green space west of downtown.

OPPOSITE PAGE *Despite the verdant green presence of the park and its row of magnolia trees, Underground Atlanta —the original ground level of Atlanta's downtown—lies beneath the grounds.*

BELOW LEFT *The park, representative of light-filled, Modernist design was, nevertheless, dominated by the dark, commanding presence of the Kimball House hotel, which in many ways overshadowed the small landscape.*

BELOW *Plaza Park functions as both a resting place and a busy thoroughfare between Peachtree and Pryor Streets. The seven-story Peters Building adjoins the Kimball House hotel to the west. Across Peachtree Street, shoppers come and go through the arched entrance to the Peachtree Arcade.*

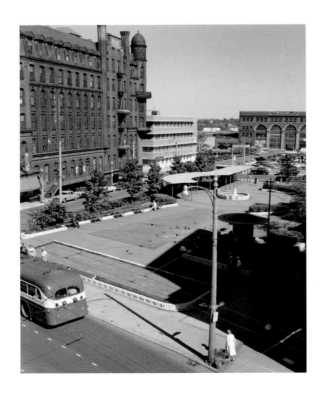

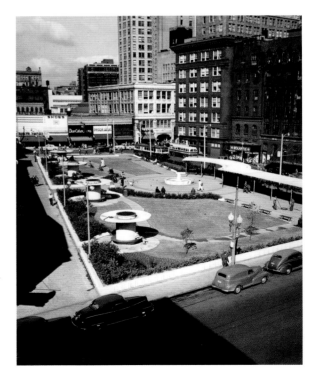

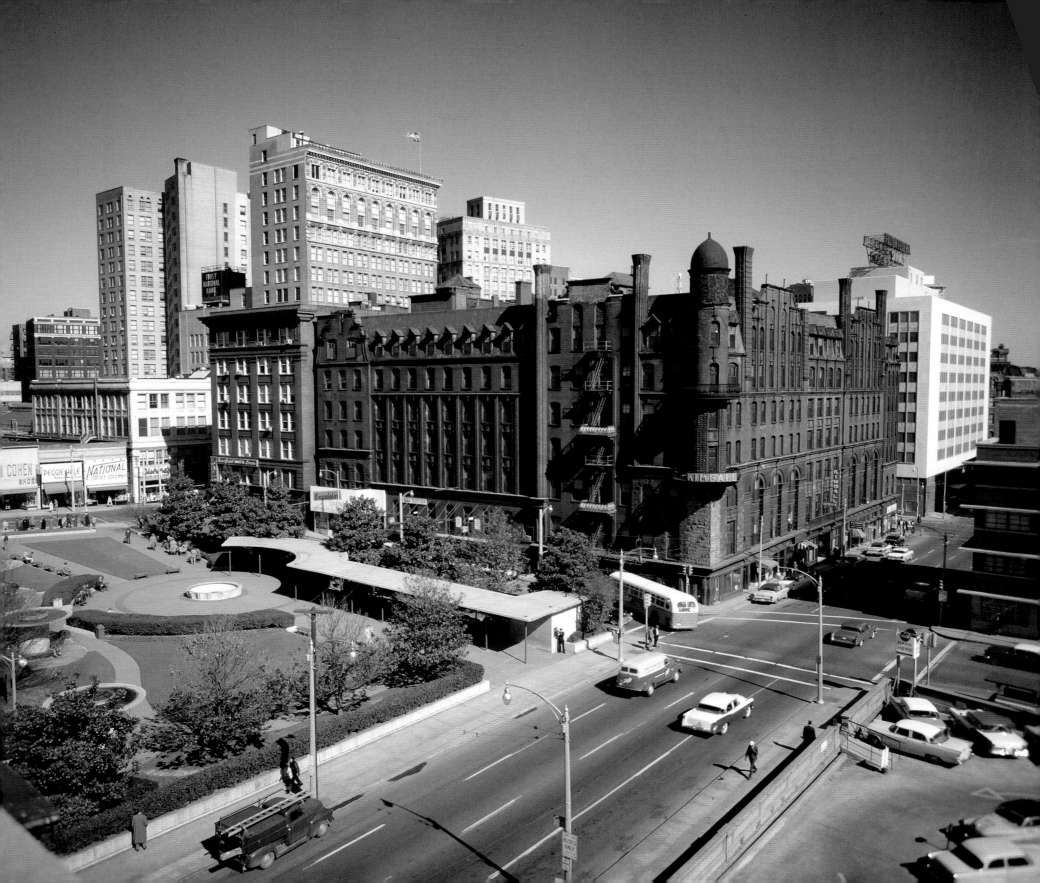

Riverbend Apartments REFORMED 1991

As the first wave of the Baby Boomer generation graduated from college in the late 1960s, many of them landed into a world of opportunity and excitement. Whether they were fresh off campus, returning from military service, or just entering the job market for the first time, many found their place in Atlanta, where jobs and leisure were plentiful. Atlanta's metropolitan population grew by over one million in the 1960s, with much of that growth occurring in its inner suburbs on the northern perimeter.

To accommodate this emerging market, developers built singles-only apartment complexes, and furnished them with amenities such as swimming pools, club houses, and other features to encourage a vibrant social life. In Atlanta, there were very few entertainment districts like those which can be found today at virtually every corner. In the late 1960s, social life for young people in Atlanta was centered in its burgeoning apartment dwellings. The origins of what was to become "Hotlanta" begin there.

In 1968, developers broke ground on a 600-unit apartment complex called Riverbend Club Apartments. Riverbend was situated on sixty-five acres between Interstate 285 and the Chattahoochee River on the southern tip of rural Cobb County. By the early 1970s, Riverbend was an oasis of debauchery in a county that strictly enforced the state's blue laws restricting Sunday alcohol sales, a move that only helped the party scene inside the bar in its active three-story club house that featured a deck overlooking the Chattahoochee.

Riverbend's proximity to the river made it *the* place to be during Atlanta's annual Ramblin' Raft Race, which featured tens of thousands of beer-soaked participants who cruised the Chattahoochee every May. The lively enclave had whirlpools, saunas, racquetball courts, and hosted block parties that lasted entire weekends, complete with beer trucks and live band performances from Mother's Finest, and other popular acts. "Like a campus for single people" according to one resident.

Riverbend was the perfect reflection of the 1970s, an era often associated with guilt-free sex, and very different attitudes towards alcohol and drug abuse. In 1972, *Playboy* magazine dubbed it

"ground zero" of the sexual revolution. "Gonorrhea Gulch" was the more earthy nickname many former residents recall. Riverbend was home to pro athletes who further enhanced its aura as party central to the young and virile. Included among its residents where former Atlanta Falcons Harmon Wages, Fulton Kuykendall, and quarterback Steve Bartkowski who lived at the complex for several months during his rookie season in 1975. Neal Boortz, the prominent conservative national talk show host, lived at Riverbend for a brief period in 1971 during his nascent radio career.

In 2006, Walton Communities purchased Riverbend and renamed it Walton on the Chattahoochee; however, it had ceased being the "Riverbend" of decades before. In 1988, the U.S. Congress passed the Fair Housing Act, which made it illegal for apartments to exclude children, as Riverbend had for years. In 1991, Riverbend's proprietor, Sentinal Real Estate Partners, was found guilty of violating the act. But Riverbend's demise as a sin palace began long before, as the

mostly-transient resident population aged and moved out to start families. The sexual promiscuity that marked the 1970s gradually waned in response to the HIV crisis and the threat of other serious sexually transmitted diseases. By 1992, Sentinal had already begun opening their door to families with children, and the infamous club house was repurposed as a leasing office. And with it, came a new marketing approach of providing "a wholesome family environment."

OPPOSITE PAGE *Onlookers sitting atop of the deck at Riverbend Club Apartments overlooking the Chattahoochee during Atlanta's famous Ramblin' Raft Race in 1971.*

BELOW *The crowded and active swimming pool area at Riverbend during a summer party features an open bar (right) and hundreds of partygoers. Scenes such as these at apartments are a rarity due mainly to liability concerns. (Photo by Nick DeWolf).*

Erlanger / Tower / Martin / Atlanta / Columbia Theatre DEMOLISHED 1995

When Erlanger Theatre opened as a live theater in December 1926, the Atlanta Constitution declared it had ushered in a "new epoch in the amusement life of this city." Built by local real estate developer William F. Winecoff and designed by Raymond C. Snow & Company, the Erlanger was located on Peachtree Street between Linden and North Avenues. It was leased by Abraham Lincoln Erlanger, one of the nation's leading figures in American theater production in the early twentieth century.

Despite its beauty, the Erlanger struggled to compete with motion pictures, and by 1942 a new consortium of owners leased the theater to Atlanta radio station WSB for five years. One of the live radio shows broadcast from the Erlanger stage was Atlanta's answer to the Grand Ole Opry. Known originally as the *Crossroads Follies*, the show was renamed the *WSB Barn Dance* and featured acts such as Bill Gattins and His Jug Band, and the Round Up Gang.

When the WSB lease ended in 1947, the Erlanger was renovated and reborn as a movie house named Tower Theatre, adding a large marquee to the facade. While still presenting theatrical productions, the Tower focused on first and second-run films, though never rivaling the Fox Theatre or Loew's Grand in popularity. A second renovation in 1962 created the Martin Cinerama and had a giant, curved screen and a three-projector process that lent a 3-D effect to films.

The building again changed hands and was rechristened the Atlanta Theatre in 1969, continuing to show films on the large screen. After 1979, the theater stood empty and was donated to the North Avenue Presbyterian Church by a member of the congregation who had purchased it for $300,000. The church used the building's store fronts to house outreach ministries while leasing the theater to the Academy Theatre for a single season.

The theater was renovated one last time in 1982, becoming the Columbia Theatre. Although its screen—35 feet x 95 feet and reputed to be the largest in the world—provided a quality movie experience, a single-screen movie palace could not cover rising costs. The Columbia closed its doors in 1987 and the building was demolished in 1995 to make way for a parking lot.

ATLANTA HISTORICAL SOCIETY / ATLANTA HISTORY CENTER

Founded in 1926, the Atlanta Historical Society, parent organization of the Atlanta History Center, originally met only occasionally and had no set premises. This changed in 1936 when the society, led by Jack J. Spalding and Walter McElreath, reorganized as a professional organization, hiring former Georgia State Historian, Ruth Blair, as the Executive Secretary. They moved into quarters on the ground floor of the Biltmore Hotel on West Peachtree Street. When the Biltmore Hotel quarters became cramped, the society moved into one of the store fronts in the Erlanger Theatre building in 1943. They held periodic open houses and continued to build their collection of documents, pictures, and artifacts documenting Atlanta's history. Three years later, the society purchased the Peachtree Street home of Dr. Willis B. Jones and moved into it, renaming it McElreath Hall.

OPPOSITE PAGE *The marquee of the Erlanger Theatre advertises the* WSB Barn Dance, *performed live every Saturday night, in 1944. The Atlanta Historical Society was located in the store front at far left.* Erlanger Theatre, 1944. *(Photo courtesy of Lane Brothers Collection, Special Collections and Archives, Georgia State University, Atlanta).*

LEFT *The November 1932 Erlanger program refers to the theatre as "The Playhouse Beautiful." The featured production was Berkeley Square starring the Atlanta Permanent Players.*

RIGHT *The marquee of the Martin Cinerama prominently extends out toward Peachtree Street in 1967. The Fox Theatre's marquee is visible in the distance.*

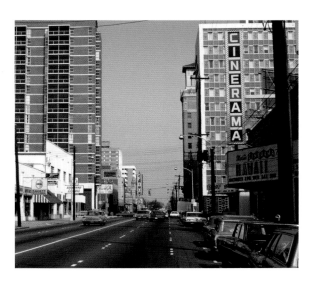

Olympic Venues ALTERED OR DEMOLISHED 1996-1997

"It's Atlanta!"—the surprise announcement in 1990 of a Southern U.S. city as the site for the Centennial Olympic Games—Athens, Greece, was the sentimental favorite to host the anniversary of the modern games—set off the rush to acquire, convert, construct, and transform the myriad athletic venues needed to hold the competitions. Of the fifty venues necessary for staging the Games, some were planned initially as either temporary or even portable. Over a million square feet of tented space alone, as well as 150,000 temporary bleacher seats were dismantled immediately after the completion of the Olympic Games and the Paralympic Games that immediately followed.

The archery range and the cycling velodrome at Stone Mountain Park were among the temporary venues removed after the Games. The velodrome was sold in September 1996 to Walt Disney World with plans for its reconstruction. Ultimately, it was purchased from storage in Florida and then moved and reconstructed at the Centre National de Cyclisme de Bromont near Montreal where it is in use today as the only Olympic-grade velodrome in Canada.

The largest of the Olympic venues constructed for the Games was the $207 million Centennial Olympic Stadium. Substantial revisions were undertaken after the Games to convert it to Turner Field as a stadium for the Atlanta Braves baseball team. The Atlanta-Fulton County Stadium built in

1965 had been the home stadium for the Braves and served as the Olympic baseball venue; it was imploded in August 1997 to provide a parking lot for the new ballpark.

The natatorium on the western edge of the Georgia Tech campus was significantly altered after the Games. All Olympic aquatic events— swimming, diving, synchronized swimming, and the aquatic component of the modern pentathlon—all competed here. The venue was donated to Georgia Tech after the Games and was modified into the Campus Recreation Center. The north stands of the natatorium, containing 11,000 seats, were demolished and the Olympic warm-up pool was modified to include a water slide and a lazy river.

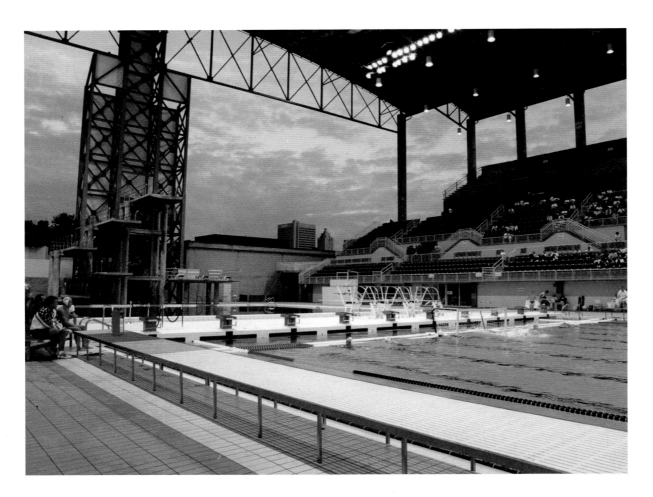

OPPOSITE PAGE *For the first time in Olympic history, all of the aquatic disciplines are held at the same venue, the Georgia Tech Aquatic Center, where trial events are held in August and September 1995.*

LEFT *Diving competitions includes events on a three-meter springboard and a ten-meter platform.*

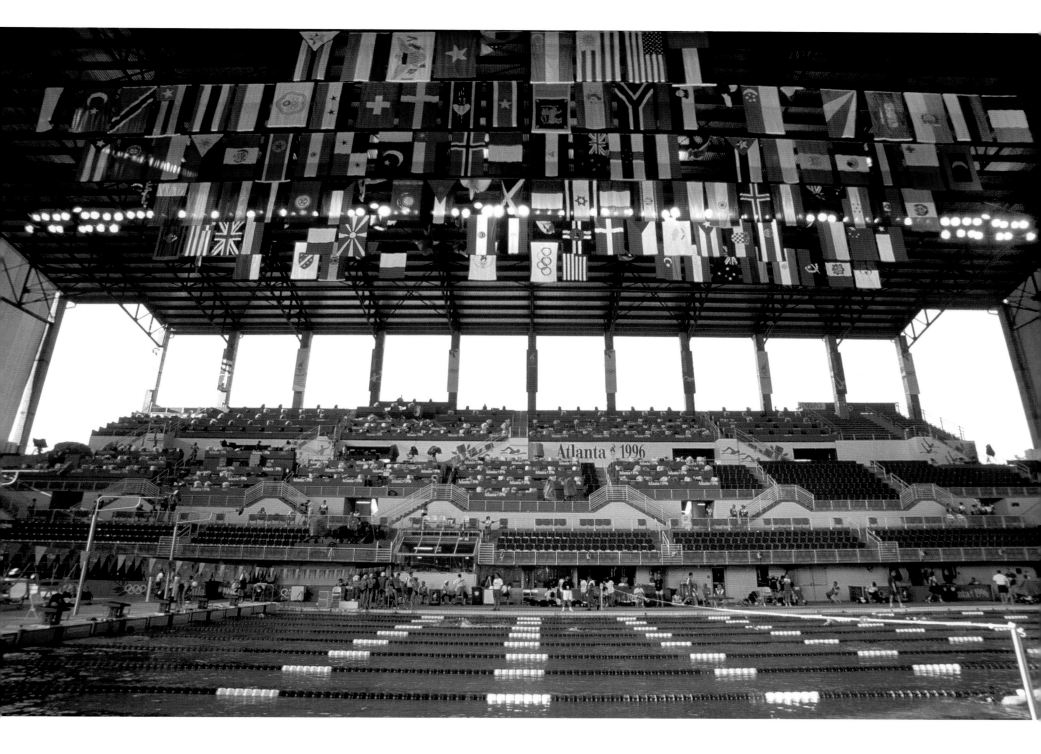

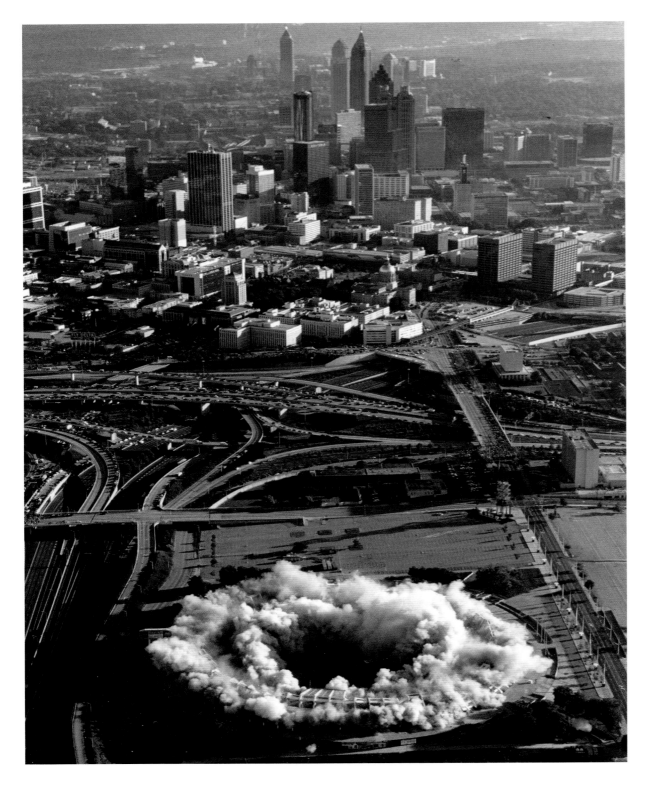

The multi-purpose Omni Coliseum was twenty-four years old during the 1996 Games. Prior to the Atlanta Games, it hosted Atlanta Hawks basketball, Atlanta Chiefs indoor soccer, Atlanta Flames hockey, and professional wrestling matches. The Omni also staged concerts for the Grateful Dead, Bruce Springsteen, Michael Jackson, Pink Floyd, and Bon Jovi. Elvis Presley performed at the Omni twelve times between 1973 and 1976. The coliseum also served as the site of the 1988 Democratic National Convention where Michael Dukakis and his running mate, Lloyd Bentsen, were nominated. Due to increasing structural problems and the desire for a larger, modern facility, the Omni was demolished in July 1997.

The impact of the Centennial Olympic Games for Atlanta was substantial international exposure and an enduring boost to the city's downtown infrastructure, witnessed by growth around Centennial Olympic Park and continuing in-town residential development. Yet, many of the athletic venues developed for the Games have disappeared —and continue to pass into sports memory.

LEFT *The Atlanta-Fulton County Stadium built in 1965 had been the home stadium for the Braves and served as the Olympic baseball venue; it was imploded in August 1997. (Photo courtesy of AP/Atlanta Journal-Constitution).*

OPPOSITE PAGE *Stone Mountain provides a mammoth backdrop to the velodrome. (Photo by Mike Gladu).*

The Omni Coliseum **DEMOLISHED 1997**

The Omni Coliseum was a $17 million indoor arena built over an unused railroad gulch downtown between Techwood Drive (now Centennial Olympic Park Drive) and Magnolia Street (now Andrew Young International Boulevard). Its name comes from the Latin *omnis* meaning "all" and reflected its purpose to accommodate a thorough variety of sporting and entertainment events.

Naming it, in fact, was controversial, since officials fought over whether to call it the Atlanta Coliseum, the Atlanta-Fulton County Coliseum, the Omni, or Union Station. The latter choice was suggested by banker Mills Lane who was the most outspoken opponent of the name Omni. Said Lane "It doesn't look like a coliseum, and it doesn't look like an omni, I don't guess, although I don't know where to find an omni except maybe in the zoo." The settlement was Omni Coliseum, but most people referred to it simply as The Omni.

For years, Atlanta officials, specifically the Atlanta-Fulton County Recreation Authority that helped facilitate the development of Atlanta Stadium earlier, had been looking for the opportunity to build an indoor stadium. In 1971, the recreation authority working with the city, Fulton County, and the property development company Cousins Properties began construction. At the time, Thomas Cousins owned the Atlanta Hawks basketball team, which he had brought to Atlanta from St. Louis in 1968 despite the lack of a professional basketball facility. Though the team

was playing at the Alexander Coliseum at nearby Georgia Tech, the Omni would provide an arena for the team.

Construction on the 16,500 seat facility began in April 1971 and was completed in time for the first professional hockey game of the season when the expansion Atlanta Flames—also owned by Cousins—played against the Buffalo Sabres in October 1972. The following night, the Atlanta Hawks played the New York Knicks. After years of aspirations, Atlanta was now a big league city in every sense with four professional teams and the professional facilities needed to accommodate each.

One of the main Omni attractions was professional wrestling and for over a dozen years people came to the Omni to see the likes of Dusty Rhodes, Andre the Giant, Ole Anderson, and the Mongolian Stomper. In addition to professional sports, the coliseum hosted college basketball games, the Ringling Brothers Circus, the Ice Capades, trade shows, and the 1988 Democratic National Convention.

The Omni hosted over 800 concerts, beginning with an October 1972 show by Cat Stevens and ending in April 1997 with a performance by the heavy metal band, Metallica. The once-perennial tour band, the Grateful Dead performed twenty-two shows at the Omni, the most by any musical act, followed by Neil Diamond who took the stage on thirteen occasions. Concert promoters recall several outrageous and humorous moments:

Guns-N-Roses front man Axl Rose punched a security guard onstage; or when singer Gino Vannelli refused to go onstage for two hours until he could get his hair to look the way he wanted. When Frank Sinatra refused to take the stage unless there was a full house, promoters covered all but three rows behind the stage to give the singer the impression of a sellout.

The Omni's ability to hold such a variety of events, however, was not enough to save it. The owners of the Atlanta Hawks—by then, Time Warner—sought an arena with a greater capacity for luxury suites. Structural problems also plagued the facility, which was levelled in 1997 to make way for Phillips Arena, a more expansive, sleek, and hopefully more durable structure with a greater potential for generating revenue.

OPPOSITE PAGE *Looking east toward downtown Atlanta, displays the twenty-five trapezoid-shaped roof pods atop the Omni that some say made the structure look like an inverted egg carton. Still under construction directly behind the Omni is the Omni Complex that eventually became CNN Center, featuring a hotel, restaurants, and the global network's broadcast studios.*

RIGHT *During construction of the Omni, builders fastened large sections of weathering steel to the façade of the structure. As the steel aged it rusted, prompting some Atlantans to call it "the rusty egg carton." The building rusted to the point where holes developed large enough for people to sneak through.*

FAR RIGHT *Atlanta Hawks guard "Pistol" Pete Maravich lit up the scoreboard at the Omni for four seasons.*

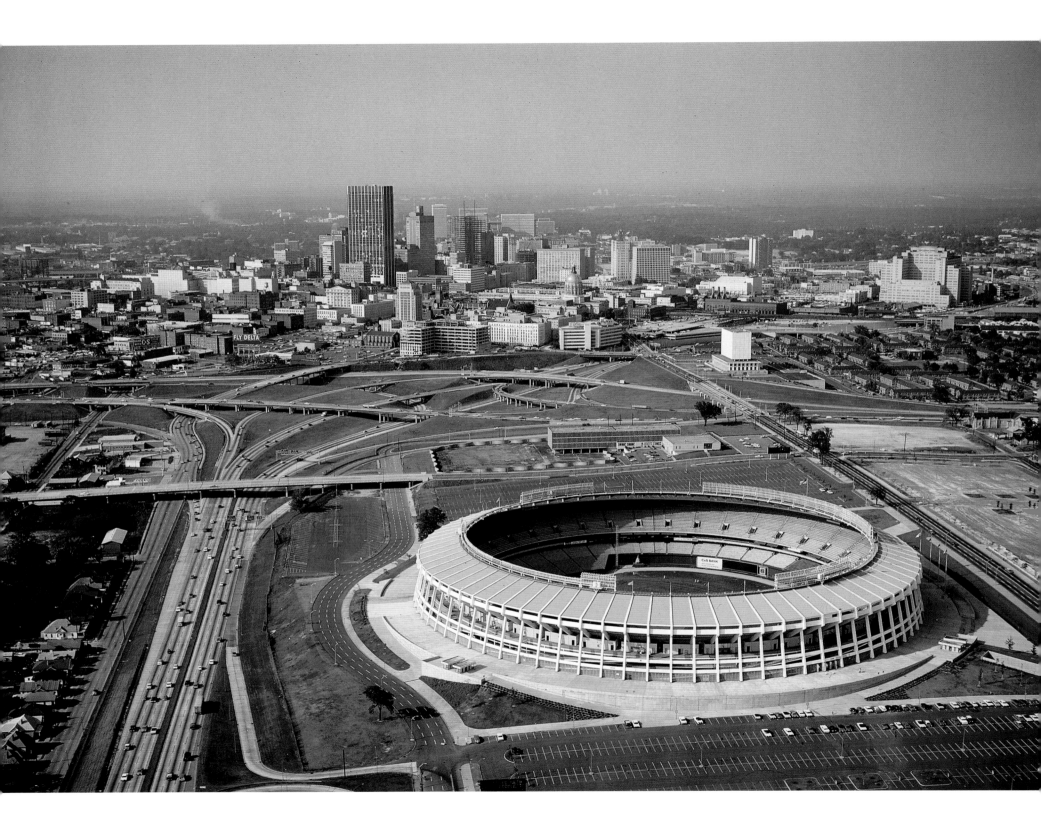

Atlanta Stadium / Atlanta-Fulton County Stadium IMPLODED 1997

Standing in a patch of land featuring the ruins of the once stately houses of Atlanta's old Washington-Rawson neighborhood, Charlie Finley, the embattled owner of the Kansas City Athletics baseball team proclaimed it the perfect location for a major league ballpark. It was April 1963, and Finley had just heard a smooth sales pitch from Atlanta Mayor Ivan Allen Jr. promoting his city as the next great baseball town—and this spot in particular as the ideal site for a new stadium. Finley, who was under pressure from league owners to keep his team in Kansas City, was sold. "You build a stadium here, and I guarantee you Atlanta will get a major league franchise."

Finley's proclamation set the wheels of Atlanta's power structure in motion, and before long Allen had nearly half-a-million-dollars to finance an architectural and site planning study. The money was fronted by Mills B. Lane, president of the Citizens & Southern National Bank, and the action took place at lightning speed before the Atlanta Board of Alderman could vote on it. Meanwhile, league owners denied Finley the chance to move his team, but that did not stop Mayor Allen from pursuing other suitors, and the Milwaukee Braves were prime prospects. In February 1964, the Milwaukee Braves won approval to make the move to Atlanta. Later Allen would boast, "We built a stadium on ground we didn't own with money we didn't have for a team we hadn't signed."

Construction began on Atlanta Stadium on April 15, 1964, and was completed almost a year later. Remarking on its closeness to downtown and the expressways, and touting the amount of available parking spaces, the *Atlanta Journal* and *Constitution* Magazine noted the stadium's convenience to fans. (Ironically, critics complained over its remote location in later years.)

The deal to bring the Milwaukee Braves to Atlanta was based on the team moving in 1966, so the Atlanta Crackers, who by this time was the AAA affiliate of the Braves, played in the stadium in 1965, their final year in Atlanta before moving to Richmond. In August of that year, Atlanta Stadium hosted a performance by the Beatles to a crowd of over 30,000.

Atlanta Stadium was a circular structure that housed a symmetrical ball field, similar to many stadiums built in that era. Ballparks in earlier times were built in tight spaces in urban areas and had to conform to the contours of surrounding streets and existing structures. Those restrictions resulted in fields of play with uneven outfield measurements.

In addition to Atlanta Braves games and outdoor concerts, the stadium hosted Atlanta Falcon football games, professional soccer matches, and college football's Peach Bowl. Sports fans witnessed a number of exciting events, but none more so than what occurred on April 8, 1974, when slugger Hank Aaron hit his 715th home run, breaking Babe Ruth's longstanding record. In 1976, Atlanta Stadium was renamed Atlanta-Fulton County Stadium.

In 1996, Atlanta hosted the Centennial Olympic Games and sports venues were constructed throughout the city. The gem of them all was Centennial Olympic Stadium, which was remodeled as a baseball stadium and renamed Turner Field after Braves owner Ted Turner. The Atlanta Braves played the last sporting event in Atlanta-Fulton County Stadium on September 23, 1996, and on August 2, 1997, the stadium was imploded in less than thirty seconds.

OPPOSITE PAGE *When Atlanta Stadium opened in 1965, it was the seventh-largest baseball stadium in the major leagues with a capacity of nearly 52,000. The stadium could expand to a capacity of around 62,000 for Atlanta Falcon football games.*

BELOW LEFT *Atlanta Stadium in 1966 shows the ever-present teepee in left field that was the province of the Braves' mascot, Chief Nok-A-Homa. The teepee was removed in 1982 to expand the seating capacity. The Braves discontinued Chief Nok-A-Homa's service in 1986.*

BELOW *Slugger Hank Aaron connects to break Babe Ruth's all-time home run record of 714 in Atlanta Stadium on April 8, 1974. Aaron went on to hit 755 home runs in his career.*

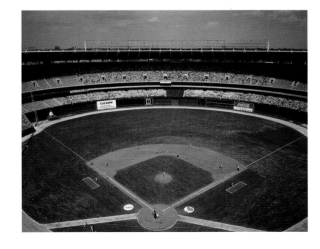

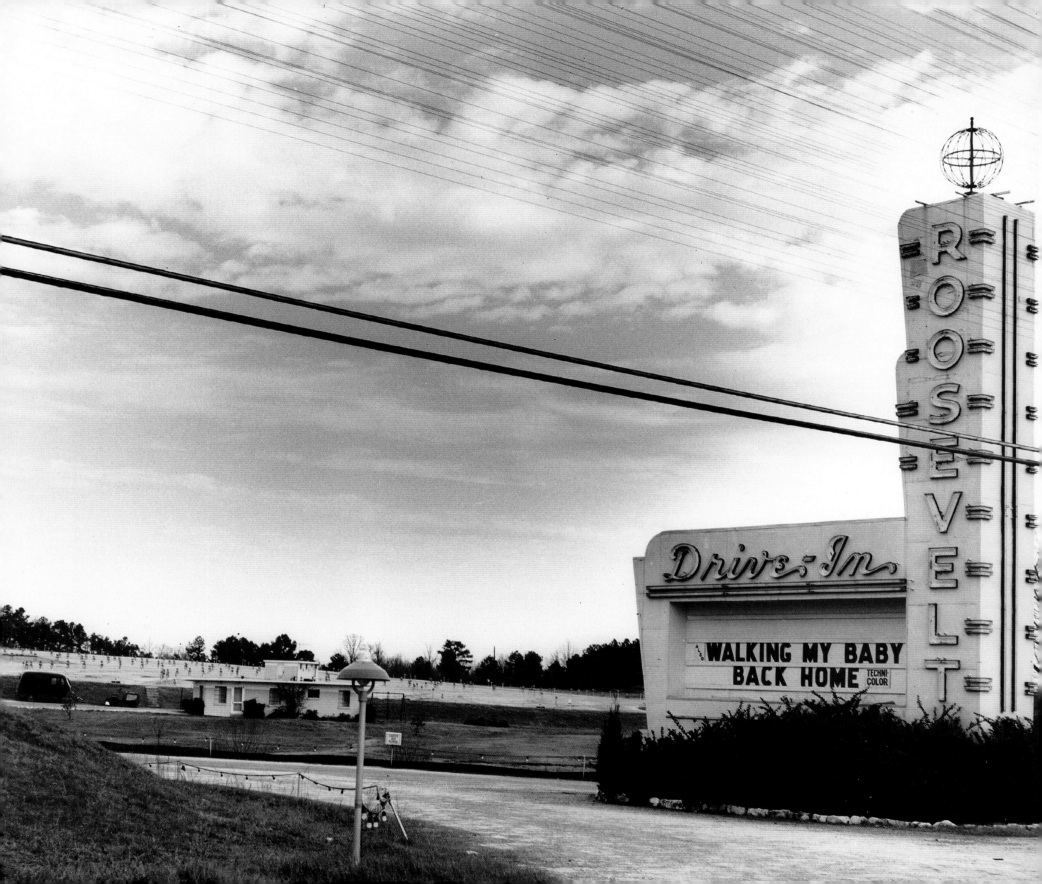

Drive-in Movie Theaters DWINDLED BY 1998

Drive-in movie theaters have been an American tradition since 1933, but none officially opened in Atlanta until 1946. At that time, they were generally frowned upon as "petting palaces" that were not necessarily family friendly. Customers could park their cars between high wooden stalls that would shield them from sight; because of this, drive-ins had a tawdry reputation among some as a place where young people could be permissive.

Theater owners worked assiduously to cultivate a family image, positioning the value of convenience for bringing young children and incorporating playgrounds and snack shops. But to many teenagers, especially in the 1950s and 1960s, the lure of the drive-in was the anticipation of seclusion with a date. This prompted many outdoor theaters to employ uniformed policeman with flashlights and a wary eye to discourage such behavior.

Atlanta's early drive-ins were simply unpaved lots located on major thoroughfares. The first two were the Stewart Drive-in at Stewart Avenue (now Metropolitan Parkway) and Cleveland Avenue (1946) and the Piedmont Drive-in at the corner of Piedmont Road and Lindbergh Drive (1947). Other early drive-in theaters were the Peachtree in North Atlanta, Bankhead near the Chattahoochee River, the Scott in Decatur, the Roosevelt in the College Park area, and the Starlight in East Atlanta. There were twenty-one drive-ins open in the Atlanta area in 1965, the most at any time.

Over 4,000 drive-ins were built in the 1940s and 1950s, most in rural areas where land was relatively cheap. Many of the drive-ins that survived in Atlanta were located along its perimeter. At the Glenwood Theater in Decatur, built in the mid-1950s, employees had to shoo cows that wandered onto the premises and interrupted the show with incessant mooing. The Glenwood closed in 1982.

The drive-in declined beginning in the 1970s, primarily due to higher gas prices, real estate costs, and more entertainment options. Observers at the time indicated a preference among adults to simply drop their children at movie houses rather than undertake a family outing. Also contributing to the decline was the quality of feature presentations at many of the establishments. Instead of the latest big-budget studio release, drive-ins garnered a reputation for featuring low-budget B-movies, late-night adult films such as schlock horror movies. Theater proprietors offered giveaways like free laundry service and promotions such as bingo night, beauty contests, weddings, and flea markets. By 1978, there were only nine drive-ins in Atlanta and its suburbs, including one in Smyrna that showed only R-rated movies.

When the North 85 Twin Drive-In closed in 1998 to make way for a modern multiplex, the Starlight Drive-In on Moreland Avenue in DeKalb County became the single drive-in theater in Atlanta. Opened in 1949, it faced difficult economic challenges but continued to be profitable, even expanding its offerings to six screens in 1983. It is now called the Starlight 6 Drive-In. Some drive-ins have experienced an increase in attendance with more families attending. Many in the Starlight's customer base are families, drawn in by low prices, the convenience of bringing in their own food, and nostalgia.

OPPOSITE PAGE *The Roosevelt Drive-In was located about twelve miles southwest of downtown Atlanta on Roosevelt Highway in the suburb of College Park. The site is now a largely wooded area with tell-tale signs of past use, including concrete speaker-pole bases and rusted electronic installations.*

LEFT *Looking west toward downtown Atlanta, the Scott Drive-in appears at bottom. It was located on Scott Boulevard where Scott met Church Street. The site of the former drive-in is now a strip mall containing mostly restaurants.*

Atlantic Steel CLOSED 1998

As cities grew and industry diversified in post-Civil War Georgia, the state remained fundamentally rural with cotton enduring as the agricultural economic staple. But for cotton crops and other agricultural products to be successful, the South relied on Northern manufacturers to supply the steel bands needed for bailing cotton and the hoops for binding barrels of rosin.

To capitalize on Atlanta's position as a rail distribution center, real estate executive George Washington Connors persuaded other Atlanta investors to form the Atlanta Steel Hoop Company. In 1902, the company built a fully functional plant three miles north of downtown Atlanta on farm land. The company changed its name in 1906 to the Atlanta Steel Company and was incorporated in 1915 as Atlantic Steel Company.

Atlantic Steel operated the first steel mill in Georgia and grew to become one of the largest employers in the state. At its peak, the company produced over 750,000 tons of steel annually, and expanded to include a variety of industrial and consumer product lines. During World War II, the company's furnaces produced hundreds of thousands of tons of steel for the war effort. In the early 1950s, production rose further still to fulfill defense orders and maintain other product lines.

Efforts to unionize the plant began in 1941, forcing closure for nearly two weeks due to an organization strike. Workers from Local 2401 of the United Steelworkers of America held three separate strikes between 1956 and 1958, each ceasing plant operations. Nevertheless, the company maintained a variety of employee activities, including landscaped baseball diamonds where company baseball and softball teams competed successfully in industrial league play.

Glenn Field, named for Atlantic Steel Chairman T. K. Glenn, was located across the street from the plant. Industrial league baseball games were popular within the city as box scores from the games were printed regularly in the *Atlanta Constitution.* Dixisteel, the trademark name for its products and the name of the company's baseball team, was a dominant force in the league as the company often recruited ringers to work plumb jobs and play baseball.

In the 1960s, the workforce began to shrink considerably as the fortunes of steel companies

dipped nationwide. The choice location for the 200-acre plant had been coveted by developers since the early 1950s when interstate construction yielded major highways that passed beside the plant. The company struggled through the 1980s and in 1997 the Jacoby Group purchased the property for commercial development. Atlantic Steel ceased operations on December 31, 1998.

In order to realize its development plans, developers worked with local, state, and federal agencies to revitalize the area and conform to Environmental Protection Agency standards. Nearly 180,000 cubic yards of contaminated soil was removed and two feet of fill dirt placed over the slag that remained on site. The cost of the cleanup of the steel mill was $250 million. The result is Atlantic Station, a thriving, a multi-use complex of residential units, offices, shops, restaurants and entertainment venues.

RIGHT An Atlantic Steel Mill worker forges a steel rod inside the mill in 1950. Workers recall having to put new soles on their shoes every ten days or so as the floor inside the factory became so hot it melted the rubber.

OPPOSITE PAGE *Atlantic Steel was founded in 1902 by local Atlanta businessmen as the Atlanta Steel Hoop Company. In October 1935, the 200-acre steel mill was in full operation.*

ABOVE *Baseball players were recruited to the Dixisteel roster and offered both white- and blue-collar jobs. Their games were played on Glenn Field next to the plant, which was named after former Atlantic Steel executive T. K. Glenn.*

Rich's MERGED 2005

Founded on Whitehall Street by Morris Rich in 1867, Rich's department store grew to become a beloved Southern institution. In 1877, Rich was joined by his brother, Emanuel, and in 1884 a third brother, Daniel, joined the dry goods firm. By 1901, M. Rich & Brothers Co. became one of the first true department stores in the South. In 1924, they moved into an Italian Renaissance-style building at the corner of Alabama and Broad Streets having outgrown several previous locations.

In 1926, Emanuel's son, Walter Rich, assumed leadership of the company. In March 1948, Frank Neely, then president of Rich's, witnessed the opening of the $5.5 million, seven-story Store for Homes adjoining the existing store. A four-story, glass-enclosed "Crystal Bridge" connected the two buildings. The following year, Richard H. Rich, the grandson of Morris Rich, was elected president. He led Rich's through tremendous growth and change until his death in 1975.

In October 1960, Reverend Dr. Martin Luther King Jr. was first arrested at Rich's along with local African American students while attempting to stage a nonviolent sit-in protest in the store's Magnolia Room. Rich navigated the institution through the civil rights era in Atlanta, integrating the store beginning in the fall of 1961, and positively influencing other Atlanta businesses with his decisions.

Under Dick Rich's leadership, Rich's evolved the traditions of excellent customer service, stewardship to the community, and memorable seasonal events. Christmas in Atlanta included the annual lighting of Rich's Great Tree on the rooftop beginning in 1948 and in 1959 the Pink Pig monorail debuted. Children rode above the toy department, and later on the rooftop before taking their gift lists to Santa Claus. In addition to Christmas traditions, Rich's launched *Fashionata* in 1945 as a community fundraiser. It grew into a hallmark cultural and social event until discontinued in 1994. Harvest markets, annual import shows, meals at the Magnolia Room, and Rich's Bake Shops famous for their coconut cake, are among the traditions remembered by generations of Rich's customers.

During the mid 1970s, MARTA rapid transit construction disrupted downtown. Late in 1979, MARTA construction was complete but patronage at the downtown store had suffered. The allure of the suburbs with its many shopping options contributed to the decline of downtown. Rich's opened their first suburban store at Lenox Square shopping center in Buckhead in August 1959, followed a month later by the stores at Belvedere Plaza, and Cobb Center in 1963, and others, eventually totaling twenty-nine stores.

In July 1976, Rich's merged with Federated Department Stores, ending the family control of the company. At the time, Rich's employed over 10,000 staff, operated twelve department stores, ten Richway discount department stores, three Rich's II boutiques, and eleven free-standing bake shops. In 1988, the French Canadian firm Campeau Corporation acquired Federated in a series of dramatic financial maneuverings. Less than two years later, however, the U.S. division of Campeau filed for bankruptcy protection. With dwindling business, Rich's closed its flagship downtown store in mid-1991.

In December 1994, Rich's long-time competitor, R. H. Macy & Co., agreed to a merger with Federated. Suddenly, the two rival department stores in Atlanta were owned by the same parent company. For a time, shoppers adapted and adjusted to the dual name brand of Rich's-Macy's. On March 5, 2005, Federated dropped the Rich's name and it disappeared altogether from the Southern commercial landscape.

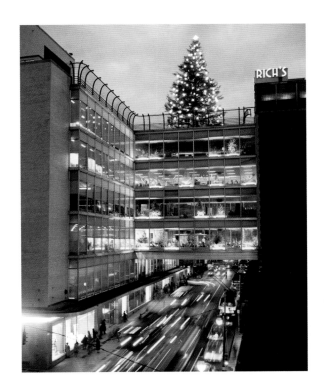

OPPOSITE PAGE *The 1924 flagship store, including the corner Rich's clock, remains a popular downtown meeting place even today as the building is reutilized.*

LEFT *Rich's Great Tree gleams atop the newly-completed Crystal Bridge over Forsyth Street in 1948. The Store for Homes, the Crystal Bridge, and the Store for Fashion were imploded in 1994. The U.S. General Services Administration restored the 1924 landmark Rich's store for office use and constructed a new "crystal bridge" connecting the former store building with the new forty-story Sam Nunn Federal Complex completed 1998.*

RIGHT *Richard H. "Dick" Rich charts Rich's progress during their centennial year in 1967. As son of Morris Rich's daughter Valerie Rosenheim, he changed his last name to Rich when he decided to follow in his forbearers' footsteps and lead the business.*

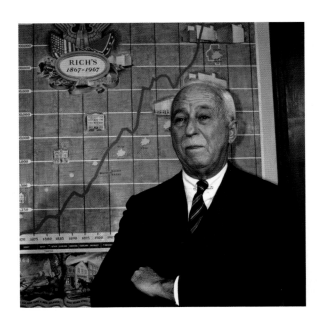

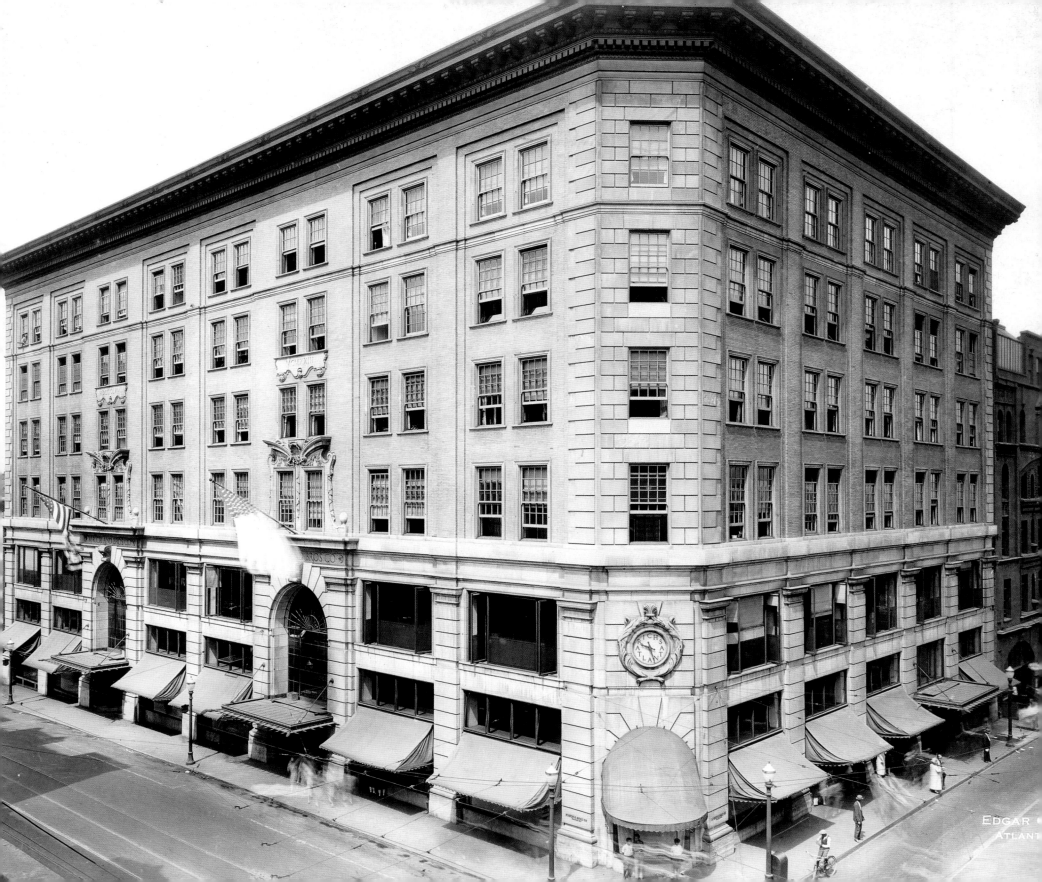

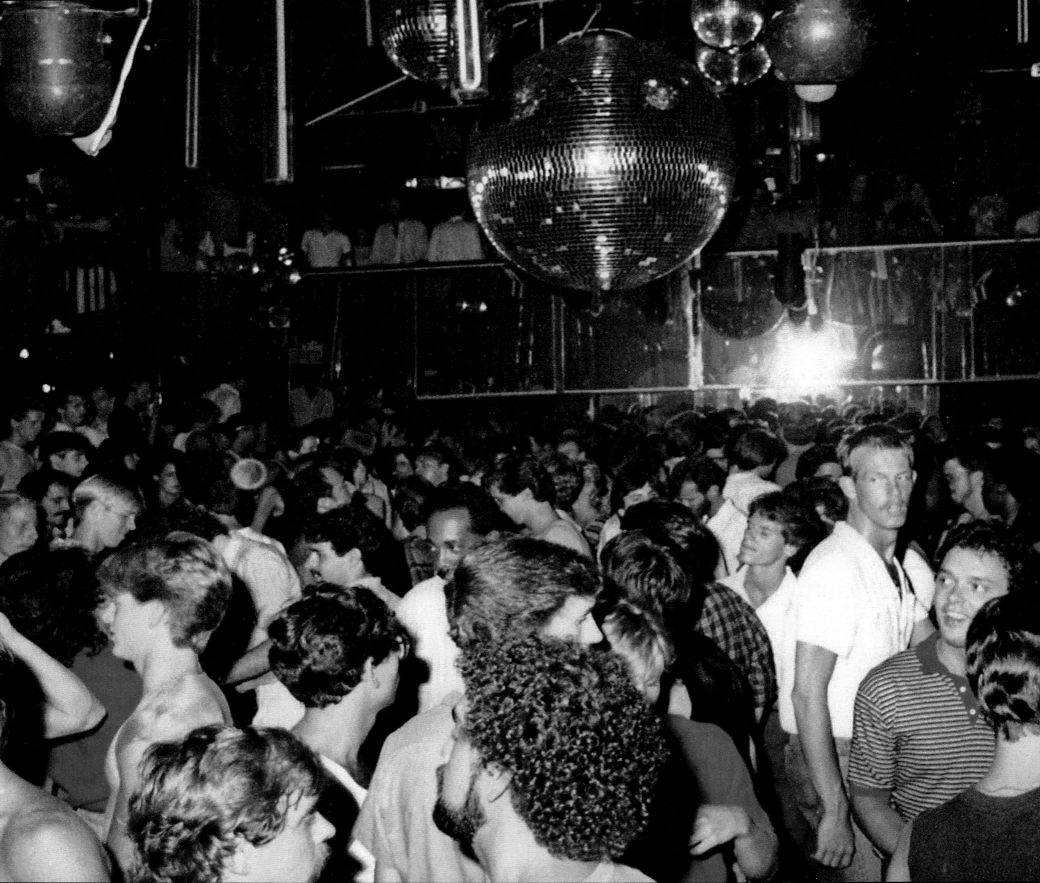

Backstreet DEMOLISHED 2005

For decades, Atlanta's gay and lesbian community has sought their own sites to socialize. Small, informal groups of men and women frequented the bars, clubs, and lounges in Atlanta's Five Points area in the 1940s and 1950s, long before many gays publicly self-identified or before Atlanta was labelled the "Gay Mecca of the South." Before any openly gay bars in Atlanta, there were the Tick Tock Grill, the Five O'Clock Supper Club, and the Wonder Club, each providing a valuable sense of community for mostly closeted gay clientele.

After the Stonewall Inn Riots in 1969, the growing Gay Liberation movement led to a proliferation of businesses, especially bars that catered largely to the gay community. In Atlanta, the most famous spot was perhaps Backstreet, a 24-hour nightclub in the heart of Atlanta's Midtown featuring cabaret acts and a huge dance floor.

When Backstreet opened as Peaches Back Door in 1971, Midtown had seen better days. Many of its old majestic houses had fallen into disrepair and street crime flourished. Located in the back of Joe's Disco on 845 Peachtree Street, the club operated briefly as Encore and reopened as Backstreet in 1975.

Backstreet attracted an eclectic range of customers, including celebrities such as Liza Minnelli, Farrah Fawcett, Cher, Paul Lynde, Cathy Rigby, and Gladys Knight. Many of its straight customers were bartenders, waiters, and managers at restaurants whose shift had ended and chose to party away the remaining hours of the night.

One of the most famous Backstreet attractions was Charlie Brown's Cabaret, located on the top floor. From 1990 to 2004, Charlie Brown, Lily White, Shawna Brooks, Raven, and other drag queens lip synched, danced, and entertained audiences. The high point of the evening usually came during Charlie Brown's performance in which she targeted audience members, usually straight men and women, for some good natured, but searing ridicule. Many of them enjoyed it immensely.

Backstreet was a private club and its status as such allowed it to set its own hours and serve alcohol twenty-four hours a day to anyone of legal age who purchased a club membership. But in 2001, Atlanta City Council approved an ordinance redefining private clubs. Under the new law, Backstreet was forced to operate the same hours as other Atlanta nightclubs. This meant closing at 4:00 a.m.—which for Backstreet was peak traffic.

It was devastating for business. The club's owners appealed, but by 2004 Backstreet and other similar private clubs lost their battle. Many of Backstreet's residential neighbors in new high rise condominiums launched crime, traffic, and noise complaints about the club that helped further its demise. Backstreet officially closed July 17, 2004.

By the time Backstreet closed in 2004 it was one of the oldest gay bars in Atlanta. Many other establishments such as Crazy Ray'z, the Pharr Library, the Gallus Restaurant and Lounge, Illusions, Scruples, the Texas Drilling Company, and 1888 had come and gone. Developers, who had been coveting the location for years for its prime Peachtree Street location, demolished the old Atlanta landmark in 2005 to make way for expensive condominiums.

OPPOSITE PAGE *The crowded dance floor at Backstreet was often packed as seen from this shot in the 1990s. Many late-night partiers came to dance at Backstreet as late as 4:00 a.m. after other bars had closed.*

LEFT *Backstreet represents an era in which men met other men or socialized in a bar setting. Today, the internet with online dating sites, chat rooms, and other web-based contacts for individuals has supplanted what for many was a community lifestyle.*

TOP RIGHT *"Atlanta's Ultimate Bitch," Mr. Charlie Brown performed Cabaret shows at Backstreet for parts of three decades. Woe to the unfortunate straight male or female who caught her attention at one of the shows.*

Techwood Homes / University Homes

DEMOLISHED 1996 - 2009

Located north of downtown Atlanta and on the edge of the Georgia Tech campus, the Tanyard Bottom area had long been an eyesore and source of embarrassment for city officials. Plagued by poor drainage, low-lying topography, poorly constructed houses and swampy backyards, and infested with rodents, the area was deemed a health hazard.

In 1917, Atlanta architect A. Ten Eyck Brown suggested transforming the area into a park leading from the edge of downtown to the campus of Georgia Tech. The suggestion gained traction. In 1923, landscape architect E. Burton Cook, backed by political leaders, real estate firms, and civic groups, proposed a 126-acre park within walking distance of the central business district: "an ideal pleasure ground," according to Cook.

Atlanta City Council approved a measure to issue $2 million in bonds to build the park, subject to voter approval in the September primary elections. But it was defeated after lobbying from commercial developers. Enter President Franklin D. Roosevelt and the New Deal. In 1933, Congress passed the National Industrial Recovery Act that, among other things, provided for the clearance of substandard housing and the development of public housing. In Atlanta, businessman Charles Palmer conceived of public housing as a money-making opportunity, and submitted a proposal to the federal government to clear the Tanyard Bottom slums and build public housing

there—as well as in an area in west Atlanta known as Beavers' Slide. The proposal was approved in 1933 and Atlanta was the first of thirty-six cities to receive public housing. Techwood Homes was completed in 1936 as the first public housing complex in the United States. Public housing, like other residential areas in Atlanta was segregated by race. Techwood Homes was reserved for white residents.

Built in 1937, University Homes in west Atlanta between Fair Street and Northside Drive was reserved for African American residents. Over 600 families were chosen from neighborhoods in Summerhill, Pittsburgh, and the Old Fourth Ward near Auburn Avenue. Like those at Techwood Homes, the modern facilities, including refrigerators and running water, were significant upgrades in the standard of living for many residents. Residents formed a tenants' association and established activity clubs for boys and girls. An auditorium on the premises provided a venue for public forums, voter-registration events, and information sessions on public health.

At both complexes there was a vital sense of community: residents planted gardens, held

dances and bingo parties, and took part in vocational workshops. But their conditions deteriorated drastically in later decades. A lack of job and good educational opportunities, coupled with increasing crime, gangs, drug use, and persistent poverty plagued many of the residents.

With Atlanta set to host the 1996 Centennial Olympic Games, the Atlanta Housing Authority was awarded $42 million to demolish Techwood Homes and build Centennial Place, a mixed-use development with apartments, retail shops, a school and daycare facilities. University Homes was demolished in 2009 without a plan to redevelop the area.

OPPOSITE PAGE *Looking east toward downtown Atlanta provides a partial view of Techwood Homes, a sprawling public housing project, the first of its kind in the U.S.*

BELOW LEFT *Tanyard Bottom was the slum razed to make room for Techwood Homes in the mid-1930s. It suffered from a variety of environmental maladies that made it a health hazard for those living within it.*

BELOW *University Homes consisted largely of two-story red brick structures designed by architect William Edwards.*

UNIVERSITY HOUSING PROJECT
FOR NEGROES · ATLANTA GEORGIA
EDWARDS & SAYWARD ARCHITECTS ··· ROBERT LOGAN ASSOCIATE
O I FREEMAN ENGINEER
PROJECT NO. 1102 1934

Pickrick Restaurant DEMOLISHED 2009

Future Georgia governor Lester Maddox grew up in the Home Park neighborhood on the west side of Atlanta surrounded by blue-collar workers at the nearby Atlantic Steel Company. After young Maddox dropped out of school, he worked at the mill to help support his family. He opened the Pickrick Restaurant in 1947 on the edge of the Georgia Tech campus. The restaurant's specialty was fried chicken and it grew in popularity over time; by 1956, it seated 400 customers.

In 1949, Maddox began to promote his segregationist political ideology in "Pickrick Says" restaurant advertisements published in the *Atlanta Journal*. In April 1964, several African Americans tried to enter the restaurant and were threatened off the property by Maddox with "Pickrick drumsticks," a euphemism for wooden axe handles.

On July 5, 1964, the day after President Lyndon Johnson signed the Civil Rights Act of 1964, three African American students tried to enter the Pickrick and test the new law—and Maddox escorted them off his property, pistol in hand. The event gained national media attention and Maddox's name became widely recognized. An ardent supporter of states' rights, Maddox took his

cause to the courts and lost. Rather than integrate the Pickrick, Maddox instead closed his business.

Following the U.S. Supreme Court's decision in *Brown vs. Board of Education* in 1954, declaring segregated schools unconstitutional, Maddox became increasingly interested in politics. He ran unsuccessfully for Atlanta mayor in 1957 on a platform against integrating Atlanta's public schools and ran again for Atlanta mayor in 1961, losing to Ivan Allen Jr.

Despite his prior political losses, Maddox ran for Georgia governor in 1966. Facing five other Democratic candidates, Maddox surprised many by winning a runoff primary against former governor Ellis Arnall. When neither Maddox nor Republican H. H. "Bo" Callaway received a majority vote, the state's general assembly then elected Maddox.

To the surprise of political observers, Maddox's administration was moderately progressive on racial matters. He supported significant prison reform and appointed more African Americans to advisory boards and white-collar government positions than any previous governor.

After leaving public office in 1975, he opened another restaurant named Lester Maddox's Pickrick, which sold souvenir Pickrick drumsticks. The former Pickrick building at 891 Hemphill Avenue was acquired by Georgia Tech in 1965 after Maddox closed his restaurant and renovated as a university facility. The building, considered by many as an historic landmark in Atlanta's civil rights history, was demolished in 2009.

PUBLIC ACCOMMODATIONS

Civil Rights conflicts occurred at other Atlanta sites beyond the Pickrick. In October 1960, Dr. Martin Luther King Jr., at the urging of student leaders, participated in a sit-in at the Magnolia Room at Rich's department store and was arrested. The intended publicity helped broker an agreement between students, elder black leaders, and downtown merchants.

Charles Lebedin, owner of Leb's downtown delicatessen, once said he would serve African Americans when other downtown restaurants did so. The restaurant was the site of a sit-in as well as a lie-in on the sidewalk in front of Leb's in June 1963. A week later, a group of Atlanta restaurateurs opened their doors to all, a milestone date for the desegregation of Atlanta public accommodations.

Moreton Rolleston, owner of the Heart of Atlanta Motel refused to rent rooms to African Americans. He challenged the validity of the Civil Rights Act of 1964, contending his fifth and thirteenth amendment rights were violated, and that Congress violated the Commerce Clause of the Constitution. In December 1964, the Supreme Court ruled against him upholding Title II of the act, which prohibited discrimination in certain places of public accommodation, including hotels.

Rich's Magnolia Room, Leb's Pig Alley Restaurant, and the Heart of Atlanta Motel are gone from the Atlanta landscape.

OPPOSITE PAGE *The Pickrick Restaurant circa1955.*

FAR LEFT *Just inside the front door of the Pickrick, Maddox posted his segregationist views on a large, autographed sign in 1964: I do not offer to serve either Integrationists or Interstate Travelers, Regardless of Race, Color, Creed, or National Origin.*

LEFT *Waitresses, cook staff, and a mound of chickens in the kitchen of the Pickrick Restaurant, circa 1955.*

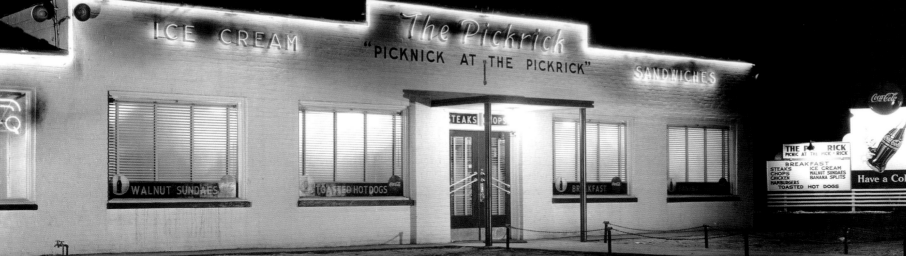

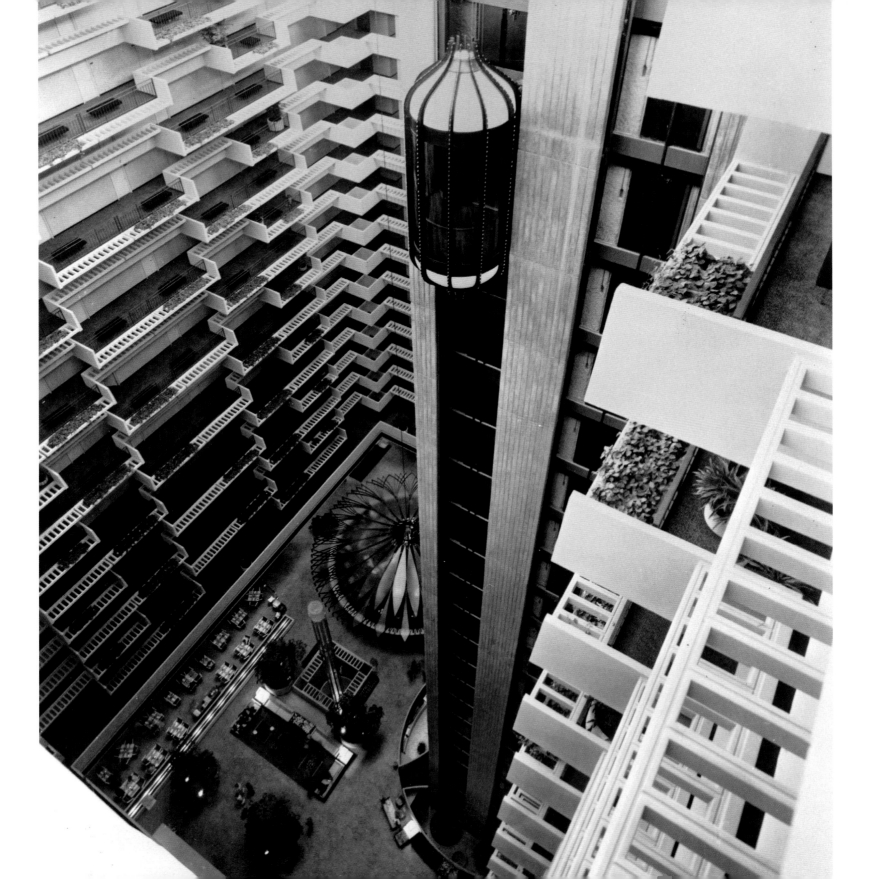

Regency Hyatt House REMODELED 2012

Though the building remains, architectural purists regret the loss of many of Atlanta architect John Portman's original design features at the Regency Hyatt House hotel. During a $65 million renovation completed in 2012, the fan-patterned cobblestone tiles of lobby floor were removed. Portman's original textured surface pattern provided the hotel lobby with the character of an indoor public square.

Also lost was the La Parasol cocktail bar sheltered by its distinctive eponymous roof, hanging by cable from the ceiling high above. Gone is Portman's original tunnel-like entrance leading from Peachtree Street, an architectural ploy to maximize the dramatic impact as one entered the soaring twenty-two-story sky-lit atrium.

When the Hyatt opened in May 1967, Portman's $18 million, 800-room hotel was hailed by architectural critics. Within three months of opening, the Hyatt booked a spectacularly successful ninety-percent occupancy rate. The open-atrium design influenced hotel architecture worldwide and the Hyatt Corporation adopted the design feature as a company standard with twenty-six open-atrium hotels worldwide by 1987.

Portman's glass-bubble elevators were also a signature feature. Not enclosed within a traditional elevator shaft, they were called "space-age" when they debuted in Atlanta. Fortunately, the open-atrium and the glass bubble elevators remain in today's renovated and renamed Hyatt Regency Atlanta.

In addition to the architectural changes, the building has suffered a gradual loss of prominence through the years. As downtown Atlanta has grown increasingly dense with skyscrapers, the views both to and from the hotel and its landmark blue-domed, revolving Polaris Restaurant have become obscured. What was once the single most character-defining silhouette on the downtown skyline, today the Polaris is all but lost from view by surrounding high-rise development.

For patrons of the restaurant in the early years, the views outward from the city were expansive. On a clear day on the eastern horizon, the granite mass of Stone Mountain featured prominently. To the northwest, the foothills of the Appalachian Mountains provided accents on the otherwise gently-hilled Piedmont terrain.

The novelty of the Polaris was the turntable. With a complete revolution occurring in an hour, diners could watch flight arrivals and departures at Hartsfield Atlanta Airport while facing south, and closer in-town they might spot any number of neighborhood features nestled within the green forest canopy, including the campanile of Glenn Memorial United Methodist Church at Emory University, the spire of Fountain Hall at Morris Brown College, and what was then the northern extremity of Atlanta's high-rise development at Colony Square. Node cities with their individual and distinctive skylines were non-existent at the time. The Polaris closed in August 2004 and re-opened in 2014 following extensive renovations. Guests still dine on a turntable floor but gone are the long-range, three-hundred-and-sixty degree vistas.

OPPOSITE PAGE *Atrium of the Hyatt Regency House, 1969.*

LEFT *The blue-domed Polaris revolving restaurant dominates the Atlanta skyline until later development obscured its prominence. A cylindrical glass tower, known originally as the Ivy Tower, is a 1971 addition to the hotel.*

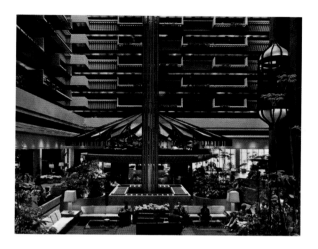

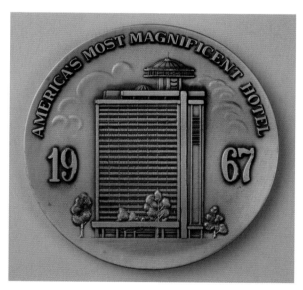

TOP *The La Parasol cocktail lounge is among the many distinctive and original designs by John Portman now lost following the 2012 remodeling.*

ABOVE *A souvenir medallion from the hotel opening in 1967 proclaims the Hyatt as America's Most Magnificent Hotel.*

Friendship Baptist Church RAZED 2014

Atlanta's oldest African American Baptist congregation, Friendship Baptist Church was established by twenty-five former slaves in a railroad boxcar in 1862. Later, the congregation bought land at the corner of Haynes and Markham Streets and constructed their first church building. Beginning in 1865, the fledgling Atlanta University – founded by the American Missionary Association, an abolitionist organization supporting African American education – held their first classes at Friendship.

Atlanta Baptist Seminary (now Morehouse College) held its first classes in the church having moved to Atlanta from Augusta, Georgia, in 1879. The Atlanta Baptist Female Seminary (renamed Spelman College in 1924) was established in the church's basement in 1881.

During its long history, only seven pastors led the congregation. Reverend Frank Quarles served from 1862 to 1881 overseeing construction of the brick church at the corner of Mitchell and Haynes Street in 1872. Reverend Dr. Edward Randolph Carter, a former slave from Athens, Georgia, came to Atlanta to attend the Atlanta Baptist Seminary while supporting himself as a shoemaker. He served as pastor from 1882 to 1944.

Reverend Dr. Maynard Holbrook Jackson moved to Atlanta from Dallas, Texas, in 1945 to pastor at Friendship until his death in 1953. His wife, Irene Dobbs Jackson was an Atlanta native and taught French at Spelman College. Their son, Maynard Holbrook Jackson Jr., worshipped here and later served three terms as mayor of Atlanta.

Friendship is known as the "mother church" for Atlanta's African American Baptist congregations. Nine other congregations were born from Friendship, including Wheat Street Baptist Church founded as a mission in 1871. Later generations of churches grew from these, including Ebenezer Baptist Church founded in November 1886. Ebenezer became the home church for Reverend Dr. Martin Luther King Sr., beginning in October 1931. Reverend Dr. Martin Luther King Jr. co-pastored at Ebenezer with his father beginning in 1960 and continuing until his death in 1968.

The Georgia Dome stadium was constructed in 1992 in the shadow of Friendship's belfry. In addition to serving as a venue for athletic and entertainment events, the Georgia Dome served the Atlanta Falcons football team as their home stadium.

In 2010, the announcement was made to construct a new retractable-roof stadium just south of the Georgia Dome on the site of Friendship Baptist Church and the nearby Mt. Vernon Baptist Church. Following negotiations between the City of Atlanta and the churches, financial agreements were reached in 2014 for the churches to relocate. Friendship held their last service on May 25, 2014. The 1872 Romanesque Revival church building was razed the following July.

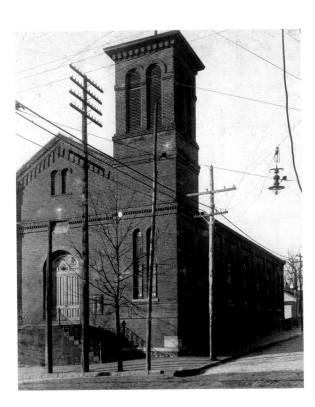

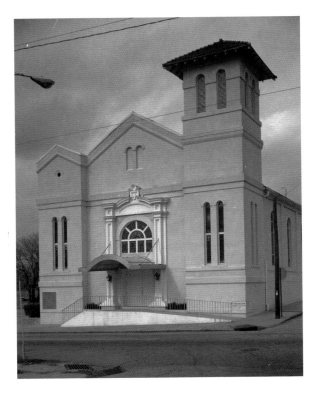

FAR LEFT *Decorative brick corbelling adorns gable ends of the Friendship Baptist Church, circa 1900.*

OPPOSITE PAGE *Prior to Reverend Maynard Jackson's tenure as pastor beginning in 1945, much of the brick was covered with stucco, the church entrance was lowered, a classical surround was applied, and the front steps removed.*

LEFT *In 1988, the Atlanta History Center documented the north façade for a museum exhibition,* Building on the Past: Perspectives on Atlanta Architecture.

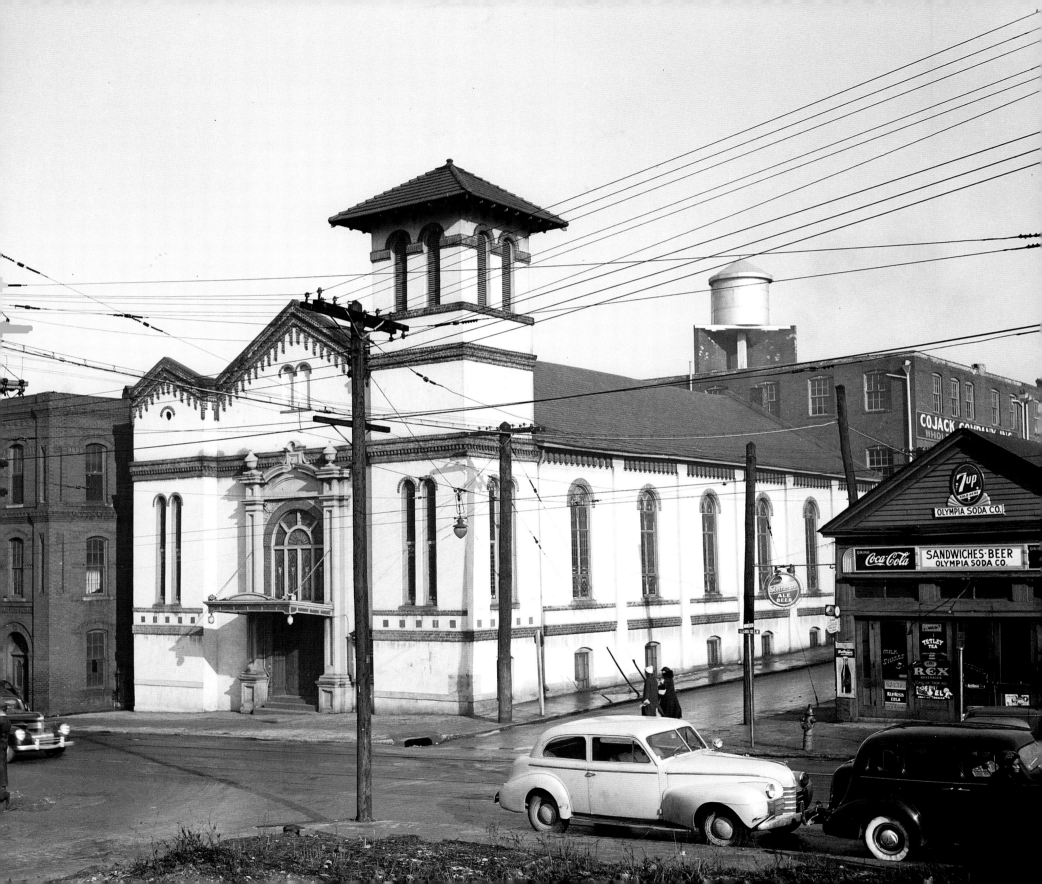

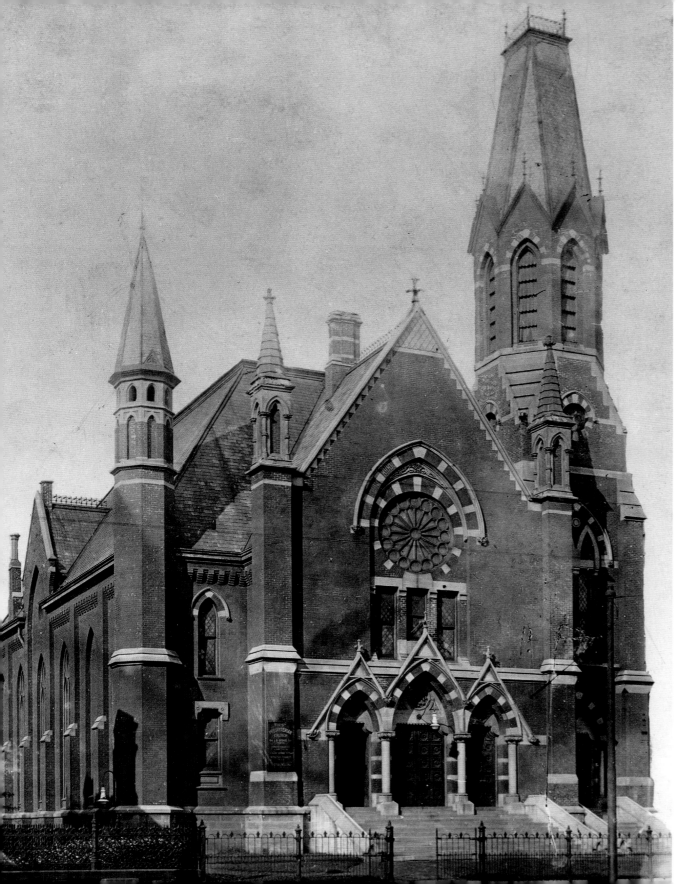

ATLANTA CHURCHES

Atlanta has lost both modest frame meeting houses and architecturally spectacular houses of worship throughout its history. In 1847, a subscription fund was established to build a combination school and nondenominational church facing Peachtree Street at Pryor Street – this was the first house of worship in Atlanta. The second church building was Wesley Chapel constructed by Atlanta's earliest Methodists in 1848 at the same site. It survived the Civil War and was demolished in 1871 for construction of the First Methodist Church at the intersection. That spired landmark gave way to the Candler Building in 1904, still standing.

At the time of the Civil War, the four prominent Christian denominations—Baptist, Methodist, Episcopal, and Presbyterian—had each built substantial houses of worship in the heart of

LEFT *The 1878 First Presbyterian Church, located on Marietta Street, employs elements of the picturesque High-Victorian style, including the distinctive clipped spire, multiple gables and pinnacles, banded keystones, and textured brick surfaces. The building was demolished in 1916.*

BELOW *Payne Memorial Chapel's simple clapboard entrance faces Hunnicut Street in 1892 as Luckie Street extends northward, full of ruts, to the Georgia Institute of Technology beyond. Methodist minister Reverend S. R. Belk, its first pastor, stands in the foreground. The 1868 building was replaced in 1892 by a red brick structure and in 1895 earned the status of Payne Memorial Church.*

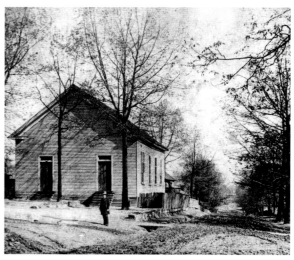

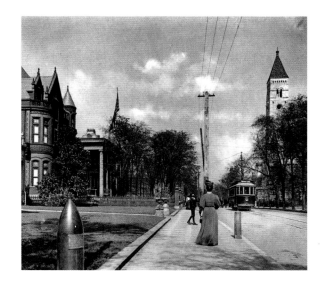

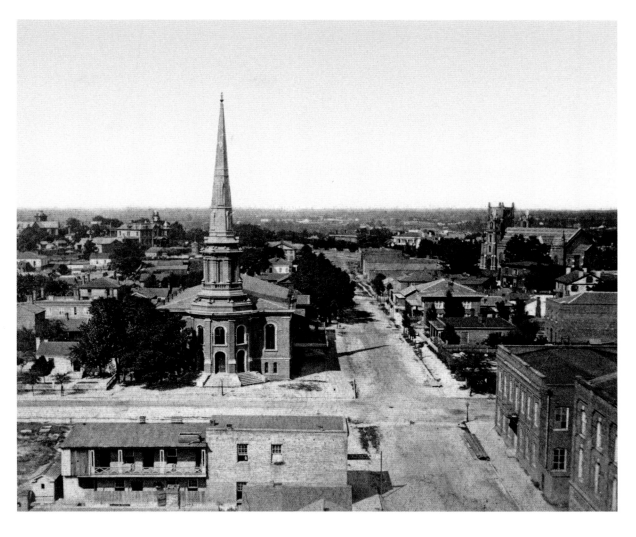

Atlanta. Unfortunately, none of the antebellum church buildings remain. Atlanta's Jewish population at the time numbered over 2,500 (among a city population of 10,000) and the Hebrew Benevolent Congregation constructed the city's first synagogue in 1875.

Urban growth and change influenced the location and the survival of many of the city's sacred buildings. When Fay & Moser architects designed Saint Philip's Episcopal Church in 1881 on the corner of Washington and Hunter Streets, little did they know that before the end of the decade a state capitol building would rise on the adjacent block. In 1933, the congregation moved to the Buckhead community, north of the city, and a state office building was constructed on their former site.

As population centers shifted and neighborhoods prospered or waned, the demolition of church buildings often followed. Congregations relocated, joined with others, or disbanded. In several Atlanta scenarios, church buildings have been repurposed. From 1961 to 1977, the Academy Theatre performed within the repurposed Buckhead Baptist Church.

The Ponce de Leon United Methodist Episcopal Church was constructed in 1917 in the Neo-Gothic style and listed on the National Register of Historic Places. With the neighborhood in decline in the mid-1970s, the congregation moved elsewhere and the church sold. In 1977, the restaurateur and developer Bill Swearingen saved the building from demolition and won an Award of Excellence from

the Urban Design Commission by adaptively converting the former church into the Abbey Restaurant.

The renovation created a kitchen in the basement, outfitted the apse as a "chapel lounge," and constructed a "harpist's loft" overlooking the main dining area in the former nave. The themed décor inspired the design of the waiters' brown hooded robes fashioned from monastic garments. The restaurant closed in 2005 and the building now functions once again as a church. Today, Ponce de Leon Presbyterian Church offers weekly services from within the revived 1917 building, and provides a breadth of ministry beyond the church walls into the Midtown community and beyond.

ABOVE LEFT *The bell tower of First Baptist Church completed in 1906 provides a striking profile at 209 Peachtree Street, across the street from the Governors' Mansion at Cain Street and the white columns of the Herring-Leyden House. Gottfried Norrman, active in Atlanta from 1880 to 1909, designed the granite sanctuary, demolished in 1929.*

ABOVE *Church towers dominate the Atlanta skyline in 1882 looking north from the roof of the Kimball Opera House— State Capitol. First Baptist Church anchors the corner of Walton and Forsyth Streets. At right, the unfinished spire of the First Methodist Church just breaks the horizon. Eventually the main spire would rise another 90 feet in height. The building was demolished in 1903 to make way for the Candler Building.*

INDEX

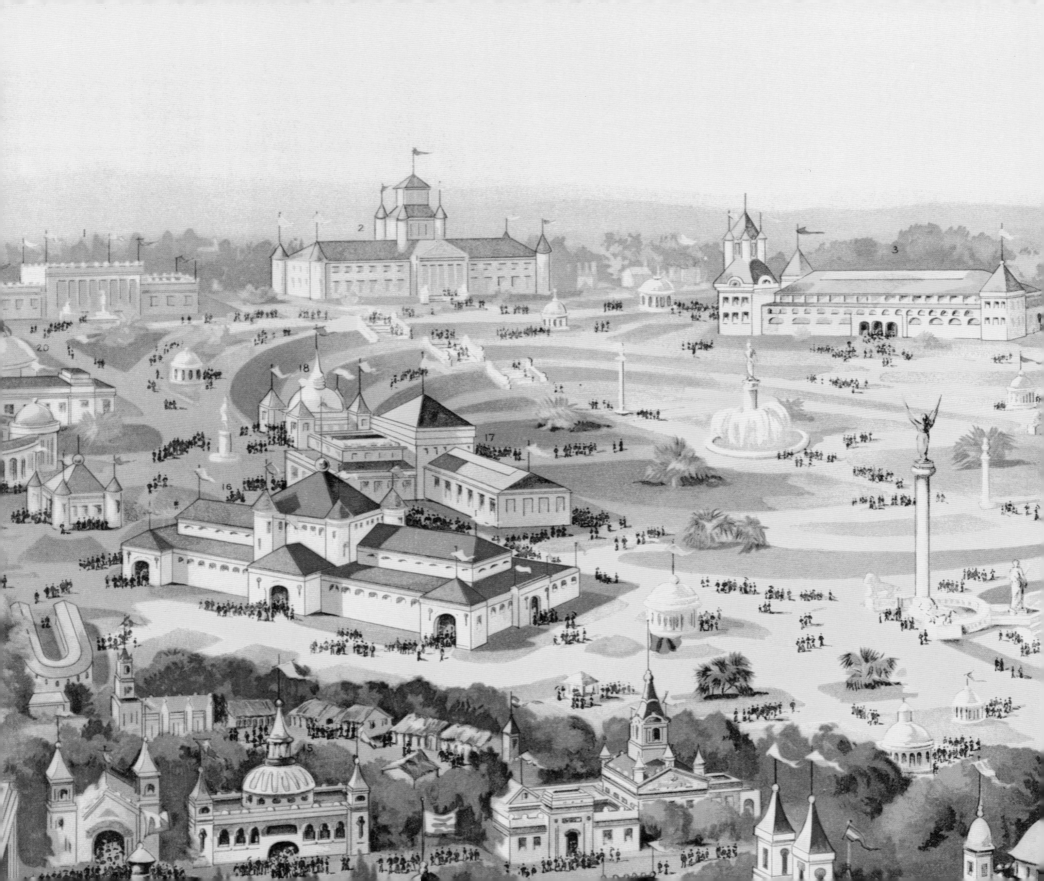